Art Spaces
The architecture
of four Tates

Helen Searing

Tate Publishing

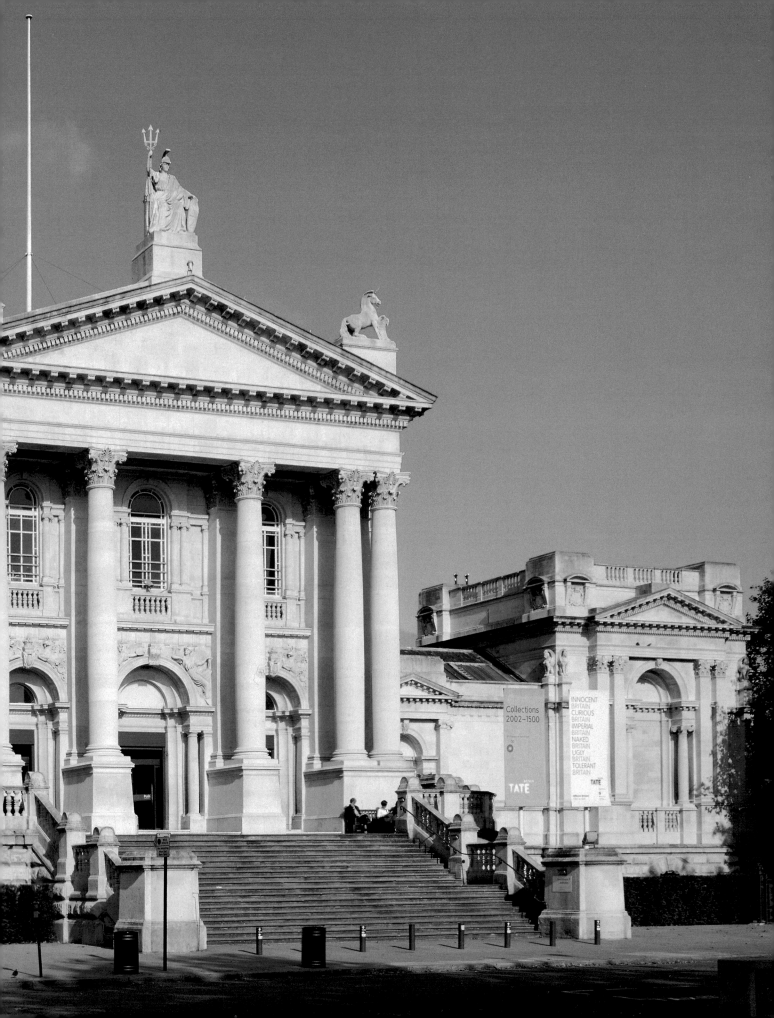

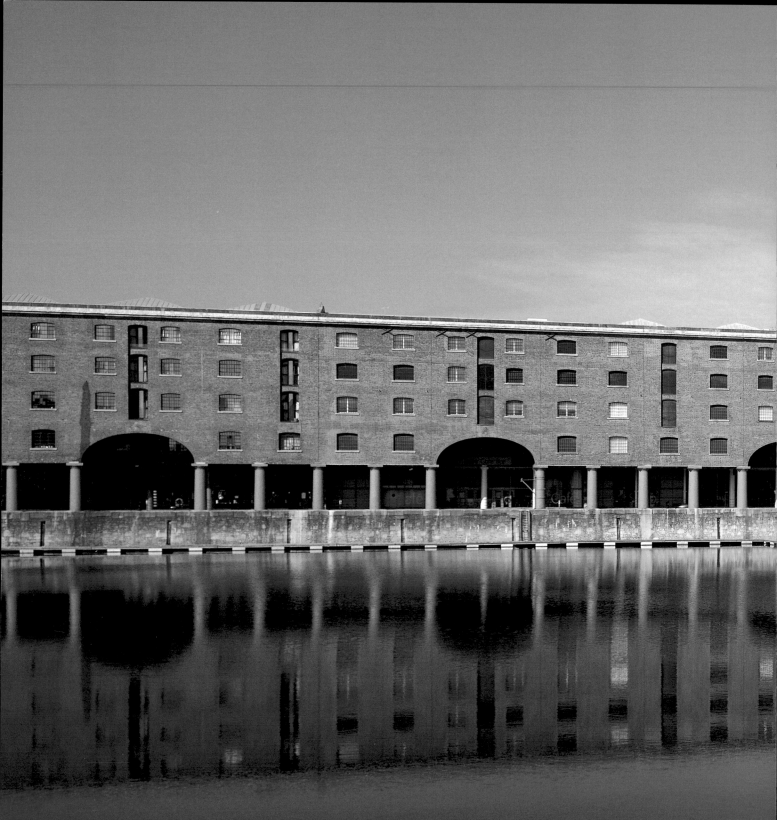

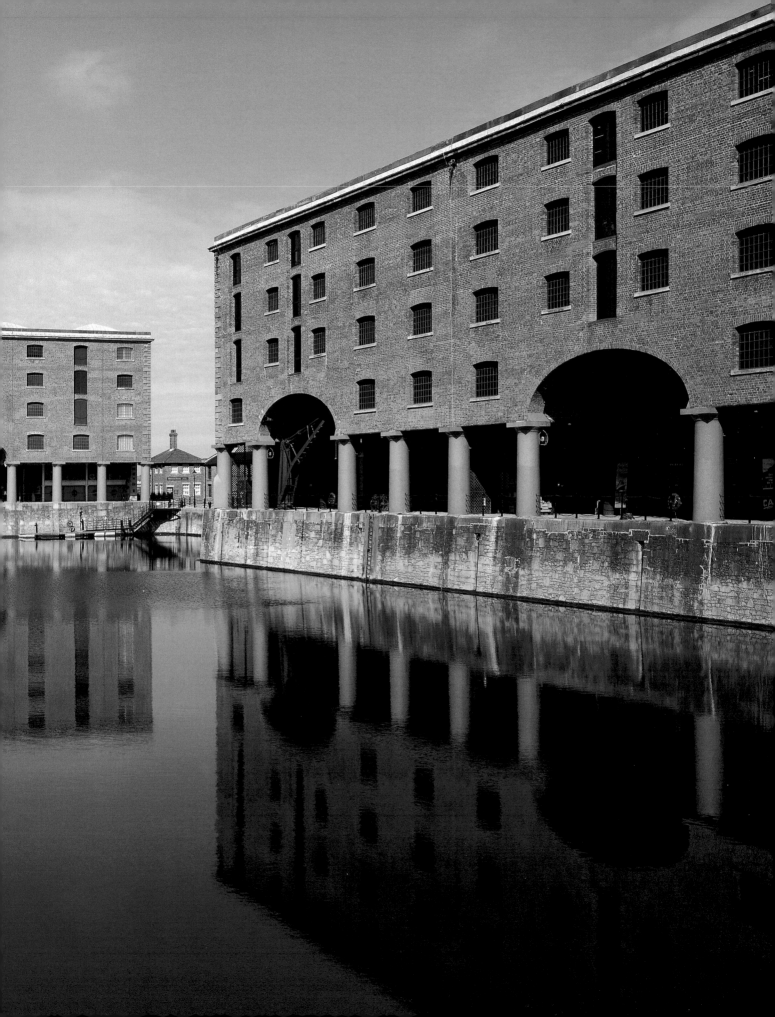

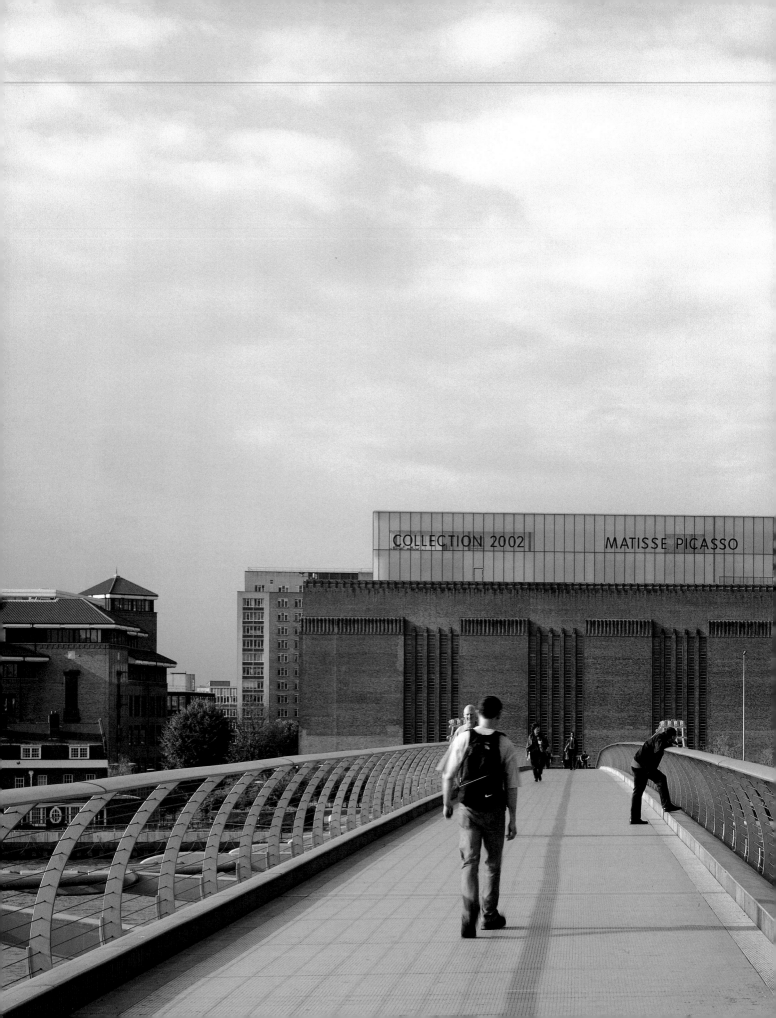

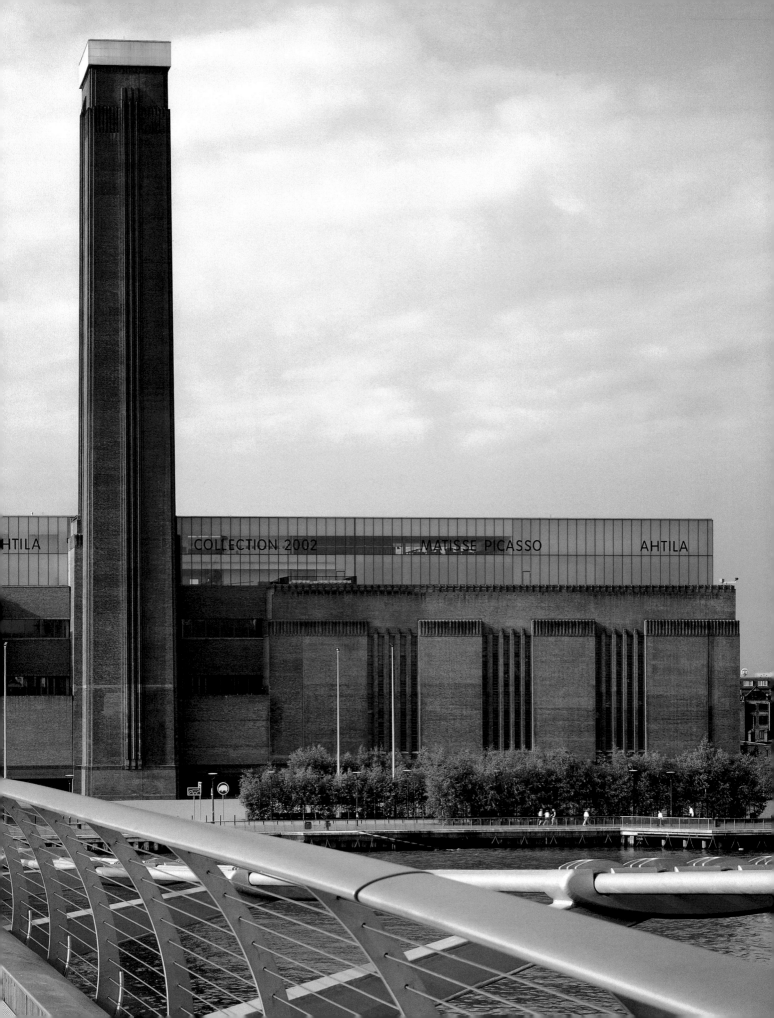

First published 2004 by order of the
Tate Trustees by Tate Publishing,
a division of Tate Enterprises Ltd,
Millbank, London SW1P 4RG
www.tate.org.uk

British Library Cataloguing in
Publication Data
A catalogue record for this book is
available from the British Library

ISBN 1-85437-398-6

Distributed in the United States and
Canada by Harry N. Abrams, Inc.,
New York

Library of Congress Cataloging in
Publication Data
Library of Congress Control Number:
2003109368

Designed by Esterson Associates
Printed in Italy by Mondadori Printing

Cover:
Tate Modern (photo: Marcus Leith and
Andrew Dunkley/Tate Photography)
Tate Britain (photo: Mark Heathcote/
Tate Photography)
Tate Liverpool (photo: Dave Lambert
and Rod Tidnam/Tate Photography)
Tate St Ives (photo: Marcus Leith/
Tate Photography)

Frontispiece illustrations:
pp.2–3: Tate Britain (photo: Joanna
Fernandes/Tate Photography)
pp.4–5: Tate Liverpool (photo:
Dave Lambert and Rod Tidnam/
Tate Photography)
pp.6–7: Tate St Ives (photo: Marcus Leith
and Andrew Dunkley/Tate Photography)
pp.8–9: Tate Modern (photo: Marcus Leith
and Andrew Dunkley/Tate Photography)

Tate's original building at Millbank was a hundred years old in 1997. That was a moment of extraordinary architectural development under the leadership of Peter Wilson, Director of Projects and Estates. In 1997 Evans & Shalev's Tate St Ives was but four years old and the second phase of Tate Liverpool by Michael Wilford & Partners, the Centenary Development at Tate Britain by John Miller + Partners and Allies and Morrison, and the new national museum of modern art – Tate Modern – by Herzog & de Meuron were all in construction. A few years later those projects are complete and their architecture has already become a seamless part of the experience of visiting the four Tate galleries. It is now, therefore, an appropriate moment to look back with some pride over a century or so of architectural activity.

Why should a museum choose to examine its architecture in a book? The factors that make up a successful art gallery are complex, but no-one can deny that the quality of the architectural space plays a significant part in the experience and that it has become a matter for appreciation and debate among visitors, artists, curators and critics alike. Of course, taste and style are the ever-present influences which act upon both architect and client in arriving at a successful design. Museum buildings – and in particular those of museums that have a responsibility for contemporary art – are inevitably a 'work in progress' and this makes any survey of one institution's architecture a difficult task. The survey must inevitably be a history, an account of what has been achieved and with what difficulties, against what challenges and to satisfy what aspirations. It must be seen in context – no museum building is conceived in isolation – there are lessons to learn, examples to be followed or to be admired but set aside. Above all, however, this book is a celebration of the work of many architects, each in their own way dedicated to providing excitement and quality in Tate's buildings.

In commissioning Helen Searing to undertake the challenging task of drawing together a coherent account of more than a hundred years of architectural activity we have been fortunate in finding someone whose knowledge and sympathy for her subject has enabled her to set Tate's various architects and their buildings in the context of the architectural development of museums as a whole. Her energy and enthusiasm for the task was notable and the result will inspire all those who are concerned for the successful display of art: we are greatly indebted to her for a book that is not only a celebration of past achievements but also a tool to inform future design challenges. The experience of Tate's first century of intense and almost continuous development suggests that there will be many such challenges to come: Tate's original building – now Tate Britain – still requires substantial architectural interventions to help it meet contemporary standards, and the adjacent site still presents opportunities for the future. The popularity and success of both Tate Modern and Tate St Ives demand architectural inputs in response, while at the time of writing Tate Liverpool faces the opportunities of the City of Liverpool's role as European Capital of Culture in 2008. Readers will discover that Tate's past in architectural terms offers many warnings to anyone wishing to predict the future for its buildings, but we can assert with confidence that there will be new architecture and that it will, as now, continue to be an essential ingredient of what we have to offer.

Nicholas Serota
Director, Tate

The genesis of this book came about through discussions with Liz Alsop, my commissioning editor at Tate Publishing and subsequently my freelance copyeditor. Nicholas Serota, Director of Tate, Peter Wilson, Director of Projects and Estates, and Celia Clear, Director of Tate Publishing, supported and shaped its long gestation.

Members of Tate staff – from the Library and Archive, Tate Britain, Tate Modern, Tate Liverpool and Tate St Ives – were always generous with their time and insights. Gratitude is due as well to the personnel of the National Art Library and the British Library and to members of the various architectural firms. My husband Philip Wiseman provided sage counsel. Jon Hill of Esterson Associates approached the complexity of design with patience and ingenuity to produce an unusually attractive volume. Valerian Freyberg chased down illustrations with acuity and speed, and Sarah Tucker masterminded the complex production process. My special thanks go to Marcus Leith, Andrew Dunkley, Joanna Fernandes, Rod Tidnam and Mark Heathcote of Tate's Photography Department, not only for their superb professionalism but for their delightful company as we set about finding the best vantage points for illustrations. Finally, it was the continual encouragement and patient care of my editor Nicola Bion that made the realisation of this manuscript possible.

Acknowledgements

Helen Searing

Theatre, cathedral, marketplace: Museum architecture and four Tates

A building as complex as a museum has many different functions. At certain moments of the day it is like a theatre; at others a cathedral. Some people would say that it is like a marketplace.

Nicholas Serota, 'Tate Frames Architecture', *ANY*, no.13, 1996

Museums have never been more important … they have become cathedrals for a secular culture, storehouses of collective values and diverse histories, places where increasingly we want to spend our free time and thrash out big issues.

Michael Kimmelman, *New York Times*, 26 August 2001

A visit to the art museum has become one of the more compelling ceremonies of our time, accompanied by elements of ritual and awe that have affinities with religious worship. Not surprisingly, art museums have been called temples (in the nineteenth century) and now are dubbed secular cathedrals. Just as the architecture of temples and cathedrals was integral to the liturgy, so the museum building makes an indispensable contribution to the experiences on offer.

Art museums bring to the fore issues of aesthetic meaning and quality, so it is not surprising that they are considered the building type *par excellence* by which to gauge the architecture of a given epoch, place, career. Since the 1960s they have been the focus of a critical attention that has further intensified during the last two decades of the twentieth century. The thirst to establish new art galleries and extend existing ones seems unquenchable, and the increasing supply has raised rather than diminished interest in the genre on the part of layperson and professional alike.

More than the history of collective or individual architectural styles is at stake here. Museum buildings are not passive witnesses to the rise of an institution that plays an increasingly important and diversified role in the community, but key players in that ascent. From places consecrated to the conservation, display and contemplation of art, museums have expanded their mandate to become arbiters of value, engines of education, revitalisers of community, generators

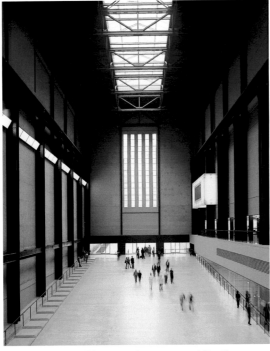

of economic wealth, sites of corporate philanthropy and reward, purveyors of entertainment, refreshment and consumer goods. For the last several decades the museum has also become a studio where artists create *in situ* installations and artefacts, and dramatically critique and reject the traditional role of the institution and its container. Methods of exhibition have changed, along with the nature of the encounter between spectator and object, often requiring altered spatial arrangements. As the most visible manifestation of such developments, museum architecture both reflects and influences these operations. The evolution of the art museum may be traced in an exceptional way by a study of the architecture of the Tate Galleries, both as telling examples of the collective genre and as structures marked by a fundamental individuality.

Four Tate Galleries

Britain's four Tate Galleries differ markedly in location and looks. Two are in London, the third in a major industrial city in the North-West of England and the fourth in a picturesque Cornish town. Two occupy purpose-built structures, the others converted premises. Yet they have in common distinctive waterside settings – Tate Britain at Millbank and Tate Modern at Bankside are on the north and south banks of the Thames, Tate Liverpool is on the Mersey and Tate St Ives is by the sea. Because of their particular situations, the customary frontality of approach is lacking. Rather than facing a stolid square or tree-lined boulevard, all the Tates confront the water, a moving and evanescent presence. The spectator has perforce a different relationship with a building arrived at laterally. The encounter is more gradual, subtler in its invitation to enter, requiring a careful look at the exterior of the building from various vantage points.

Moreover, all the Tates are built over sites previously dedicated to radically incongruent uses – penitentiary, dock warehouse, local gasworks, power station – and distant from the fashionable centres where such cultural establishments typically find a home. Each makes a powerful statement about the architectural priorities dominant at the time of conception and construction and, in the case of the original Millbank building, of extension. And each has been key to the regeneration of a neighbourhood or town.

Yet the circumstances of their origins are totally disparate. The first has existed since 1897 and undergone numerous extensions and revisions. The others did not come into being until the final fifteen years of the twentieth century. The original gallery, initially called the National Collection of British Art, was a gift to the nation by a successful sugar manufacturer and art lover turned philanthropist. Popular success fuelled a need for continued development. No fewer than seven additions (and several reconfigurations) – the first four funded entirely through private benefactions – have been required since its founding, and the building is expected to be further expanded and modified in the next ten years. The extensions and refurbishments record a changing mandate: initially housing modern British art exclusively, then British art of all periods since the sixteenth century, and subsequently modern foreign art. Finally, in 1992,

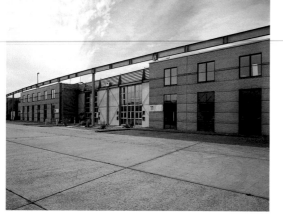

it was decided to divide the holdings by creating a separate gallery devoted to modern art, and in 2000 the museum at Millbank officially became Tate Britain.

The Liverpool gallery, converted in 1988 and 1998, was prompted by the desire to find a place in the north of England to show the ever-expanding modern Collection, a wish that coincided with the Merseyside Development Corporation's drive to save the magnificent buildings of the disused Albert Dock. Tate St Ives (1993) had its origins in a local initiative, when the village that since the 1890s had been home to innumerable artists wanted to honour and revitalise its legacy. The building is the fruit of collaboration between the Cornwall County Council, which owns the structure, and the Tate, which operates it.

Tate Modern, which opened in May 2000, was the inevitable consequence of the Tate's mission to be Britain's chief repository of contemporary art, foreign as well as British, a responsibility that necessitates perpetual acquisitions and demands a capacious and celebratory container. The daring decision to transform Bankside Power Station into one of the world's largest museums of modern art has been rewarded with a record-breaking audience, drawn by the architectural conversion as well as the Collection, and international critical acclaim for the building. The remarkable Tate Store newly established in Southwark should also be mentioned. Carved out of several recently constructed warehouse buildings – thus like Tate Liverpool and Tate Modern a refitting of an existing structure –

and offering environmentally sound rooms for storage and handling of the entire Collection, it releases space in the gallery buildings for additional display and other activities directed toward the public.

The architectural variety manifested in these structures, in terms of size, materials and methods of construction, patterns of circulation and illumination, and stylistic vocabulary, has much to tell us about their institutional singularities – the nature of their collections, the constituency, the situation, the management. To some degree the variety is also the outcome of the desire to forge a distinctive identity for each. In only one case has the same firm worked in two locations: James Stirling, Michael Wilford and Associates accomplished both the Liverpool renovation and the Clore addition at Millbank, and were selected for the vast, unexecuted New Museums project of the 1980s planned for the Millbank site. For Tate Modern a major international competition was launched, and the short list comprised an entirely fresh cadre of architects. A non-British firm, Herzog & de Meuron were chosen.

There reigns among the four Tate buildings an independence from the received models of their respective eras, as will be seen in the more detailed descriptions that follow. At first glance, Tate Britain is just one in a line of conventional classical museums so ubiquitous in the nineteenth century, yet its first architect, Sidney Smith, forged his own path amid his exemplars and subsequent additions have rendered the complex building ever more singular. Similarly, with Tate St Ives Evans and Shalev eschewed a revolutionary approach but, nevertheless, thanks to their sympathy with the inimitable character of the town, produced an exceptional instance of the purpose-built museum.

The quality of the original buildings distinguishes Tate Liverpool and Tate Modern from other industrial conversions, since the 1970s very popular for galleries of contemporary art across the world. But the two transformations have necessarily been handled differently: Stirling preserving much of the rugged character of Hartley's interiors; Herzog & de Meuron, in their new galleries, emphasising the refined over the raw.

Although all four of the Tate fabrics manifest the belief that the architecture should be a work of art in itself and part of the attraction for visitors, they illustrate no less strongly the conviction that the container should not overpower the contents. Perhaps the fact that the term 'gallery' is preferred over 'museum' reflects the determination to avoid the grandiose and flamboyant in architecture, focusing drama and provocation primarily on the display of art.

The architecture of the museum and the Enlightenment

As the product of many different minds and hands, serving the multitude rather than the few, public buildings have always mirrored their historical context more thoroughly than any other artefact. Art museums, which arose in mid-eighteenth-century Europe, replacing temples, cathedrals and palaces as communal repositories of the arts, arguably have done so more acutely than any other functional type. They are treasure houses of our cultural heritage and aesthetic distinction has been an integral part of the brief since their invention.

By the early 1800s a paradigmatic architectural solution for art museums had been codified – by architectural theorists in France, archaeologists at the Vatican, and German scholars of the nascent discipline of art history, the birth of which coincided with that of the art museum. For the next 150 years this solution was repeated, with subtle variations, throughout Europe and North America. But since the 1940s, museum buildings, erected with accelerating frequency throughout the world, have presented an exhilarating if occasionally bewildering range of formal and practical schemes that mirror the course of stylistic experimentation in architecture, a course that is illustrated vividly by the four Tate establishments.

Initially museums were distinguished chiefly by the number, kind, quality and accessibility of their holdings; the buildings that housed them were fundamentally generic, though each was provided with a decorously recognisable image. However, by the mid-twentieth century, competition for funds and visitors prompted each institution to search for an increasingly individual identity and for a comparably original architectural envelope. World-famous architects, themselves desiring these most prestigious of commissions, are wooed by ambitious trustees and directors to design monuments that will call attention to uniqueness and memorability.

Nevertheless, long before the twentieth-century obsession with innovative museum design, the institution had flourished, and the buildings it occupied, even if frequently cut to a familiar pattern, were seen as the measure of a city's prestige as cultural centre and travel destination. Products of the Enlightenment belief in self-improvement through the cultivation of the mind and the senses, and of the growing demand for access to the means of this cultivation, museums in diverse fields (natural history, archaeology, fine and decorative arts, eventually ethnography, science and local history) proliferated, along with other secular institutions of improvement such as libraries, conservatories and academies. At the top of the hierarchy of such cultural establishments in continental Europe were art museums. One of the most far-reaching and lasting results of the French Revolution was the founding of the Napoleonic Museum in the Louvre, and the German states followed this lead. Nineteenth-century nationalism was a driving force in the creation of museums and recent scholarship has demonstrated how the organisation of the displays reinforced patriotism.

Great Britain lagged behind the Continent and North America in responding to enthusiasm for art museums, preferring to compete internationally in commerce and industry. The government was not inclined to match the apparently disinterested generosity of the French and the various German states. Its main arguments for supporting museum formation were the benefit to industry through the demonstration of good principles of design and the civilising influence on the working classes, keeping them content by raising their aspirations. The future Victoria and Albert Museum, established through the profits of the 1851 Great Exhibition, was motivated by the desire to teach British tradesmen to produce more desirable goods. Not surprisingly then, it was well into

Tate Store: loading bay and storage area.

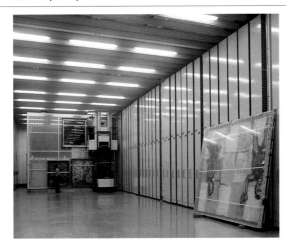

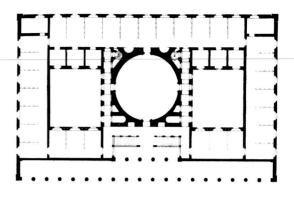

the twentieth century before Britain's museums and galleries could compete architecturally with Continental and American exemplars.

William Wilkins had to cope with such a parsimonious budget that it was inevitable the National Gallery (1832–8) should look compromised when compared to its contemporaries in Europe and the later North American institutions founded by wealthy philanthropists. With a few exceptions – Sir Robert Smirke, C.R. Cockerell (designer of the Ashmolean Museum at Oxford, 1839–45, which he was forced to combine with the Taylorian Institute), and the short-lived George Basevi (whose Fitzwilliam Museum at Cambridge, 1836–45, was completed posthumously in 1848 by Cockerell) – the more gifted and ambitious architects gravitated toward commissions for government office buildings and religious and domestic architecture where funds, respectively public and private, were not so scarce. In fact, it was precisely because it was paid for by the magnanimous Sir Henry that the Tate Gallery makes a more assertive impression than the National Gallery.

The classical paradigm
Public museums were first constructed during an age dominated by historicism, which demanded the revival and renewal of various period styles. Most purpose-built art museums were immediately identifiable by an architectural language derived from Greek, Roman and Renaissance precedents, by symmetrical compositions with deliberately orchestrated circulation patterns, and by features such as imposing staircases, domed rotundas, some square rooms called cabinets, and almost always longitudinal rooms termed galleries – most frequently vaulted – disposed around internal courtyards. Typically elevated over a podium, museums rarely exceeded two storeys. The walls, usually constructed of pale stone, tended to have few openings and to be decorated with the classical orders. The paradigmatic example is the Altes Museum (1823–30) in Berlin.

Its architect, Karl Friedrich Schinkel, is still thought of as Prussia's most talented and versatile architect. Called upon to design a magnificent structure to house

the nation's artistic patrimony after Napoleon's occupation of Berlin was lifted and the treasures that had been forcibly removed to Paris were returned to the Prussian capital, Schinkel devised a memorable model. Typical was the integration of the Greek orders with the Roman dome, the plan disposed around two light courts, and the column screen before the entrance. Uncharacteristically, rather than using the temple portico favoured by most architects, Schinkel based his façade on the ancient stoa, a secular building type customarily found in the marketplace and associated with learned discussion. One of the delights of the Altes Museum is that the open colonnade allows, indeed demands, a view toward the palace (the original source of the collection), the formal gardens that lie between museum and palace and, most importantly, major buildings in Berlin – from 1870 the capital of Germany – to underscore the inextricable link between city and institution.

The first level is devoted to antiquities: statues, ceramics, coins and gems. The central rotunda, rising the full height of the building, receives light from the oculus and is as much a meeting place for reflection as an area to display copies of ancient sculpture. For the paintings, housed on the top storey, Schinkel rejected the more common top-lit vaults in favour of flat ceilings and side-lighting through windows. Most of the pictures are hung on screens perpendicular to the outer walls – thus increasing the surface for display – so that they are observed in raking light.

This system of lighting is one of the rare anomalies

Altes Museum:
section showing
central rotunda
and second-floor
galleries with
screens at right
angles to the
outer wall on
which to display
paintings.

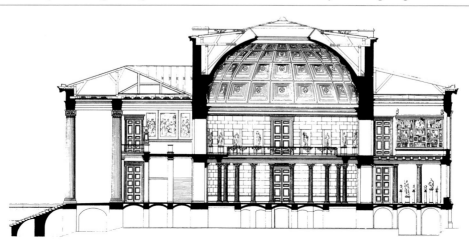

of the Altes Museum, for it ran counter to preferred museum practice. In England there was a clear and reasoned partiality for top-lighting, through clerestories, monitors or skylights. Thus Sidney Smith, referring in 1892 to his early design for the Tate, wrote, 'it is impossible to exhibit pictures properly in side-lit rooms and therefore the building is all lit from the top'.

During the heyday of historic revivals in the second half of the nineteenth century, some museum buildings turned polychromatic and were decked out with unclassical trappings, Neo-Gothic or castellated, but the preferred image remained classical in origin. Initially it was spare and archaeological, from the dignified Graeco-Roman Neo-Classicism of Smirke's British Museum (1823–47), its Ionic order based, like the Altes Museum, on the Erechtheum (although Smirke opted for the temple rather than the stoa as the model for his central façade) to the pure and noble Doric Revival of William Playfair's National Gallery of Scotland (1850) in Edinburgh, the 'Athens of the North'. This was followed by an approach combining ancient, Renaissance and Baroque motifs, manifested in the Walker Art Gallery in Liverpool (1874–7) and the Tate, but such eclecticism was subsequently rejected, as seen in the severe Roman grandeur of the National Gallery of Art in Washington, DC (1937–41) by John Russell Pope, Duveen's architect and designer of the Duveen sculpture hall (1933–7) at Millbank. Eclecticism finally returned, now with a Mannerist twist, as manifested in the Sainsbury Wing of the National Gallery (1992). Thus each age has its own interpretation of what Sir John Summerson has termed 'the classical language of architecture'.

The classical language was appropriate for as long as art museums were the elevated sanctuaries of accepted masterpieces: ancient fragments, coins, gems, ceramics, along with paintings and sculpture from the subsequent Christian, Enlightenment and early modern eras, and even, as occurred increasingly in the late nineteenth century, artefacts originating outside Western Europe, especially the Far East. When art ceased to be confined to statues on pedestals and pictures in frames, when the institution became more democratic and took on new didactic and promotional functions, and when art itself underwent revolutionary transformations, overturning all categorisation, especially that imposed by the museum itself, the type of container that had for two centuries signalled 'art museum' would appear in need of major alteration.

Museums of modern art

Initially most museums were reluctant to take responsibility for displaying contemporary art, although institutions such as the Musée des Artistes Vivants in Paris, founded under Louis XVI in 1816, did exist. England, otherwise so conservative where art was concerned, was a rather surprising exception, perhaps because the contents stemmed not from aristocratic collections but from purchases by self-made entrepreneurs. During the Victorian period, museums, especially those in the industrial North, were markedly hospitable to the artists of the day, following the example of the Sheepshanks Gallery in South Kensington (inaugurated in 1857), with its holdings of recent British pictures. The Tate, with Henry Tate's donation and the acquisition of the Chantrey Bequest, both of which included work by living artists, extended this practice. On the Continent it was easier to keep abreast of the latest trends at the salons run by various national and local academies (e.g. France's Ecole des Beaux Arts, Vienna's Kunstakademie), the popular international expositions (where the works were shown either in a separate Palais des Beaux Arts or side by side with commercial and industrial products in the main pavilions), the commercial galleries that began to flourish in the 1870s, or the displays organised by artists not admitted to, or satisfied with, such official venues. The Salon des Indépendants was established in Paris in 1884, the Salon d'Automne in 1903. In German-speaking lands the *Künstlervereine* became popular; these in turn spawned secession groups who had found the parent society too conservative – the *Weiner Sezession* even had its own *Jugendstil* building designed by J. M. Olbrich. Eventually there would be international exhibitions devoted exclusively to art – the biennales, the first held in Venice in 1895, and New York's Armory Show of 1913, come to mind. Although

Altes Museum: perspective, showing stoa-like façade.

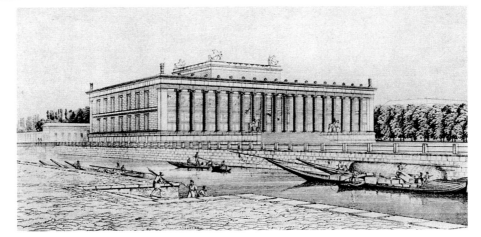

some intellectuals and artists – Gustave Flaubert, Paul Valéry, the Futurists, Kasimir Malevich, Le Corbusier, to mention only a few – scorned the very idea of the museum, denigrating it as a mausoleum enshrining dead artefacts and perniciously separating art from life, others recognised the service that the institution performed, and aspiring artists saw that acceptance into the marble halls inevitably conferred prestige, which also helped sales, and made available to the public the exciting, if occasionally baffling, artistic experiments of the time.

Eventually groups of individuals who wanted to support the art of their own era established a new type of museum, one dedicated to art that had not readily found popular or professional approval. One of the first was New York City's Museum of Modern Art (MoMA), founded in 1929 and dedicated to acquiring the best that was being made at the present, including media normally excluded from art museums. Reflecting beliefs about the integration of art and design fostered by movements such as De Stijl and Constructivism, periodicals such as Le Corbusier's *L'Esprit Nouveau*, and institutions such as the Bauhaus, MoMA's Department of Design collected not only industrial arts but elegantly made machines; gradually photographs, then films and finally video and computer-generated art were incorporated into the permanent collection. The various types of art displayed, so striking in their unorthodox materials and imagery, demanded a setting that was equally unconventional and detached from the past. When MoMA opened the doors to its new building on West 53rd in 1938, the received wisdom about museum design was radically altered.

The purpose-built structure by Edward D. Stone and Philip Goodwin was an example of the modernist architectural ideals, mostly formulated in Europe, that MoMA had promulgated in its 1932 exhibition introducing Americans to the International Style: asymmetry of composition for greater functional efficiency, volume rather than mass as a demonstration of new structural materials, and the avoidance of ornament and historical motifs, considered inappropriate to a machine age.

The container, once a temple or a palace, had become a simple box.

One of the most important tenets of International Style modernism, the 'universal space' – an interior free from bearing walls, making possible the ideal of infinite flexibility – was to have a profound impact on museum planning. First given expression in 1942 by Ludwig Mies van der Rohe in his 'Museum for a Small City', this concept became the norm for three decades and, in diverse permutations, dominated museum architecture for almost fifty years. Mies's version was perfected in the Neue Nationalgalerie (1962–8) in (West) Berlin, a glass pavilion contained by eight steel cruciform columns painted black which, two to a side, supported the 213 square-foot roof composed of girders welded to a continuous plate; there are no intermediary supports. The transparent walls of the main storey make it difficult to hang paintings and to manage natural light. The podium on which the pavilion sits provides a lower floor for the permanent collection. For the most part the gallery is artificially lit, as became common in museums constructed between 1950 and 1975, a step that facilitated control over illumination.

The Nationalgalerie exquisitely incarnates Mies's motto, '*beinahe Nichts*' ('almost nothing'), which, one might contend, should be the goal of all museum architecture in order that the art dominate; indeed, at the time, many critics argued that such mute box-like volumes of undifferentiated 'universal spaces' best suited the museum programme. But Mies's formula for the National Gallery in Berlin, first conceived in 1957 for the unexecuted Bacardi Office Building in Cuba, was unexpressive of any particular museological function. It could be – and was – employed with equal relish to classrooms, chapels and houses; discrete signage more than architectural form indicated the specific purpose of the building. Nevertheless Mies, a great admirer of Schinkel, was very aware of the rival structure, at that time in ruins, across the Berlin wall. One might see his design as the contemporary equivalent of the stoa, in steel and glass rather than stone and plastered brick, where a few metal columns support an entablature

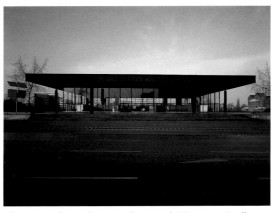

of unprecedented spans, thus exploiting practically and visually the structural and spatial power of new means and methods of construction.

The practical disadvantages of the glass box were corrected by making the container opaque, and restoring a degree of natural zenithal lighting to some of the spaces. Illustrating this trend are such buildings by Mies's acolyte, Philip Johnson, as the Munson-Williams-Proctor Institute in Utica, New York (1960), the Amon Carter Museum in Fort Worth, Texas (1962) and the Sheldon Memorial Art Gallery in Lincoln, Nebraska (1963). Most of the extensions, which were becoming ever more urgent as classical museums continued to grow, followed the paradigm of the top-lit, flexible open space within the windowless box; Richard Llewelyn-Davies's addition to the Tate (1969–79; see pp.45–8) and the wing by I.M. Pei for the Boston Museum of Fine Arts (1977–81) are but two examples. Occasionally the design might depart from the rectangular form to assume a more assertive shape on behalf of a particular site, as in Pei's marble-faced tetrahedrons for the East Wing of the National Gallery of Art in Washington, DC (1975–8). The apparent incongruity of such juxtapositions was purportedly mitigated by the employment of a stone matching that used in the original museum.

A different sort of universal space was moulded by Frank Lloyd Wright, who hated modernist 'boxes', in his inimitable commission for the Solomon Guggenheim Museum in New York City (1943–59). The interpenetrating cylinders and the spiral-girt interior rotunda had no immediate progeny, but today this venerated sculptural structure has been used to justify even more unorthodox and attention-grabbing museum buildings, including those for the galaxy of Guggenheim 'satellites'.

Louis I. Kahn, whose museums achieved almost mythical status, developed a new interpretation of the fluid interior. At the acclaimed Kimbell Museum in Fort Worth (1966–72), Kahn employed concrete rather than steel to achieve a structure as breathtaking in its horizontal spans as those by Mies in Berlin. He reintroduced symmetry and hierarchical order into the plan without jettisoning the ideal of flexibility. Concerns had developed about the amorphousness and lack of direction enountered in many museums based on the universal space doctrine; visitors were sometimes puzzled as to where and how to proceed, and traditional works of art often seemed swallowed up in the undefined spaces. Using partition walls on a measured grid, and vaults rather than endless flat ceilings, Kahn re-established the sense of distinctive galleries while maintaining freedom of circulation and options for recurrent reconfiguration according to curatorial needs. An equally important contribution was Kahn's return to the traditional understanding of the gifts and hazards of natural illumination and his exploration of the relationship between daylight and artificial light. The vaults of the galleries at the Kimbell Museum are perforated at the top to let the changing quality of Texas light enliven the atmosphere without endangering the works, which are carefully illuminated by electric light.

Thus Kahn reinvigorated the practice of mixing natural and artificial light sources. Significantly, this practice had already been tested in the Tate Gallery at Millbank, and would continue with increasing technical sophistication in all the later extensions there, as well as in St Ives. Moreover, the top storeys of Tate Liverpool and Tate Modern also enjoy the benefit of zenithal natural lighting. The lessons that James Stirling learned from Kahn in this regard shaped his design not only for the Clore Gallery at the Tate (1980–7) but for the Sackler Wing at Harvard University's Fogg Museum (1979–84) and for the Neue Staatsgalerie in Stuttgart

(1979–84; see pp.94–5). Yet before this time, another essential redefinition of the art museum, as both institution and architectural monument, would occur, at the Pompidou Centre in Paris (1971–7).

Although the transparent shell enclosing layers of open space had antecedents in both the nineteenth-century exposition building and the totally glazed structures of Mies, the Pompidou's height and industrial imagery – colourful tubes reminiscent of an oil refinery, escalators snaking up the outside in a futurist-expressionist way – and provocative indifference to its location in the historic Les Halles district, caused a sensation. The young laureates of the highly visible competition – Richard Rogers (British of Italian extraction) and the Italian Renzo Piano – delivered a blow to current conceptions of museum architecture. In part this was due to the novel conception of the institution: the Pompidou was not just a repository for twentieth-century art, but a mediathèque, a platform for theatrical, musical, political, acrobatic and cinematic performances, a hive of people in motion, looking for sensation as well as enlightenment. Its iconoclasm invited many who previously might have shunned museums as dead places not only to enter but to participate: the temple-like serenity and encouragement to contemplation of the ur-museum vanished in the frantic modern world, the visitor now bombarded by transient sensations and unexpected encounters.

Particularly shocking at first was the view of metal trusses and tubes – the bones and guts of the building. Boldly revealed inside and out are the skeleton of the structure and the housing of the services. Pipes and ducts, colour-coded to indicate the services they supply – plumbing, electricity, air intake and exhaust, services that increasingly are necessary to make buildings, especially museums, environmentally sound are celebrated here. So are the qualities of spontaneity, ephemerality and contingency, the antithesis of the deliberation and permanence typically exuded by museum buildings.

The upper floors given over to the galleries initially were left undefined to allow visitors maximum freedom of movement (later they were redesigned).

This was a heritage of the universal space ideal. There are no top-lit galleries at the Pompidou; areas adjacent to the glass walls fortuitously receive natural light (which is difficult to control), but in large part the light that bathes the works is artificial. The Pompidou's novel aspects brought unprecedented attention and attendance, and heightened the aspirations of museums everywhere to acquire instant recognition through the means of a striking building.

Museum architecture today

Contemporary art museum buildings are rarely self-effacing or anonymous. Deferential they may be – to the collections and the context – but the expectation remains that the design must signal to the public that this is a special place. Museums by Frank Gehry, Daniel Libeskind, Richard Meier, and, somewhat earlier, James Stirling, whose personal styles are instantly recognisable, confer immediate media attention on the institution. Nevertheless, there are the quieter works, conceived with equal intensity and perhaps enjoying more sustainable approval, by architects such as Rafael Moneo, and Herzog & de Meuron.

After the advent of the Pompidou Centre, there was no longer a governing image for museums, in contrast to their first century of existence. Post-Modernism, which restored allusions to and quotations from historical motifs, at first seemed perfectly suited to an institution that conserves and reveres artefacts from the past. Stirling's Clore Gallery and the Sainsbury Wing of the National Gallery by Venturi, Scott Brown and Associates are conspicuous examples of the more progressive side of this trend incorporating traditional references without entirely eschewing modernist spatial and structural tactics. However, before long every fashionable movement of the moment had produced its museum exemplar – High Tech, Deconstruction, Neo-Baroque, post-Miesian, computerised Blob design – and conformity to a given pattern became anathema. Uniqueness was all. This is nowhere more evident than in the decision by the Guggenheim Museum's director, Thomas Krens, to distinguish the galleries he is sowing over the globe by employing different architectural firms with highly personal styles.

To counter the tendency toward the grandiose and super-assertive monument, there appeared in the 1970s a phenomenon, at first tentative, that is strong today. This is the use of existing buildings as a means to avoid the tendency of the purpose-built structure to upstage its contents, and to refocus attention on the primary goal of the gallery – the showing of art. Another aim was to purge elitist connotations from the ritual of museum attendance by relocating its temples to places once occupied by workers. At one stroke this tactic emphasised art-making as productive labour connected to the real world of struggle and resistance – the studios of the artists whose work was most at home in such settings tended to be in loft buildings once used for manufacturing – and democratised the institution by making its cathedrals less intimidating.

One of the pioneering representatives of this practice, the Hallen für Neue Kunst in Schaffhausen, Switzerland, received scarcely more than a coat of paint and a pair of banners at the entrance when it opened as a gallery in 1984, and it still resembles nothing other than the disused textile mill it was. But most conversions have been more interventionist, in response to a perceived necessity to make some gesture to distinguish art galleries from everyday venues, while keeping them psychologically accessible. Usually some changes are required to make former industrial buildings environmentally responsible, but the degree of interference depends on the nature of the collection. The first occupants of these recycled structures typically were works of large scale and rugged materials, frequently huge sculptures associated with movements such as Minimalism and Arte Povera. For artists a major attraction was the opportunity to make work or installations that responded to the specific nature of the given space. When holdings conceived for more domestic or politely institutional situations also claimed entrance, architects were engaged to make more drastic changes and the metamorphoses became more sweeping. Nevertheless, such conversions do provide a more populist ambience than the purpose-built museum.

Both Tate industrial complexes occupy a privileged position by virtue of their aesthetic excellence. The Albert Dock, where James Stirling and Michael Wilford inserted Tate Liverpool with restraint and respect, rivals in the subtlety of its composition the putatively nobler public buildings of its time. The former Electric Power Station at Bankside gives its new owner, Tate Modern, an imposing, architect-designed structure that surpasses in scale and presence many of the most prestigious museum buildings of the day. Museums installed in former power stations, which are frequently located near the heart of a city and have been designed as public buildings of a kind, often strike a balance between the functional and the fine. Another example, the handsome stone and brick Neo-Romanesque Electricity Works in Malmö, Sweden, constructed in 1900, was transformed in 1988 into the Rooseum, the venue for the collection of contemporary art belonging to Fredrik Roos as well as for temporary exhibitions. Serendipitously the first director of Tate Modern, Lars Nittve, had been the first director of the Rooseum, and was prepared to appreciate the unexpected delights that come with the territory of such a hybrid structure.

Very little is routine about current museum design and even less is certain about the future configuration of art museums. What probably can be predicted is that they will continue to be erected and expanded in significant numbers, that major architects will compete to be involved, and that the architecture will undergo consistent transformation. The Tate galleries that have opened since 1988 provide critical examples of current trends, just as the first Tate Gallery, steadily evolving between 1897 and 2001, summarises the preoccupations of the times in which it was constructed and amended. Yet in their different ways, they all stand on one side of the great divide that since the 1980s has split consensus about the ideal museum building. One conception is the dramatically bold, where the architectural image takes precedence, the other the measured, where visually interesting design none the less respects the priority of the art it shelters – an attitude definitively embodied in the four Tates.

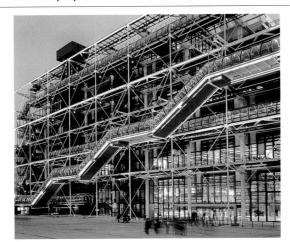

Paris: Centre Pompidou (1971–7), Richard Rogers and Renzo Piano.

Tate Britain

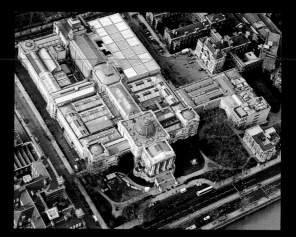

Above: Tate Britain
(1897–2001): aerial
photograph taken
in 1994.

Right: Tate Britain:
main façade from
the south, 2000.

The Tate Gallery at Millbank on the Thames, now
known as Tate Britain, opened in 1897. Additions in
1899, 1910, 1926, 1937, 1979, 1987 and 2001 make
it the most polymorphous of the Tate galleries, and
reveal a succession of attitudes towards style and
substance in museum building and management.
As one moves around the building in space, one also
travels in time, an exercise that potently illustrates
that museum buildings are subject to an ongoing
and inevitable process of alteration determined
both by architectural trends and by successive
directors, trustees, designers, curators,
conservators and government agencies, according
to the perceived needs dominant at any given time.
In recent years artists, through the kind of work they
produce, and museum-goers, through selective
attendance, also have made their influence felt.

The Gallery's location, separated from the
embankment by a thoroughfare, means that it is
approached from the side rather than head on,
and so is first revealed, as its architect intended,
in perspective from the west or the east. The view
is of an imposing expanse of Portland stone,
advancing and retreating, rising and falling, and
embellished with a cornucopia of classical motifs.
The most conspicuously modern feature is the glass
dome, reflecting light by day, emitting it at dusk.
Below the dome, atop the temple front, presides
a stone Britannia, carrying a copper trident and
attended by the figures of the lion and the unicorn,

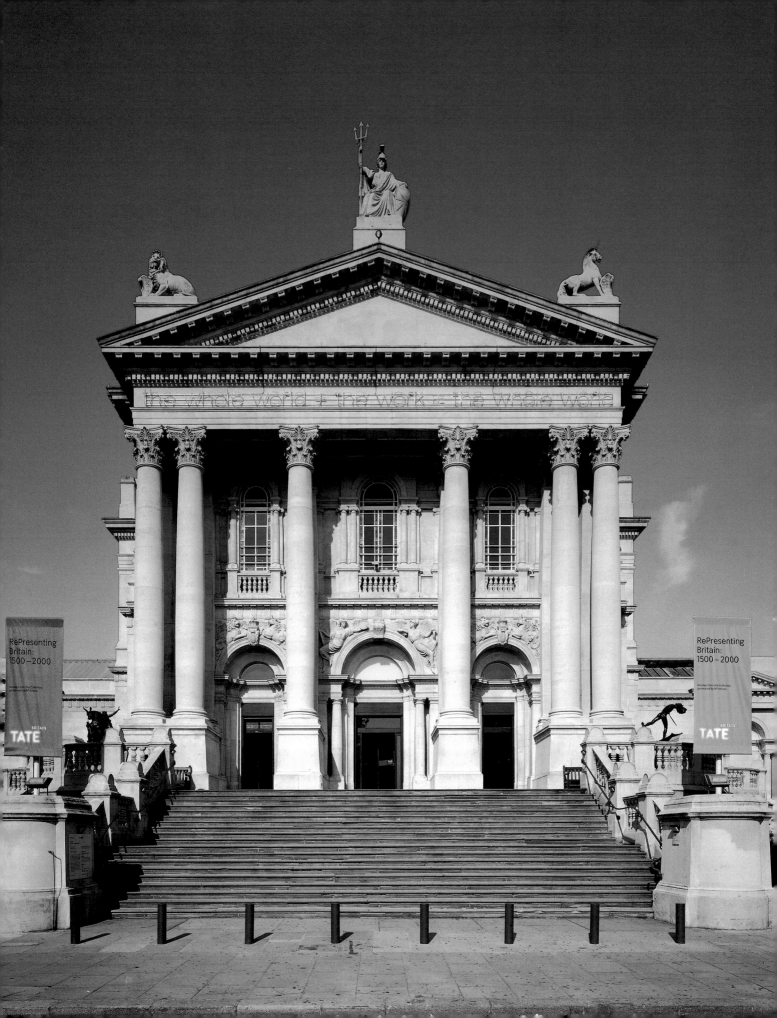

the whole world + the work = the whole world

rampant on pedestals at the right and left edge, respectively, of the pediment, reminders that this is the National Gallery of British Art.

A heavily rusticated basement punctuated by low arches supports the main mass of the building and an impressive flight of stairs leads to the entrance, high above street level. Eastward, and stepped back from the original building, is the lower, L-shaped wing of the Clore Gallery (1987), which offers independent access at ground level via a bright green revolving door inserted into a glass wall, which in turn is set within a slab of Portland stone. To either side of that entrance a gridded surface of ochre stucco and red brick ties the ensemble also to the bordering Edwardian Lodge, a blend of Queen Anne and Neo-Georgian features, which, as the Commandant's quarters, once formed part of the Queen Alexandra Military Hospital (QAMH) but today houses Tate offices. The west flank, along Atterbury Street, discloses successive additions to the north-west quadrant of the site, and since October 2001 has provided an alternative, lower level entrance. The blank walls above the basement – inevitably indicating the presence of a bank or an art gallery – envelop spaces that are top-lit, while craters in the masonry preserve the memory of war damage sustained in two air-raids in the autumn of 1940. Comparison of the articulation of the long wall as it stretches northward shows changing attitudes toward the manipulation of classical elements, from the busy pile-up at the 1897 corner pavilion to the simple grandeur of the 1910 addition, where a slight projection topped by a semicircular pediment indicates the beginning of the Turner wing; the north-west corner, added in 1926, is similarly spare and dignified. Further along on John Islip Street is the rear face of the gallery, where the 1979 extension, the Conservation tower, devoid of any ornamental detail, completes the north-east quarter. The unifying element is the facing in Portland stone, a medium-hard limestone that looks handsome whether carved with many details or left smooth and undecorated. These elevations are quite properly secondary to the main front, which represents a familiar and unforgettable image.

Above: View along Atterbury Street, showing the original building by Smith (1897) and additions of 1899 (Smith), 1910 and 1926 (Romaine-Walker).

Right: Tate Britain: view of main building from the east in 2003.

Tate Britain

National Gallery of British Art 1892–1910

When Sir Henry Tate, the Liverpool-born entrepreneur who made a fortune from refining sugar and selling it in cube form, decided in 1889 to offer his collection of 'modern' British pictures to the nation, he encountered preposterous difficulties. After the National Gallery declined to accept his pictures, Tate offered to pay for a separate structure, but he looked to the government to provide a site. It was the Treasury's responsibility to decide the fate of such benefactions and George J. Goschen, Chancellor during 1888–92, treated Tate's gesture with cavalier disregard. Locations in South Kensington, in Kensington Palace Gardens, behind the National Gallery and in the City between Temple and Sion College were discussed but for various reasons proved unfeasible or were withdrawn from consideration. When the powers in Whitehall and Westminster made little effort to find an area more suitable, Tate withdrew his offer, explaining in *The Times* (5 March 1892), 'I had not the slightest desire to build a gallery merely for my own collection but was quite prepared to erect a building so constructed, arranged and top-lit that it would in itself I believe have attracted gifts of high class pictures and sculptures and thus have become the permanent home of the best examples of British art.'

Then the idea was advanced that the land in Millbank where the huge penitentiary, built on Benthamite principles in 1813, stood glowering at the river would make an appropriate location for a gallery

London: site of former Millbank prison, with plan of Tate Gallery superimposed. The plan includes the first addition originally envisaged by Tate and Smith.

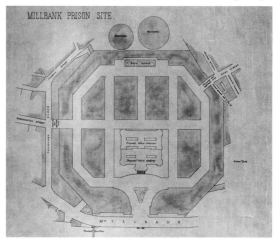

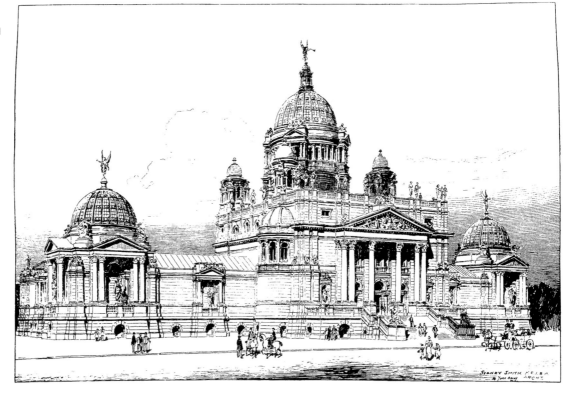

of British art (in 1867 John Ruskin had proposed the south bank, opposite the penitentiary, as a suitable site). When the old 'Peppercaster Prison' was scheduled for demolition, the proposal that a portion of its site be made available to the future gallery was facilitated by Sir William Harcourt, who on 17 August 1892 had replaced Goschen as Chancellor. Tate, satisfied with this solution, generously renewed his pledge, and his architect, who had been sketching proposals for the various discarded plots, at last had a definite place on which to project his grand schemes. On 21 July 1897 the National Gallery of British Art at Millbank was formally opened by the Prince of Wales, as a branch of the National Gallery.

Tate had met his architect, Sidney R.J. Smith, in connection with the South Lambeth (now Brixton) Library (1888), one of Tate's many philanthropic interests. Smith had made something of a speciality of designing local libraries, a genre that like the museum had the same requirement of well-lit spaces, and he would design several more for Tate. Clearly there developed a sympathetic understanding between patron and architect, and both had a preference for classical styles. In a letter to *The Times* of 8 March 1892, criticising Goschen's lack of enthusiasm, the architect had explained, 'Mr. Tate instructed me to spare no trouble in procuring a design which should have the best lit galleries obtainable, and …to this end, I visited many of the picture galleries on the continent and in the provinces.'

After various studies, the penultimate design was published in 1893. Although Smith had adopted as his central motif the familiar convention of a temple front, the total effect was more that of a cathedral, not necessarily a welcome association for a secular temple of art – it was not until the later twentieth century that art museums were dubbed the 'cathedrals of the modern age'. Nevertheless, the project was described

as 'if not a work of genius … certainly a work of talent in which utilitarian requirements have been skillfully handled and artistically realized' (M.H. Spielman, *Magazine of Art*, June 1893). But this version was subject to criticism from the Royal Academicians whose work would be on display; they were worried on practical grounds that the high domes would be disadvantageous to the lighting and might also have been concerned lest the container usurp attention from its contents. Edward Burne-Jones complained, 'Who wants his architectural features – damn his staircase – we want to see the pictures.' Sir William Harcourt also advised a more reticent and less pretentious design.

Smith toned down the grandiosity but the core of his project survived. The basic composition remained and although initially only half was executed, within two years the whole had been realised. Wisely he heeded suggestions to reduce the prominence of the domes, which had contributed to the unfortunate

Plan showing original Gallery of British Art, 1897, the addition of 1899, and the Turner wing of 1910. Note the first floor with vaulted galleries overlooking the rotunda.

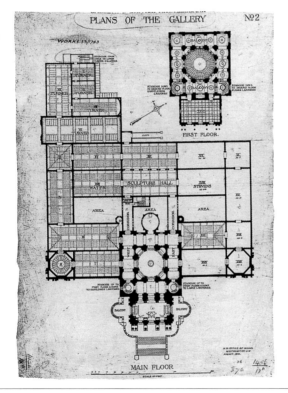

religious effect. For the rest, Smith continued to speak 'the classical language of architecture'. As he proudly acknowledged, he had studied other museums and these almost invariably would have been classical in style; indeed in the *Builder* (19 March 1892) Smith had stated in no uncertain terms that 'the only suitable style is classic; refined moldings with Greek feeling and ornament, sparingly introduced, are the chief study to get a good sky outline'. He was also determined to surpass the National Gallery (1834–8). Smith consistently compared the generous measurements and well-lit galleries of his proposed building to its much maligned predecessor, noting that 'the dome rises 100 rather than 62 feet from the ground', and that the size and shape of the galleries ensured a much better hang than was possible at Trafalgar Square.

In keeping with Edwardian taste, the Tate at Millbank is more lavishly decorated and sculpturally extravagant than English Neo-Classical predecessors. After seeing it under construction in 1895, visitors from the Architectural Association, who also examined the drawings, described Smith's design as a 'free treatment of the Italian Renaissance inspired by Greek motives [sic]'. A more sophisticated analysis would have emphasised the 'free', pointed out more affinities with both contemporary and earlier English buildings than with the 'Italian Renaissance', and queried the authenticity of the 'Greek motives'. A few of the details may have been derived from Somerset House (Sir William Chambers, 1776–86, extended in 1830 by Sir Robert Smirke, in the 1850s by Sir James Pennethorne), a source admired by a number of Edwardian architects and located immediately east of Smith's offices. Iconographically Chambers's masterwork was an appropriate model, for it was located on the north bank of the Thames and at one time had served as the headquarters of the Royal Academy. The pitted masonry and vigorous rustication of the base of the Tate, the ground-hugging arches springing directly from the heavy stones of the first course, and the motif of doubled columns supporting curved vaults, may echo Somerset House, but the latter was informed by a scholarly and theoretical acumen alien to Smith's sensibility and experience.

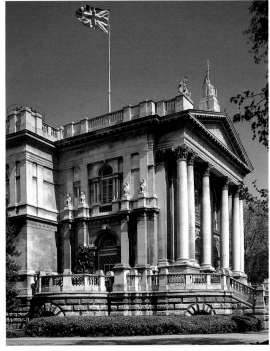

The Edwardian architect, who had to master new technological and typological challenges, rarely deemed it necessary to acquire the archaeological knowledge possessed by the previous generations of classicising architects. By Smith's day it was sufficient to peruse architectural history books, emulate features of the newly popular English Baroque, and examine contemporary buildings for stylistic hints. Although there were purists who found the proportions ponderous, the details coarse and the combination of motifs ludicrous, the executed Tate Gallery was deemed by many contemporaries to be unusually handsome and monumental for such a building type on British soil. When it opened in 1897, Smith's *magnum opus* was described in the *Pall Mall Gazette* as 'a work of art … a creation that will rank as one of the important buildings of the world'.

After this brief honeymoon Smith's contribution was consistently denigrated, but the recent architectural climate may make viewers newly susceptible to its roguish charms, just as the solecisms of the Clore Gallery have their champions.

The influential theories of the American Robert Venturi, who approved 'complexity and contradiction', both/and (versus either/or), and Mannerism in architecture, and who quipped – in reaction to Mies van der Rohe's aphorism that 'less is more' – 'less is a bore', seem tailor-made to engender appreciation for the ensemble at Millbank.

The composition was the time-honoured one of temple front flanked by recessed arms and projecting end pavilions. Smith chose the tallest and most elaborate of the orders for his portico, elevating the Corinthian columns, doubled at the corners, even further by placing them on pedestals. The unfenestrated walls of the corner aedicules have details mimicking the temple front. Smith's treatment of the classical language is Baroque, a way of composing that encourages the use of multiple motifs when one or two would do. Mouldings proliferate, pilasters reinforce columns, arcades are tripled. Few areas lack embellishment: sphinxes crouch on plinths atop the Tuscan Doric pilasters; winged lions, whose haunches form scrolls, guard the portico. Lions and unicorns occupy the spandrels above the outer portals, winged victories, as found on triumphal arches, those of the central one. Everywhere bas-relief enhances the effects of light and shadow, creating a rich tapestry of advancing and receding planes.

The portico extends much more aggressively from the body of the gallery than is usual in museum buildings; indeed, it was a more reticent feature in Smith's earlier designs. The alteration may have been a response to the location on the river, as above the vestibule lies a boardroom overlooking the Thames (which later in the institution's history would serve as the director's office). The portico provides a deep ceremonial vestibule within, which prepares the viewer for the avalanche of Portland stone columns, pilasters, entablatures that must be encountered before entering the museum proper.

The vestibule leads to the central hall, crowned with the glass dome and resembling a rotunda encircled by niches. The greyish stone against white painted surfaces enlivens the monochromatic palette of the rotunda with a variety of tones. A circular

1897

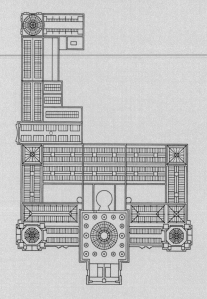

1926

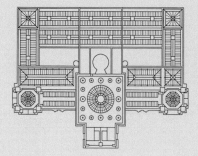

1899

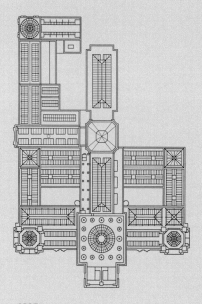

1937

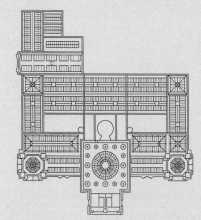

1910

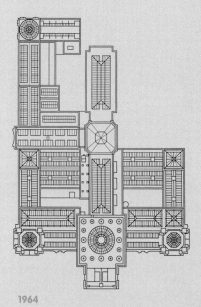

1964

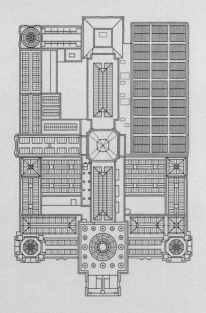

1979

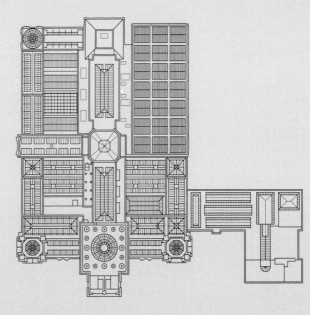

2001

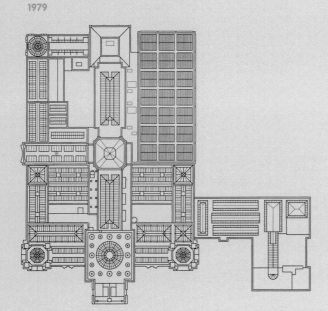

1987

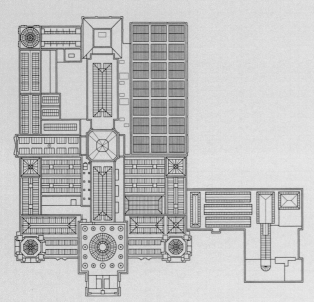

1990

For interior finishes and colours Smith had advice from such experts as the painter Sir Edward Poynter, director of the National Gallery, and Walter Armstrong, future director of the National Gallery of Ireland. The floors were polished oak, with wooden grilles down the centre for the heating. The walls in the galleries were covered with a new product, Tynecastle Tapestry, moulded canvas that resembled embossed fabric, here in a deep purplish hue. The two octagonal cabinets, which contained George Frederic Watts's gift of his own works, had plain walls painted in a dark red of the artist's choosing, and terrazzo pavements.

For all its stylistic pretensions, the first Tate Gallery was up to date in its practical provisions. The lower storey housed the heating apparatus, storage spaces and rooms for receiving and caring for works of art, as well as dining facilities for staff. The building was fireproof, 'warmed and ventilated on the most advanced scientific principles', according to Smith himself. It was wired for electric lighting, a relatively new means of artificial illumination that in the 1880s began to rival, and eventually replace, gas lighting, but fears that it might prove a fire hazard delayed its use at the Tate for several years, leaving the sun as the sole light source. Thus conditions for viewing were not optimal on grey days and in early twilights until electric light was implemented a few years after the opening. Zenithal natural lighting, which until the 1940s remained *de rigeur* for the majority of art museums, has continued to be a requirement for all subsequent additions and alterations.

balcony overlooks the court, offering a vantage point from which to observe the spectators below. Sequences of round and elliptically vaulted compartments, some with glazed domes, create the effect of an elaborate ambulatory.

To either side of the central hall ran the seven exhibition spaces that were the main destination. The first tier consisted of two longitudinal picture galleries, each leading to an octagonal cabinet covered by a shallow, glazed dome. A second row of galleries ran immediately behind the first, the right-hand side subdivided unequally to create two rooms, one of which was almost square and intended for small works on paper. By turning left at the central hall and then proceeding through the galleries in a clockwise direction, it was possible to perform a full circuit before returning to the rotunda from the right. As in most museums of the time, the route was prescribed, but in 1897 the hang was not didactically arranged in terms of schools or styles, as was customary, but according to the collections from which the pictures had been drawn.

Initially, concern about the location had been voiced, not solely by pundits but by members of the public who wrote to newspapers questioning the wisdom of putting a gallery in such an isolated place. Nevertheless Tate and Smith were content because the plot was so spacious and as yet unencumbered, unlike the cramped site of the National Gallery. Sir Charles Holroyd, the first keeper, wrote in 1905 that Millbank had been 'terra incognita to all but a few Londoners. The stretch between Lambeth and Vauxhall Bridges was seldom used by others than those who had business at the barge wharves or in the full dirty backstreets of Westminster. Since the gallery

Vestibule. Note multiple Ionic colums and black-and-white tiled floor. View c.1910.

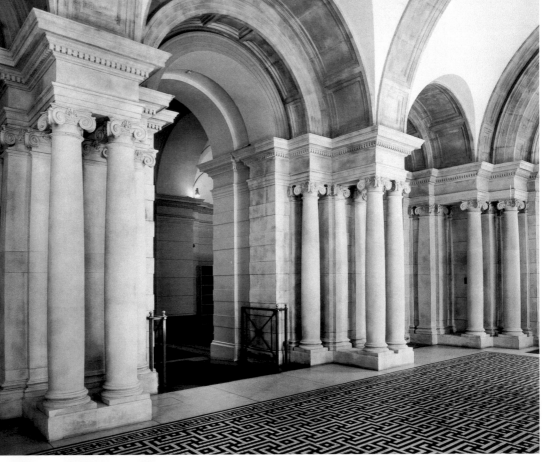

Rotunda with goldfish pool. View c.1900.

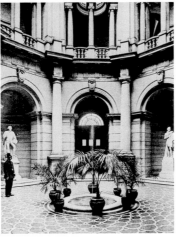

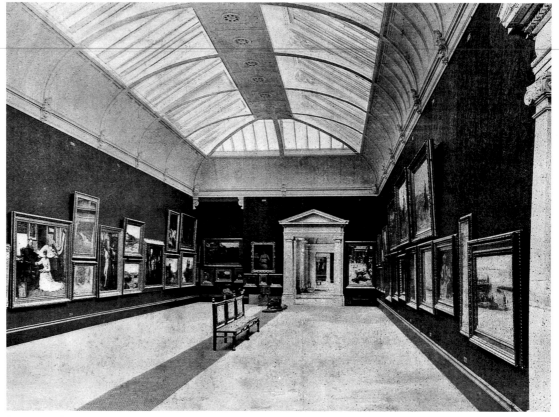

has opened however, this curious byway of London has become one of the most frequented by visitors to the metropolis.' Aiding accessibility was the new Vauxhall Bridge, completed less than a decade after the Tate opened.

As Brandon Taylor has shown in his masterly deconstruction of the motives that brought the Tate into being, the incongruency between a place of forced incarceration of unwilling criminals, and premises where works of art were held for the voluntary enjoyment of the cognoscenti, was exploited by several commentators, who suggested that improvement, not punishment, was now the agenda. As had been true throughout most of the nineteenth century, public institutions of cultivation and learning were regarded as antidotes to revolution – not just the middle but the working classes were thought to be pacified as well as educated by access to the cultural capital represented by libraries and museums. Although the Tate with its lofty façade might at first appear intimidating, evidently it did not lack proletarian visitors. Here one could enjoy popular narrative pictures and feel patriotic pride in a collection that celebrated British over foreign art. The opulent palace that housed the collection was freely available to the people of London, and there were other attractions: besides gazing at art, one could enjoy the fountain, installed in the central hall and supplied with goldfish, or indulge voyeuristic pleasure in people-watching.

Today it is difficult to envisage the dominant presence that Smith's building originally projected. Subsequent construction, especially the 32-storey Vickers (now Millbank) Tower built in 1963, has obscured its silhouette and diminished its commanding scale. The emptiness of the site that

Tate Britain

Smith had so appreciated was short-lived. Soon after the Tate's opening, there would arise across Bulinga Street, at that time the eastern boundary of the Tate's property, the brick and stone 'Wrenaissance' buildings of the QAMH, and, across Atterbury Street, the similarly styled but larger buildings for the Royal Army Medical College together with a cluster of barracks. The London County Council acquired a generous site to the rear on which to erect artisan dwellings, which were completed in 1903. The handsome five-storey blocks, designed in a simplified Queen Anne vernacular, were pointedly named after prominent eighteenth- and nineteenth-century English artists.

Within two years, the Tate Gallery's popularity led to the need for larger quarters. At the opening in 1897, Tate had declared his readiness to fund an extension or, perhaps more correctly stated, to complete the larger scheme that originally had been intended; regrettably he did not live to see its realisation. Smith had the design ready to hand, which more than doubled the exhibition space, surpassing that of the National Gallery. Because the mainly rhetorical parts

of the building – the vestibule, the central rotunda – did not require repetition, the new areas on the main level exclusively benefited display, while the basement contained offices, a studio, and a refreshment room. The Tate had wisely engaged a caterer to serve light meals and snacks to visitors who, because of the remote location, had nowhere to dine.

Eight picture galleries were added, along with a double-width sculpture gallery, described as 'Pompeian in feeling, divided by massive stone columns of the Doric order'. That would disappear when the Duveen sculpture hall was built. Before his death Tate had pointed out the importance of including sculpture, which the gallery was gradually acquiring. The overall composition now came into conformity with the standard nineteenth-century museum plan, with two courts situated between the earlier and the newer galleries. The symmetrical circulation route was slightly more complex, in that some doubling back was required. Two square galleries at the rear balanced the octagonal ones in the front.

Smith replicated the lighting and proportions of his earlier galleries. Springing from the cove that curves upward from the walls are elliptical iron beams, which support slanting skylights directing the light onto the walls. The beams meet in a dropped soffit, containing the electrical wiring, which blocks daylight from the centre of the room, a measure that prevents visitors from seeing themselves reflected in the glass which invariably protected the paintings. The design makes for a rather intricate ceiling, but it worked well to admit light and, through the blinds that were soon added, control it.

Both the older and new rooms have the same detailing. The doorframes have unusual Ionic capitals, flattened versions of the very sculptural ones found in the vestibule. The volutes turn noticeably downward like those uniquely found in the interior of the Temple of Apollo at Bassae, excavated in 1811 by Cockerell, and used by him at the Ashmolean Museum. Smith, who had studied the Oxford structure, admired Cockerell's paraphrase of the Ionic and employed it on other buildings designed in the 1890s.

The compositional completeness, symmetry and stylistic consistency of Smith's building were not to endure for long. In 1910 yet another addition was opened, introducing a lop-sided emphasis on the north-west quadrant that would remain for seventy years. The fact that no one seems to have minded or even commented on this suggests either that the museum container was in these years a matter of some indifference, or that it was generally accepted that successful museums were subject to continued growth and that extensions could not always retain symmetry. After all, the National Gallery was subject to several awkward alterations hidden at the back, and the Edward VII addition to the British Museum similarly disturbed the original balance.

The new wing was prompted by the clamour to make publicly available more of Turner's work; much of his vast bequest was scattered and hidden away. The National Gallery had been induced to relinquish some of its holdings, and demands mounted for a modest addition to the Tate to honour the man considered to be Britain's premier painter. Again, a dispute with the government loomed. It made perfect sense for the proposed Turner rooms to be erected on the vacant land remaining behind the Tate Gallery, but the Treasury had wanted it for a stationery office. Mr L.V. Harcourt, First Commissioner of Works (and son of the Chancellor who first secured the Millbank site) recognised the priority of the Tate's claim. A donor to pay for the construction appeared: Joseph Joel Duveen, a dealer in furniture and the fine and decorative arts who, like Tate, did not confine his generosity to funding architectural improvements but gave works of art as well.

Although Smith was still in practice, he was not considered for the job. Duveen had his own architect, W.H. Romaine-Walker. D.S. McColl, Keeper during 1906–11, was especially pleased with the choice because he found Smith's building overly ornate. Romaine-Walker, four years older than Smith, anticipated in his work at the Tate the taste for simplicity that would succeed Edwardian opulence. The reviewer for the *Morning Post* (19 July 1910) opined that Romaine-Walker 'has managed cleverly to make

Tate Britain

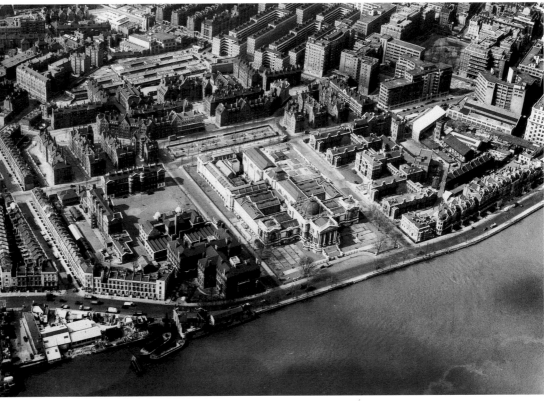

the addition harmonise with the existing hideous edifice while preserving externally a purer style of architecture. For this we cannot be too grateful.' A comparison of the two pavilions on Atterbury Street gives a lesson in alternative interpretations of classicism – the Baroque and the 'purer style' – and shows that the latter meant no diminution of grandeur, in fact quite the reverse. The pavilion that marks the start of the Turner wing in what is today roughly the centre of the western side is spare and dignified, just a large simple aedicule to acknowledge its busy neighbour to the south. The chief embellishment is the pediment that concludes the projection at the top, but it is semi-circular, and supported by Ionic pilasters rather than the catalogue of orders employed by Smith. It also announces at architectural scale the motif that Romaine-Walker develops for the doorways in the first Turner room, and signals that its major axis runs crosswise to that of the main building.

The initial room of the new wing is breathtaking, exceeding in height and length all the earlier galleries. In contrast to the complicated ceiling profile of the earlier galleries, the vaults are now fully semicircular and run continuously from one side to the other. Moreover, by eliminating the cove that marked the transition from wall to skylight in Smith's rooms, Romaine-Walker has created a smooth sweep from cornice to cornice. The rosettes at the base and apex of the vault, between which run the curving glass top-lights, are in keeping with the room's monumental scale. The two grand doorways are placed off-centre to continue the axes of the north–south line-up of Smith's rooms. The strategy also gives a long unbroken surface for the hang. Instead of painted wood for the doorways and skirting boards, green *verde antica* marble is used; with the original red brocaded walls, it made a stunning backdrop for Turner's paintings.

North of this gallery run four unequally

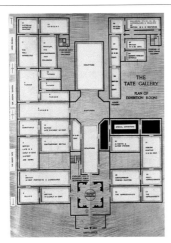

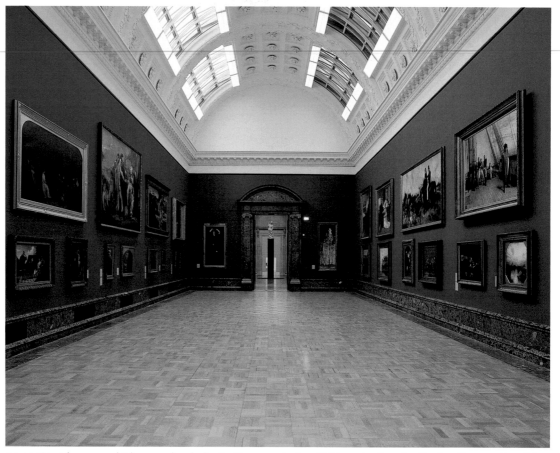

proportioned rooms, which were also dedicated to Turner. The doorways in the smaller galleries are topped with flat lintels rather than semi-circular pediments, but all have the unusual Ionic capitals of Bassae – or Cockerell – that Smith introduced in his interiors. In the basement, originally intended for offices, a series of small display spaces were fitted out for works on paper, a suitable decision given the much lower light levels there.

The Times pronounced Romaine-Walker's contribution a success, 'both splendid in itself and perfect for its purpose. Neither money nor architectural skill have been spared to make the Turner wing as complete as possible.' Unfortunately, Sir Joseph Duveen (who had been honoured in 1908 for his largesse) died before his benefaction was ready,

just as Sir Henry had expired before the opening of the first extension. But Duveen's son, another Joseph, the future Lord Duveen of Millbank, knighted in 1919, made Baronet in 1927 and Baron in 1933, saw it through and paid for some modest changes, such as inserting a north stair to facilitate circulation between the basement and main-floor rooms in the Turner wing.

Although the National Collection of British Art was closed from 1917 to 1921, the war years brought decisions of vital importance to the future physical as well as administrative shape of the Tate. A committee chaired by Lord Curzon, investigating the complex inter-relationships between the national collections, concluded that Millbank should be designated the prime venue for the comprehensive collection of British pictures, and a separate board of trustees was

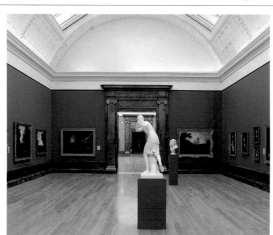

appointed. There was also growing sentiment on the part of many connected with the Tate that it should acquire and show modern foreign, especially French, art, an idea that was greeted with suspicion by some trustees, Royal Academicians and government officials, who doubted the validity of works that departed from British canons. Still, the possibility became more and more likely that the Tate, which already had shown some foreign pictures on loan from the National Gallery, would have a new remit. Thanks to bequests and to benefactors like Samuel Courtauld, foreign art of a kind not represented elsewhere in public collections was entering the gallery.

When it reopened in 1921, the Tate had yet another official name – the National Gallery, Millbank – and some refurbishments, among which were unpatterned wall-hangings in lighter colours for the galleries. In 1923 the octagonal cabinet to the west received a new mosaic floor to replace the one damaged in a Zeppelin raid (the original can still be appreciated in the matching cabinet to the east, now a part of the bookshop). This was a work of art *in situ* by Boris Anrep, a member of the Bloomsbury group who would also execute mosaic floors in the National Gallery. Paid for by private donors, the composition nicely complements the shape of the room. It surrounds the octagonal metal grill that replicates the covering over the sloping skylight. The tesserae are of the muted Omega Workshop colours – terracottas, ochres, grey-greens and black – and depict scenes and aphorisms from William Blake's *The Marriage of Heaven and Hell*, Blake, with Turner, being considered one of the heroes of British art. Human, animal and mythological figures occupy the eight fields, joined by an inner and outer border that corresponds to the shape of the gallery.

In 1926, thanks to another of Duveen's initiatives, the unprepossessing refreshment room began to be transformed by the murals of the young Rex Whistler. That same year saw the conclusion of the next major architectural campaign: in order to make more space for the acquisition of modern foreign art, another new wing was added through the benefaction of Lord Duveen.

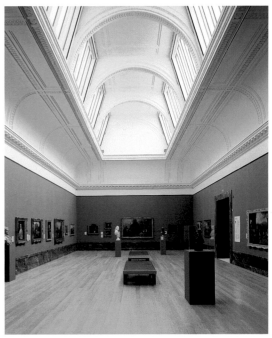

Four galleries, one for the work of John Singer Sargent and three for modern foreign art, were seamlessly joined to the Turner wing, running to the boundary of John Islip Street and effectively filling in the north-west quarter of the site. The two to the west continued an enfilade that ran from the first gallery of 1897 to the rear of the building. On the exterior, Romaine-Walker continued the manner he had adopted for the earlier Duveen extension: blank walls above the basement windows, the corner concluded with Ionic pilasters. Inside, the door frames repeat those in the Turner wing, though the ceilings of the galleries were given another treatment: a deep cove above the cornice leads to a stilted profile where the glazed openings act like clerestories, felt to be an advance on ordinary skylights. The decor and the details differed little from what had been the norm since 1897, except that the new galleries were more lavish. Displays were now arranged chronologically and served to demonstrate national characteristics.

The last addition before a forty-year gap was also funded by Lord Duveen. In 1927, straight after completion of the 'Modern Foreign Galleries', he had

Tate Britain

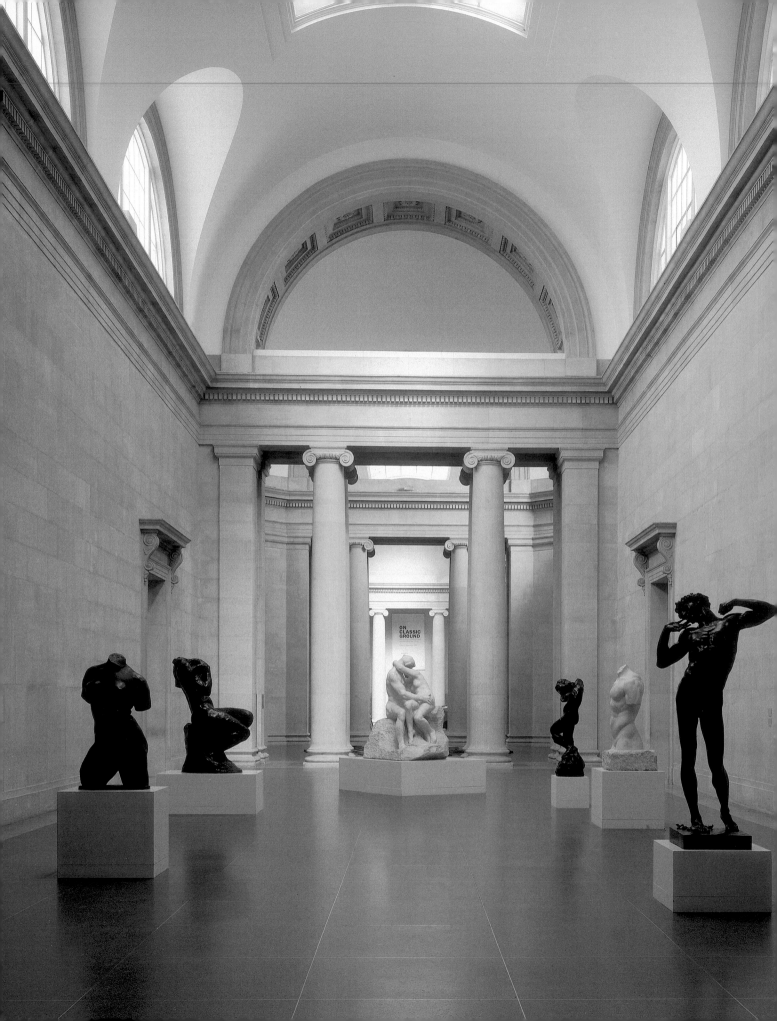

offered to build a gallery for modern sculpture, but the trustees requested instead that he provide offices and storage. Duveen declined, determined to hold out for a prestigious project that he considered worth both his own involvement and that of the internationally recognised architect he wished to engage: the American John Russell Pope, the first truly eminent architect to design for the Tate Gallery at Millbank.

Duveen had been acquainted with Pope since 1920, and proposed that he bring his talents to England (in 1937 Pope would design the Elgin Marbles Wing at the British Museum, also a gift from Duveen, realised in collaboration with Romaine-Walker). In 1933 the Tate trustees approved Duveen's proposal and Pope's design, and when the Sculpture Hall opened in 1937 King George VI declared it 'the greatest sculpture gallery in the world'. Others have found its huge dimensions unnecessary as well as intimidating. It is true that the Tate was not at the time endowed with the appropriate works to justify the gallery's majestic proportions. Nevertheless, whether the client was inordinately prescient or the architect indifferent to all but his own desire for Roman monumentality, the Duveen sculpture gallery has proved extremely hospitable in its vastness and lack of ornament to the type of sculpture that began to develop in the 1960s.

Construction entailed the demolition of the sculpture gallery of Smith's extension in order to create a grand axis that runs north from the central entrance hall almost to the edge of the site (now terminated by the conservation studio of the 1979 extension). The new interior is scarcely perceptible from the outside, except for the semi-circular thermal windows that rise above Romaine-Walker's earlier additions. Within, these windows function as clerestories to bring in daylight from the side, while the vaults that crown the gallery to either side of the octagon contain skylights.

Understandably, Pope focused his efforts on the interior, its severity striking in contrast to the entrance hall and the picture galleries, its pristine coolness making even Romaine-Walker's rooms look elaborate. In lieu of ornamental detail, Pope concentrated on the refined handling of the materials. The greyish golden stone that clads the walls varies subtly in tone.

The lowest layer is vertical, forming a two-dimensional dado; above, the slabs, set with a minimum of mortar, are arranged horizontally. The strikingly beautiful pavements extend back into the original gallery. The floors of the rotunda and its immediate surrounding were given the same treatment of multi-toned green and brownish marbled terrazzo and red and beige marble as the central space in the Duveen. The joints between the terrazzo pieces are bronze and the floor patterns echo the vaulting above in both the rotunda and the new octagon.

The Duveen sculpture hall was open for just two years before the outbreak of war, when the Tate, along with other London museums, removed the collection to safety away from the capital. When in 1940 the building was damaged in two air raids, its personnel dispersed, except for the heroic director, John Rothenstein, who for a period during the war lived in a flat in the basement. The gallery would not reopen fully until February 1949, although six rooms went on view in 1947, the year of its jubilee.

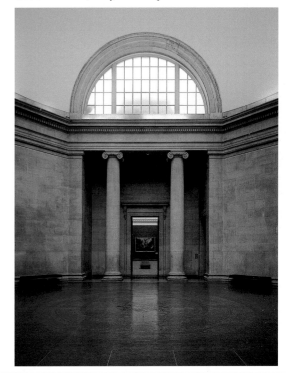

Duveen sculpture
hall, octagon
rotunda, looking
west. Note
terrazzo floor with
bronze seams.

Tate Britain

For thirty years after the war, the Tate had to cope with growing pressures on the existing fabric. Not only did its own collection quadruple in size and its audience increase threefold, but inevitable operational changes had a further impact. Temporary exhibitions accounted for an increasingly significant part of the Tate's activities. These exciting and audience-distracting events took display space away from the permanent collection, and so many of the holdings were in storage that the press compared the Tate to an iceberg. Although during this time galleries were refurbished, some rooms given new purposes and, in 1955, lighting and ventilation improved by the Ministry of Works (at that time responsible for the care of the building), the pleas on the part of trustees and staff that these measures were insufficient and that an extension was urgently required grew ever more insistent. The statement issued by the trustees in 1979 looking back at that period, summarised the situation:

'the Gallery, which began as hardly more than a set of rooms for the display and storage of paintings and sculptures, had become a complex of studios, offices, library, lecture rooms, catering facilities, archives, workshops, temporary exhibition galleries, packing rooms, photographic studios, shop and Publications Department. All of these compete with the ever-increasing needs for gallery space … and storage space where works in reserve can be seen by visitors.'

However, 'homes before statues' was the government's policy and it was not until 1963 that any positive action was taken. Even when plans for an extension were published in 1965, it would be fourteen years before they were realised. Other measures had to be taken to respond to the Tate's dynamic agenda and to the radically changing nature of twentieth-century art.

The Tate, which began its collecting of modern art on a conservative footing, would not be faced with a serious problem of juxtapositions between works until it exhibited avant-garde and contemporary art. At first, details such as dados and cornices were concealed or disguised, panels introduced to subdivide existing rooms, and velaria suspended from skylights to lower ceiling heights. The architecture was compromised

without necessarily improving the display space. But one strategy that received critical approval was the employment of architects to design the temporary exhibition installations. From 1966 on, Michael Brawne created many such displays with subtlety and restraint, but some architects erected ephemeral mini-museums within the building.

In 1964 there was wide praise for Peter and Alison Smithson's designs for the major exhibition 'Painting and Sculpture of a Decade, 1954–64'. The *Guardian* (21 April 1964) commended their creation of 'a continuum of matte white walls [that] meanders through all the galleries, annihilating the existing architecture, even in the great Sculpture Hall'. John Russell wrote, 'the Smithsons are committed to using the Tate building merely as protection against the weather and to set down within it a Museum of Modern Art to be stocked by the curators'. Nigel Gosling observed that 'the first thing that strikes you on entering is that London has acquired a fine new gallery. In place of large, chilling saloons, there are intimate bays and passages leading into one another without gimmick or ostentation' (*Observer*, 26 April 1964).

In 1971 Neave Brown was similarly commissioned to design the frame for two exhibitions in the Sculpture Hall: one featured Léger and Purist Paris, the other, held in 1973, the contemporary artist Robyn Denny. Brown's comments (*Studio International*, May/June 1975) on his intervention are representative of the prevailing attitude toward what he calls

'the mausoleum-like body of the Tate Gallery':
'Every exhibition has unique requirements. In an attempt to make unpromising space suitable, the central area of the ceiling was lowered with a lighting grid and the walls lined to obliterate detail. However it remains intractably long, thin and symmetrical and the old vault glowers ominously down through the grid … Such is the nature of the Tate Gallery that the original quality of space must be totally obliterated.'

At the time these words were written, the fifth extension was still unfinished, and the danger of 'obliteration' had already been faced.

An agreement finally had been concluded in 1957 with the Ministry of Works that a detailed expansion plan would be drafted for what was now called 'the final fourth quarter', the assumption being that the new wing would fill out the vacant spot in the north-east quadrant. The Ministry also indicated that it was prepared to consider a building different in style from the existing one, a solution urged by the trustees.

In 1963 Richard Llewelyn-Davies of Llewelyn-Davies, Weeks and Forrestier-Walker, was invited by the Minister of Public Buildings (succeeding the Ministry of Works), with the hearty approval of the trustees (who, evidently, had Llewelyn-Davies in mind as early as 1961), to prepare a feasibility study. The partnership had no preceding – nor succeeding – experience with art galleries but had specialised in hospital design, housing, and urban planning (which would have recommended it to a post-war government). The left-wing Llewelyn-Davies, appointed Professor of Architecture at London University in 1960 (and in 1963 made life peer, the first architect to be thus honoured) preferably occupied himself with research and had a scientific bent vis-à-vis architecture. He was first and foremost a functionalist whose approach may be deduced from his own statement:
'My work is based on belief in the power of human reason. Creative Design must be based on real depth of understanding. The architect must understand the purpose of his building in a very broad sense, which includes understanding a lot about the society and culture within which he works. I also believe that his

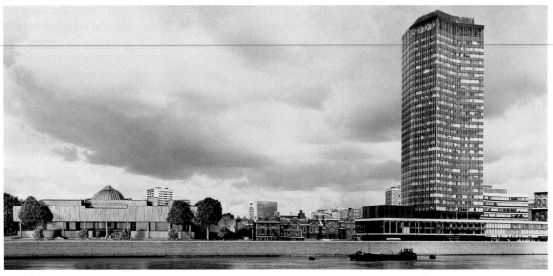

technical understanding of the means of building needs to be very complete. Only when he has mastered a design problem in all of its rational aspects can he be comfortable … I do not think there is a great deal of difference between the creative act of the designer and the scientist.'

The partnership's two previous London buildings – offices for *The Times* (1960–4), and the new Stock Exchange (1964) – were a departure from their specialty and had been executed in collaboration with other architectural practices, who recognised the firm's skill in packing the maximum amount of usable space into the minimum allowed volume, ensuring that there was no wastage. The Stock Exchange is an example of what came to be called the New Brutalism, a term coined by the Smithsons and the critic Reyner Banham to convey a complex set of architectural propositions but one that eventually was used to signify all the unsightly and aggressive concrete buildings which disfigured London in the 1960s and 1970s. The stripped-down nature of his Tate design, ready in 1965 and based on 'rational' considerations, was perfectly in accord with prevailing taste.

The feasibility study and accompanying designs would produce a heady reaction. Llewelyn-Davies had concluded that instead of locating the addition in the proposed north-east quadrant, it should instead be placed in the front, masking the old building and leaving the north-east corner free for a car park. The trustees were very open to such an unexpectedly radical proposal. In the Gallery's *Biennial Report 1964–5* they described the original frontage as 'undistinguished' and added defensively,

'we are attached to it due as much to site as to design. The old façade is rather like the massive frames of the period. It pays impressive tribute to art, yet eventually becomes a burden to it. It is hardly more considerable in its own right. In fact the fulsome entasis of the columns and the coarse detail that surrounds them betray a certain falseness; they blunt the very sense that the gallery exists to sharpen. The sentiment that is felt for the place and its purpose deserves something better. It can hardly weigh against the urgent needs of the Gallery's work.'

Llewelyn-Davies had prepared a scheme that would result in the destruction of the original stairs and façade. A featureless box on stilts, it would project to the roadway and contain a restaurant, a lecture hall and new galleries mainly for temporary exhibitions. Even by the standards of the day, the scheme, stretched across the entire frontage, is extreme in the indifference to what lay behind. The row of simple pillars that supports the upper level is flush with its outer surface; the recessed lower storeys form a

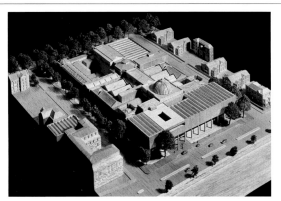

quasi-loggia to shelter the main entrance, now placed asymmetrically, according to modernist shibboleths. Above the entrance is a trio of windows in one variant, a horizontal band in the other, the only interruptions in the taut plane of the upper wall. The one traditional aspect of the proposal is that the galleries were to be top-lit, not so obvious a solution at a time when most new museums and extensions had as far as possible eliminated daylight in display spaces. The trustees had insisted on the preservation of this feature.

Llewelyn-Davies's initial schemes found wide official and critical support, accompanied by a torrent of merciless condemnations of the old building. Models making the proposed variants vivid for lay viewers went on display at the Tate in July 1969. Although neither the Fine Arts Commission nor the Westminster City Council had objected to the

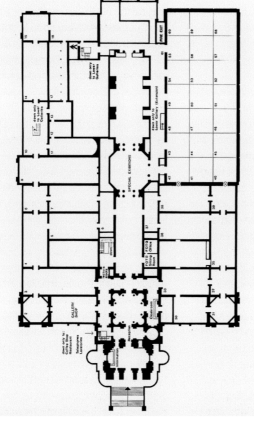

Tate Gallery: plan showing fifth extension galleries upper right (north-east corner), 1979.

annihilation of the old façade, so great was the outcry from members of the general public that the scheme was scrapped, and the original idea of completing the north-east quadrant reinstated. The trustees acknowledged that 'following the exhibition [of the models], the forceful expression of the public's feeling in favour of retaining the existing façade prompted Her Majesty's Government to reconsider the scheme, insofar as it affected building across the front' (*Biennial Report*, 1968–70). In an issue of *Connoisseur* celebrating 75 years of the Tate (July 1972), Director Norman Reid observed,

'Great though the need was for more room, such drastic restyling of the beloved building was too painful to contemplate. The 'Image' of the Tate is perhaps more subtle than even its own staff was aware, something to do with the physical presence of a building which in some idiosyncratic way suits the mood of the people who climb the steps in mounting anticipation. To disturb its stones would seem to inflict intangible injuries on its contents. So people seem to have felt and they made their feelings known.'

The decision was made easier by word from the government that it was prepared to make available to the Tate the adjacent site of the QAMH and to 'permit immediate implementation of plans for the modification of the existing building and completion of the fourth quarter' (*Biennial Report*, 1968–70). With room to expand to the east, some of the provisions that had seemed necessary in the fifth extension could now be planned for a new site, and a less ambitious – and destructive – project devised by Llewelyn-Davies's office. In a face-saving gesture, the trustees hastily averred that 'we, like all the other bodies involved, had been averse to destroying the existing façade … but as no other land was then available it seemed it could not be avoided'. A new brief was swiftly written, which placed the new galleries in the north-east quarter and a conservation block behind the Duveen sculpture hall.

This brief was prepared with the assistance of Michael Compton, who had trained as a naval architect before becoming Keeper of the Exhibitions and Education department at the Tate in 1965. For the

View of the north side of Tate Britain from John Islip Street, showing the Conservation block to the left.

Tate Britain

galleries the requirements were very specific: an expanse, top-lit and unbroken by supporting columns or walls, of more than 18,000 square feet of exhibition space on the same level as the existing galleries that would allow integration with them. Additional display areas, providing a further 4,000 square feet, were available in the link with the Duveen sculpture hall and in a new temporary gallery in the water-tight basement, which also housed photographic studios, facilities for storage and handling, and screen rooms where the public could access the reserve collection. One of the goals was, in Compton's words, 'to carry on the basic rhythm of existing galleries so the curators would not be obliged by any differences to locate one group of works in the old and another in the new' – in other words, there was to be continuity. He further explained that since 'the placement of painting and sculpture in an obvious temporary environment reduces their presence and power', the internal partitions, while in fact movable, should look like 'real walls and meet at floor and ceiling as real perimeter walls do'.

Llewelyn-Davies's mathematical interest stood him in good stead with the plan, a series of twenty-one 30-foot squares in groups of three, matching the width of the older portion of the building. In fact the original cabinets, said to be 30 feet square, and galleries, 30 by 60 feet, were taken as the dimensional guides for the new addition. The square bays, articulated within by the floating concrete structure and crowned with double-glazed pyramidal skylights, could be joined or separated, configured by the curators as required for any exhibition. The flexible universal space was made possible by a free-span roof structure, a sort of space frame that contained environmental services and all the controls for both natural and artificial light. If at first the organisation of these bays was rather predictable, in recent years a new confidence is evident in the creative layouts of the temporary displays to which the space was originally devoted – although today part of it is used for the permanent Collection.

According to Alan Powers (*Twentieth Century Architects*, ed. Emanuel 1994), Llewelyn-Davies had particular admiration for two architects – Mies van der

Rohe and Palladio. Presumably it was the use of a system of geometric proportions that recommended the sixteenth-century architect from Vicenza who, since the seventeenth century, had been remarkably significant for British architecture. Mies van der Rohe, on the other hand, was revered for his elegant simplicity and his embrace of the grid, which Llewelyn-Davies thought adaptable to a system that might provide modules which could be multiplied as needed, whatever the building type. Yet the square compartmentalisation of the roof structure introduced a very different rhythm overhead and in plan from anything found in Mies, and perhaps owed more to Louis Kahn, who in these years began developing projects based on square units. An addition very similar in conception and also appended to a classical museum originating in the same period can be found in I.M. Pei's wing of the Boston Museum of Fine Arts (1977–81).

The exterior of the fifth extension could certainly be described as a version, if markedly less elegant, of Miesian work. Stone panels framed by the steel structure indicate the horizontal dimensions of each bay of windowless façade. The five-storey conservation block on John Islip Street, crowned by a pyramidal roof, completes the grand axis formed by the entrance and the Duveen gallery. Its glass walls suit the very different functions it houses, and here the bays are articulated by stone piers. A gesture to contextualism has been made by the use of Portland stone, but because there is no carved detail, texture has been sought by employing slabs from the bed of the quarry which contain fossilised shells and have a slightly pitted rather than smooth appearance.

Completion of the extension was attended by difficulties. A number of false starts and misguided experiments delayed optimistic expectations of an inauguration in 1973. The blinds installed in each bay to control daylight proved unusable, and in 1974 it was decided to substitute a double layer of aluminium louvres. A full scale mock-up of three bays was constructed to test the lighting under real conditions, through which was developed the system of an upper layer of louvres adjusted on a seasonal basis to

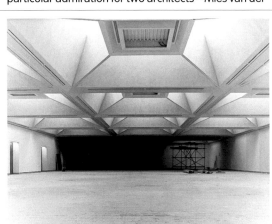

Fifth extension by Richard Llewelyn-Davies. Construction photo showing uninterrupted span of galleries before installation. View in 1979.

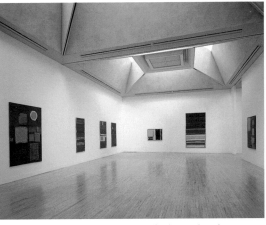

prevent excessive heat gain, and a lower level controlled electronically depending on the changing character of daylight and the medium on display (thus natural light could be completely excluded for works on paper). A complex method of artificial lighting also was devised, whereby 'building' and 'task' lighting were skillfully combined, the former consisting of fluorescent lamps for ambient illumination, the latter tungsten spots directed at the works of art. At last, on 24 May 1979, Queen Elizabeth declared the fifth extension open.

The Department of the Environment summed up the practical virtues of the Llewelyn-Davies wing in a press release of 3 April 1979: 'The salient features of the new galleries, adding 50 per cent to the present gallery area, are natural light, environmental control, and emphasis on the works rather than the architecture. The design has deliberately avoided calling attention to itself, and aims to provide a calm, non-assertive background against which the works are the focus of attention.' The trustees' assessment was equally laconic, stating that the design 'does in general meet the requirements of the brief, that it should combine the essential character of the old galleries, which belong to a tradition which has proved itself over 150 years, with contemporary requirements of light and atmospheric control and a degree of flexibility in the pattern of room size and circulation … At best the galleries provide a cool, airy and neutral setting which seems well suited for the display of

contemporary art.' A different board is speaking than that which had been so prepared to obscure the Sidney Smith façade.

Lawrence Gowing, long involved with the Tate as guest curator, trustee, and Keeper of the British Collection, 1965–7, fairly and more evocatively summed up the strengths of the new extension (*Encounter*, August 1979):

'The spaces are logical and beautiful and the total provision is ingeniously lavish … How good that like the old, the new galleries should not only have natural light but be seen to have it [although] we find ourselves looking at the sky between no fewer than three superposed systems of ribs, each with a different character, each with its own residuum of unresolved detailing.'

Gowing's concern about the complexity of the superstructure could apply equally well to the ceilings of the original galleries, but in fairness to Llewelyn-Davies, the welcome glimpses of the sky afforded by his solution are more direct and engaging.

During construction, the director Norman Reid made an important decision about the old galleries which, as he acknowledged, had been 'nibbled away for years … The conclusion I am making is that they are best as old rooms, in their crystal palace style, kept clean and well decorated, which is part and parcel of their total appearance, rather than chopping them up and trying to pretend they are different from what they are' (*Connoisseur*, July 1972). Here Reid is referring to the alterations made in 1967–78 to the Turner galleries of the Romaine-Walker addition so that rooms would resemble the 'white cube' spaces of many of the most recent museums and extensions.

A less puritanical attitude toward historicising architecture and the recognition that, just as contemporary works of art required a sympathetic setting, so older works deserved the same, would provide a markedly different climate for the next initiative undertaken by the Tate, which resulted in the completion of the Clore Gallery eight years later, in 1987. It began with the permission to develop its new property to the east, on the grounds of the former QAMH.

Architectural budgets have caused grief since the cessation of funding by wealthy Maecenases, whether princes or pontiffs. It has long been taught that public buildings require maximum volume at minimal cost, and inevitably budgets continue to act as a brake on schemes for every building type. In the case of the Tate, however, the extreme penury experienced from 1939 through the 1970s would be eased for a brief period. This applied to acquisitions as well as buildings and maintenance. As in the past it was the private sector that fuelled the new initiatives introduced when the QAMH site was made available, but eventually the government would supplement the generous donations from individuals and corporations. In the euphoria surrounding the millennium, funding through the Millennium Commission and the Heritage Lottery Fund would make a big difference to the architectural fortunes of the Tate in the final decade of the twentieth century.

Even before the opening of the fifth extension, the trustees, Norman Reid, and incoming director Alan Bowness were making ambitious plans for utilisation of the QAMH site. At the end of 1979, they interviewed five architectural firms and chose Stirling, Wilford and Associates to develop a feasibility study in co-operation with the Department of the Environment. The scheme, initially called the Tate Centre and later The New Museums, was based on Bowness's conviction that the existing Tate should exclusively house British art. With that in mind, he envisaged a group of adjacent structures on the hospital site comprising a Modern Sculpture Museum, the New Art Museum (to include a sculpture conservation studio and handling facilities as well as public amenities), the Museum of Twentieth Century Art and a Study Centre. Begun in 1983, Stirling, Wilford's proposal wove new structures artfully among the Edwardian buildings to be retained; ready in 1986, it was destined never to be realised.

Before the development of a larger scheme, however, an opportunity occurred for immediate development on the QAMH site, and Stirling, Wilford set to work on what would become the Clore Gallery. Although the Duveen rooms had been built for the

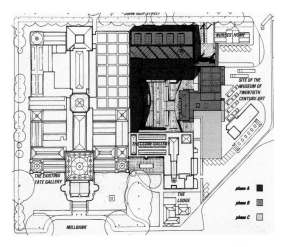

the monumental design restored Stirling's reputation as a gifted artist and a stylistic innovator who did not display the historical amnesia of more orthodox modernists. The three German museum entries were markedly responsive to the existing fabric and at Millbank Stirling would behave no differently, as shown in his willingness to retain two of the hospital structures completed in 1905. The strategy employed in Llewelyn-Davies's original proposal for the fifth extension would have been unthinkable to Stirling at this stage of his career.

Over the course of the twentieth century, especially after the Second World War, museum trustees and personnel increasingly were involved with architectural decisions. In 1980 the Clore Gallery Working Party was established which, in partnership with the Property Services Agency (PSA), developed a brief and worked closely with the architects, and the engineering firms providing essential mechanical, electrical and environmental services. The relations between some members of this committee and the strong-willed architect were occasionally very stormy, particularly with regard to external details, the colours of the rooms, and the perceived disorientating effect of the entry to the galleries from the main stairhall.

In addition to rooms sympathetic to the display of Turner's work – top-lit for oil paintings, artificially illuminated for works on paper – the requirements, which were not established immediately but evolved during the course of design, included a separate entrance, lecture hall, seminar room, reserve galleries, physical plant room and a paper conservation studio. Most importantly the new galleries had to be smoothly linked with the existing ones on the eastern side of the old Tate. Stirling conceived an L-shaped scheme, which first moved east across Bulinga Street, closed off for this purpose, then turned at right angles to extend south to the Lodge. At the upper level four small and two large painting galleries continue the axis of the older building, while another large picture gallery and two smaller rooms – one for reserve and the other for prints and drawings – lie in the right angle. On axis with the Lodge is the area containing the entrance hall and stairs, linking the ground floor and the first storey.

Turner bequest, there were large quantities of the artist's work that could not be shown and in 1975, following the highly successful bicentenary exhibition at the Royal Academy, agitation for a separate Turner gallery recommenced. For a time, Somerset House was advocated as the ideal location, but after various campaigns, and the intervention of Vivien Duffield, the Tate retained its claim as chief venue for Turner's art, now to include the enormous holdings of works on paper. The basic scheme was approved in 1981 and construction started, after the closing of Bulinga Street and the demolition of two of the wards of the QAMH. In 1982 the Clore Gallery, named in honour of Mrs Duffield's father, Sir Charles Clore, and funded in part by the Clore Foundation, was under way next to the Tate, the first expansion beyond the original plot designated for the gallery in 1897.

The choice of Stirling to create what would be his first public building in central London was understandable. In the 1960s Stirling had cut a forceful figure in the architectural world through such works as the Leicester University Engineering Building (1959–63), designed with his then associate, James Gowan, and the Cambridge University History Faculty (1964–7). Thereafter his practice had languished until, with his new partner, Michael Wilford, he entered three museum competitions in Germany. They won the third, for the Staatsgalerie in Stuttgart (see Ch. 3), and although it would not be completed until 1984,

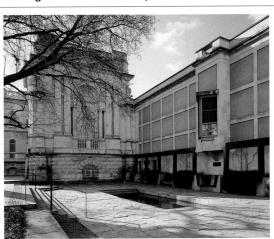

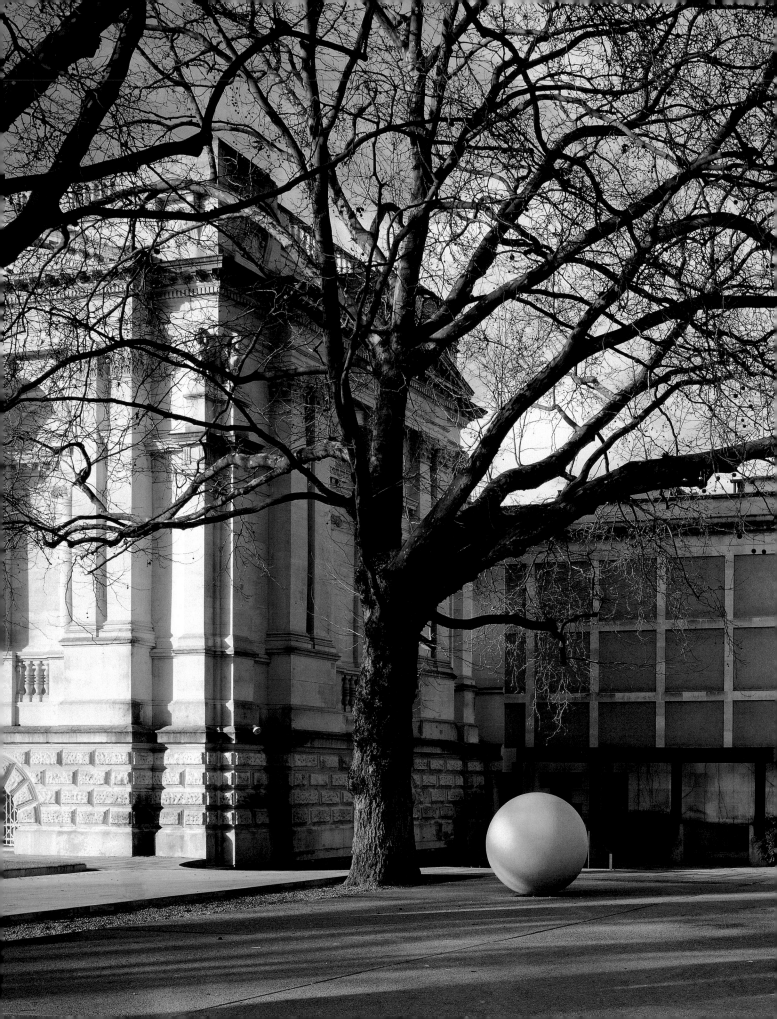

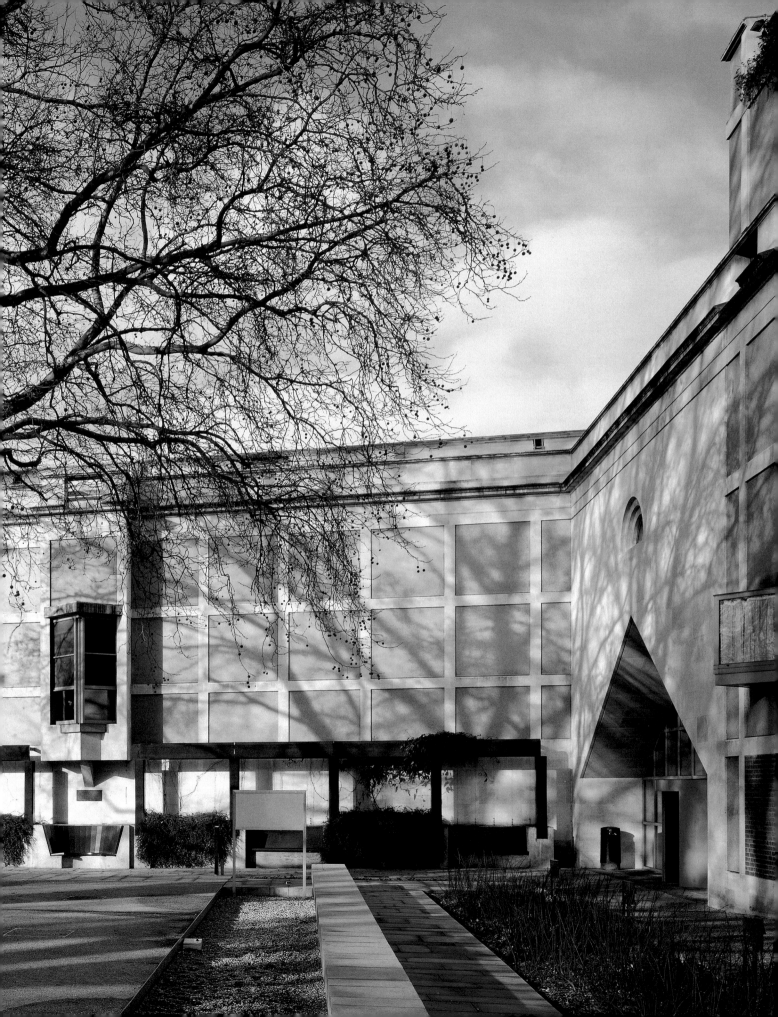

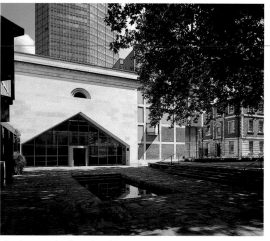

The lecture hall and public amenities fitted very neatly beneath the painting galleries. To the right of the entrance is the Reading Room, now the Duffield Room for entertaining and seminars, to the left cloakrooms and lavatories and the lecture theatre, areas that can be kept open after the galleries have been closed.

At the third level are two galleries for works on paper, and the Prints and Drawings Study Room where graphic works in the Tate Collection are made available to the public. In addition to the more than 8,000 drawings and watercolours and 280 bound sketchbooks that came with the Turner Bequest, there is now the Oppé Collection of some 3,000 British works on paper dating from 1750 to 1850, and the Modern Print Collection. The Clore has become an important repository, with its paper conservation studio, of works that cannot often be placed on public view because of their fragility.

The main galleries, the size and shape of which were carefully determined by the curators, conform to those typical of the exhibition spaces of Turner's time. They are on the same level as earlier rooms; although Stirling's details are more abstract, they are compatible additions that can be entered directly from the original building. Alternatively, the visitor can reach the new galleries by climbing the stair in the Clore's entrance wing and making a 180-degree turn, a more indirect way to proceed. The bifocal entrances introduce an ambiguity in terms of any attempt at a chronological hang, one with which the curators must deal when deciding the arrangement of the pictures. A thematic solution responds well to the organisation of the plan.

The carefully controlled top-lighting, inspired to some extent by Alvar Aalto's art museum at Aalborg, Denmark (1969–73) and simultaneously explored in Stirling's design for the Sackler addition to Harvard's Fogg Museum (begun in 1981), is admitted through scoops and clerestories rather than the conventional greenhouse type of skylight. As in the case of the Llewelyn-Davies extension, a full-scale three-dimensional model was erected to test different possibilities. Finally a very complicated and somewhat visually obtrusive section evolved for the roof structure, one that offered a variety of options depending on hour of day and time of year and responded brilliantly to international standards developed for safe illumination of works of art. Other issues regarding the galleries were not so compatibly resolved. A major source of contention was the colour and texture of the walls. The architect – and the Director – wanted an oatmeal-tinted fabric, the curators deeper colours such as would have been used in Turner's time. Although the building opened with the oatmeal tint in the main picture galleries, the reserve and watercolour rooms were painted in darker hues. In 1994 the picture galleries were also redone with the original 'picture rail' being removed, the walls painted and the original carpet replaced with wooden floors. Plaster rather than fabric facilitates the alterations in the palette thought necessary as displays change.

The colours in the double-height entrance hall were also opposed by Tate staff, who found their brightness and chemical quality disconcerting and inimical to appreciation of the pictures. Taken individually, the purple, peach, fuschia and blue-green hues might be discerned as flecks in some of Turner's paintings but the combination at architectural scale is startling and far from nineteenth-century sensibilities. Stirling saw the discord as an encouragement for exploration by the visitor, who mounts the stairs and, guided by the colours, turns to enter the galleries which are concealed beyond the balcony at the top.

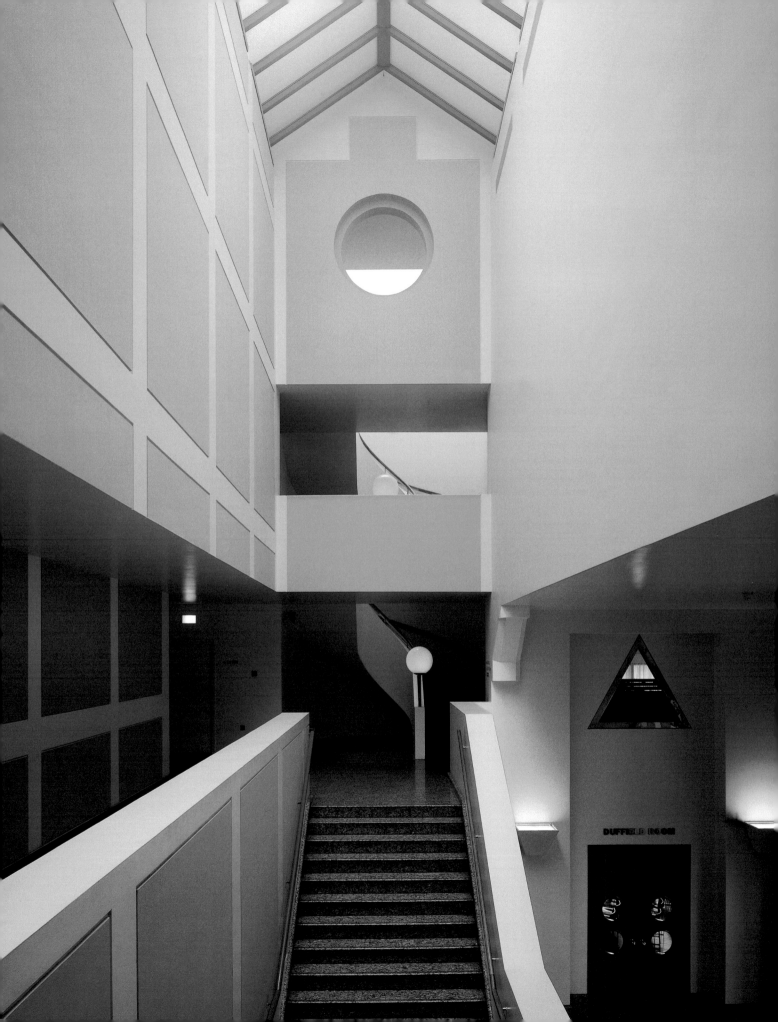

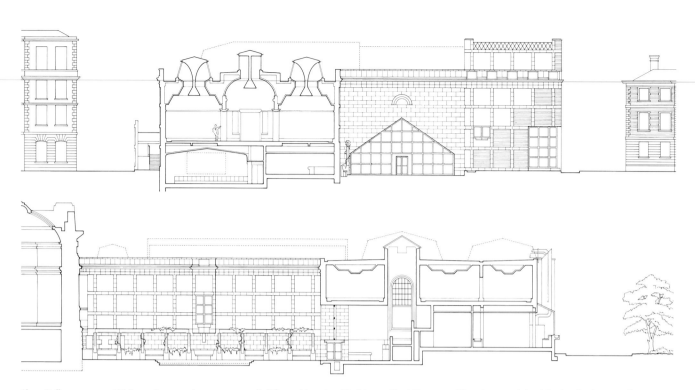

Clore Gallery. Top: section looking east through main galleries, and west elevation. Bottom: south elevation, and section looking east through entrance hall and reserve galleries.

Stirling also used sequences of different levels of light and varied volumes of space to entice the viewer who comes not from the older building but steps directly into the Clore from the adjacent garden, through the green revolving door set within the stone portal. The architectural promenade so striking in the Clore was one of Stirling's passionate interests at this time.

That the Clore Gallery was a provocative work of architecture cannot be denied, yet as one views it from the other side of the river – and even close by – its reticence is appealing. Although it advances southward beyond the Tate toward the Lodge, Stirling has tried to lessen the impact of broken symmetry by keeping the height low. The two storeys rise no higher than the wings connecting the centrepiece and the corner pavilions. The triangular portal, at right angles to the main entrance, built of Portland stone, is Stirling's personal version of Smith's portico, though in its proportions it resembles a Mycenean or late eighteenth-century shape rather than a Graeco-Roman one; the low pedimental silhouette is repeated in the proscenium of the auditorium. Stirling admits

that the portal has 'a sepulchral feel', alluding perhaps to past and present identifications of museum and mausoleum, an identification also explored in the building at Stuttgart. He cannot have been insensible to the thought that Henry Tate's real memorial is the gallery, rather than the tomb in Norwood Cemetery designed for him by Sidney Smith.

While Stirling respected the Tate Gallery's main building, he also was inspired by the brick and stone Lodge, completed in 1905. The vernacular character of this Neo-Georgian structure was vastly attractive to Stirling, and may have proved more influential than the Tate itself for the Clore exterior. Most of the Clore's outer walls are gridded, the pattern formed by stone cladding over squares finished either in yellowish stucco or red brick. The paper thin quality acknowledges the fact that these are not bearing walls but an envelope over a concrete skeleton. The transition from stucco to brick happens gradually, in a rhythm that makes a fairly obvious bid to connect the Clore with both the Tate and the Lodge. The walls of the Clore are pierced by sash painted in bright acid

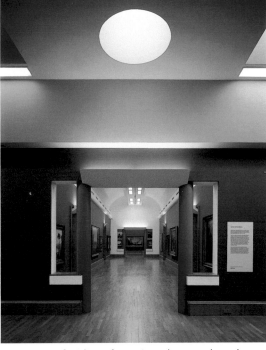

green, one of Stirling's favourite colours and used consistently for window frames (for example, at the Neue Staatsgalerie and the Sackler). Both the window to the right of the entrance and the one facing the Thames, required in the brief to provide not only relaxation from the intensity of the pictures but also a view toward the river that Turner knew and loved, are prow-shaped, like those found on Expressionist buildings of the late 1910s and early 1920s.

Stirling's design is a meditation on the differences and similarities between old and new, the historical and the contemporary. He has written that 'the shapes of the building should indicate the usage and way of life of the occupants, therefore be rich and varied in appearance. The collections of forms and shapes which the public can be familiar with and identify with is essential.' Thus the miniscule layered arch above the peak of the pediment is meant to connect visually with the basement windows in Smith's building, but also is detailed in the manner of Sir John Soane, one of Stirling's heroes. The entablature is simpler than that provided by Smith, but on the southeast corner

stone alternates with glass to make the point that cornices are not usually forthcoming on modern buildings, and that this one is merely for visual effect, to relate the new wing to the original building. Inside, asymmetrical counterpoints prevail as well. Thus the railings of the stair differ from one wall to the other: painted industrial pipes with conspicuous bolts on one side, the twentieth-century solution, contrast with the more craftsmanlike one of wood and brass opposite.

Critical opinion was divided about the Clore's architectural qualities. Sir John Summerson admired it, and approvingly noted the references to Soane, whilst Charles Jencks enjoyed it as a ratification of his Post-Modernist sympathies and taste for Mannerism, although noting that some of the contextual responses create 'overpowering tensions and disjunctions'. Colin Amery admitted to mixed feelings, describing its 'bizarre colours, toy monumentalism as entertaining as it is baffling, ornament applied with scissors, spaces used in a way that can distract from the sculptural character of spaces convincingly cut from solid forms'. He concluded that the visitor's 'mild shock is soon forgotten in the calm and diffused light of the galleries' (Waterfield, *Palaces of Art*, 1991). Still, he preferred the more elaborate Staatsgalerie, and thought that English conventionality had compromised the London work. Nevertheless, satisfaction on the part of Tate trustees was sufficient to gain Stirling, Wilford and Associates another commission – Tate Liverpool – and since the Clore's opening in 1987, familiarity and a certain mellowing have disarmed discontent.

The abandonment of Stirling's New Museums plan was not due to any perceived deficiency in the design, but occurred because of the realisation that the divisions of the modern collection into 'sculpture' and 'twentieth-century art' were not appropriate at the turn of the new century, and because there was insufficient space at Millbank to do justice to the modern collection – a conclusion that coincided with the belief of the new director that the best course would be to move the modern collection to another, and separate, venue.

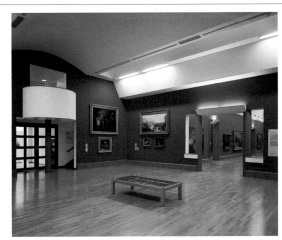

The completion of the Clore in 1987 and the start of preparations for a new gallery for modern art did not mean that the Tate would rest on its laurels at Millbank. The main building, especially that part of it dating back to the turn of the century, has been subject to continual adjustments and improvements. It has recently been listed Grade II* and therefore is protected from unsympathetic interior as well as exterior changes. In 1987 Colquhoun & Miller were appointed to devise a masterplan for the original building and to oversee a programme that would re-fashion old spaces to serve new uses in a manner that would not compromise their original integrity.

Founded in 1961 by Alan Colquhoun (Professor of History and Theory at Princeton University, who retired from the partnership in 1989) and John Miller, this distinctive architectural practice had already made a name in the museum world as expert in upgrading and extending art galleries. Their work at the Whitechapel Art Gallery, accomplished when Serota was the director there, won the praise of critics, and their competition design of 1985 for the extension

Right: Tate Britain Centenary Development, Atterbury Street. Glazed wall, ramp and steps of the new Manton entrance by Allies and Morrison (beneath the original Turner wing). View from south. Opposite: Nomura Room (originally Gallery IV, now Gallery 19), 1990-1. Restoration and refurbishment by John Miller and Partners.

Shaping the future from the past 1987–2001

Tate Britain

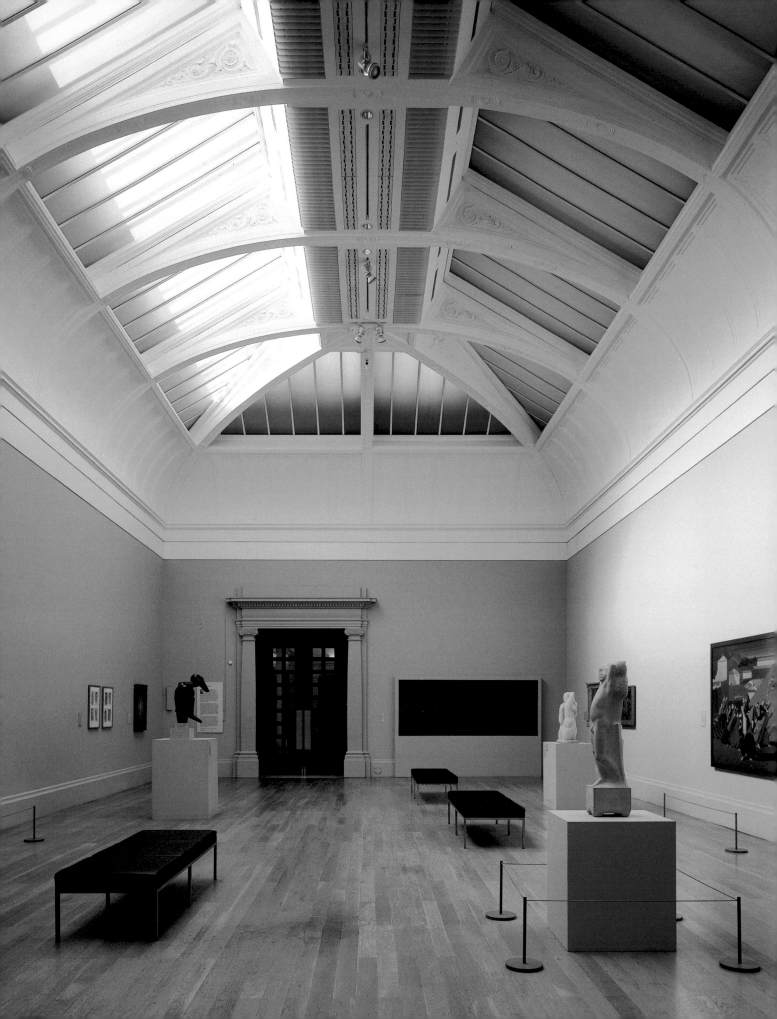

to the National Gallery was one of the six short-listed entries. Some of the principles that accompanied that proposal are pertinent in relation to Miller's later work at Millbank: 'A modern building should not be a clone of an old building (any more than a modern novel should exactly imitate the style of Balzac or Dickens)… The word "context" should be taken to mean not only the actual physical context, but also those general architectural ideas which constitute the raw material out of which a new building is made – the "architectural tradition".' Su Rogers, Miller's wife, is another partner with long experience in museum design; she had been involved with the Pompidou Centre when she worked with Richard Rogers.

Initially, Miller & Colquhoun was engaged in incremental enhancements within a larger plan. Sometimes these were primarily of a technical nature, stemming from the need to make the museum environment more benign for art objects, a necessity that has been subject to progressively higher stakes. Miller's skill in accomplishing this unobtrusively can be witnessed in the Nomura Gallery, a re-creation of two

of the 1897 galleries, funded by the Japanese securities firm of that name. The redesign is a prototype for the improvement of the other rooms in the original building. Smith's internal ceiling structure has been renewed but is no longer cluttered with distracting and disparate elements. Electric lighting has been integrated into the soffit, which also houses the air supply; power outlets are discreetly incorporated into a new oak floor. Needs unforeseen in Henry Tate's day, such as air conditioning, fire sensors and video monitors, are accommodated without disturbing the original character of Smith's rooms, in sharp contrast to the practices of the 1960s and 1970s.

Another function inconceivable when museums were first constructed, but one that became increasingly more important and therefore required ever more space, is the gallery shop. In its earliest days a bookshop of sorts, designed by Colin St. John Wilson, was squeezed into the vestibule. Miller installed the expanded version in the anteroom and two galleries (or more accurately gallery and cabinet) immediately to the east of the rotunda. The former function has not been concealed – the vaults with their skylights have been retained, the main alteration being the insertion within the shell of the rooms of an oak liner crafted to serve variously as shelves, stands, and sales desks.

Yet a third type of incremental move involved the gallery café, an ingenious design of 1982 by Jeremy and Fenella Dixon which, located under the rotunda, took the circular motif as its theme. Under Miller's supervision this was enlarged, made more accessible and also brighter by a specially designed cold cathode lighting system (there is no natural light in this lower level area); an espresso bar was also introduced.

Miller's major task at Millbank was the Centenary Development, a project that definitively completes the north-west quadrant. It entailed the demolition of four of the former Duveen galleries, new construction on that site and in a former courtyard, and reconfiguration and renovation of existing areas. Besides providing more public space within, it introduces a new entrance on the Atterbury Street flank of the Tate, named after the donors Sir Edwin and Lady Manton. Excavated from Romaine-Walker's

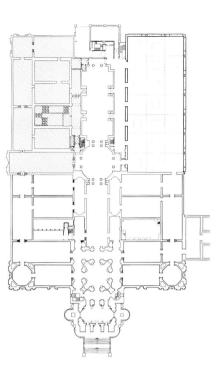

Plan of main floor (Level 2)

Plan of lower floor (Level 1)

imposing basement wall but otherwise leaving the rusticated base undisturbed, the Manton entrance offers not only greater accessibility to visitors, but the possibility of keeping this wing open for special events after regular gallery hours.

On the main level, there are four new exhibition spaces. One of these is a corridor that starts at the atrium and runs along the west side of the Duveen sculpture hall. Dubbed by the architects the 'ambulatory', its flat ceiling inset with softly glowing frosted glass panels, the space serves both as the link between the Sculpture Hall and the western galleries, and an intimate display area in its own right, a 'pocket gallery'. Running at right angles to the ambulatory are the new galleries to either side of the stairhall. While

the materials and sophisticated environmental system are wholly new, the proportions and the elliptical shape of the top-lit vaults correspond to the very first rooms erected for Henry Tate.

Miller's design illustrates the technical progress that has taken place over the last one hundred years and the particular relevance of that progress to the museum programme. In comparison with Smith's rooms the structure has been simplified and the temperature and air quality made more protective of the works on view. In comparison with the fifth extension and the Clore, the environmental provisions have become less visually intrusive and more effective. In all three cases computers are used to regulate the light at different times of day and seasons of the year,

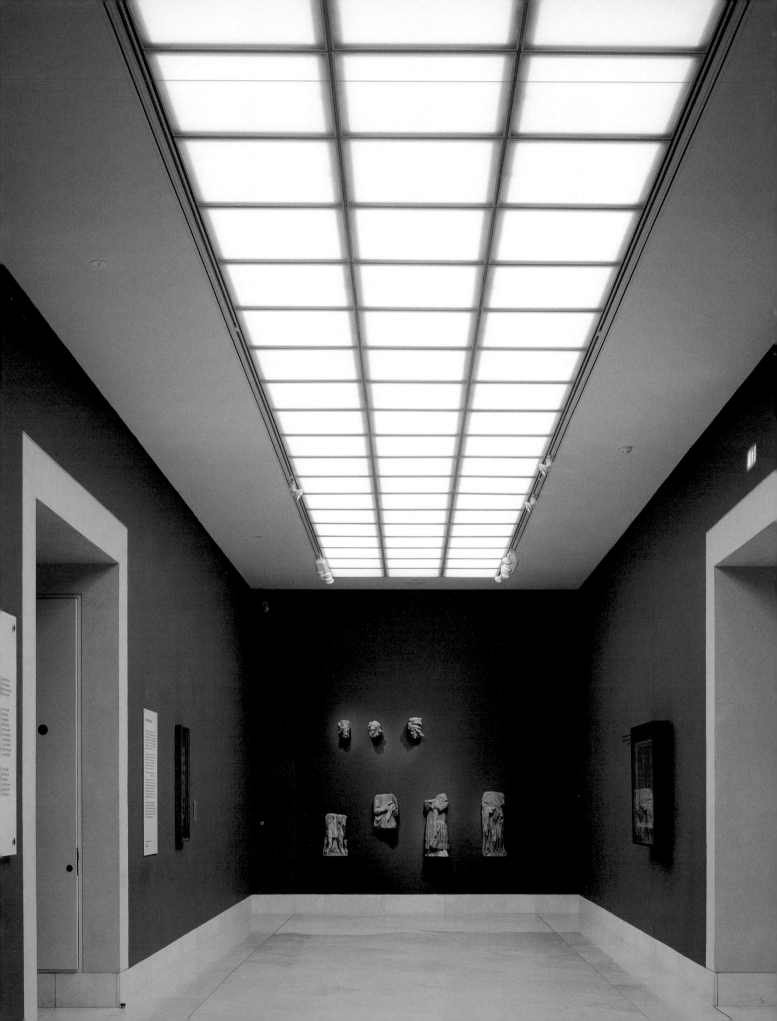

Right: Centenary
wing, detail of
new gallery portal
with *verde antica*
marble frame.
Left: Centenary
wing, 2001.
Pocket Gallery
or 'ambulatory'
(Room 1).

and the rapidly evolving capacities of electronic
devices mean that the Centenary Development
represents the state of the art in this regard. But
technical proficiency is not in itself sufficient to make a
place ideal for viewing art. Architects must ensure that
in the museum, technology does not become the main
object on display.

Miller has integrated the devices that control
mechanical services, including natural and artificial
illumination, into a sleek conduit that circumnavigates
the walls. Overhead, tidy banks of fluorescent lamps,
baffles, internal blackout blinds and skylights shielded
by exterior blinds under the pitched glass roof perform
smoothly and covertly to create a variety of lighting
conditions. Moreover, the balance between new
means and traditional ends has been restored through
the choice and detailing of the materials. Just as the
architects of Tate Modern were concerned to preserve
aspects of the industrial character of Bankside Power
Station, so Miller has devised ways to show respect
for the very different nature of his given building by
stressing refinement and de-emphasising the
technological – the use of polished white-oak floors,

for example, with their fastidiously crafted wooden
grilles. As one passes between the galleries through
the apparently thick walls (which house various
mechanical services), the transition is marked by a
change underfoot from wood to a honey-coloured
limestone from Italy that is more luxurious in
texture and warmer in hue than its Portland stone
cousin. The green marble doorframes, while less
elaborately detailed than the old, none the less are
chamfered and channelled with a sensitivity and
sensuality too seldom encountered when a modernist
engages with the orders, or a Post-Modernist
deliberately distorts them.

The renewed or 'reconstructed' spaces have been
given no less attention. These comprise five rooms
added in both the 1910 and 1926 campaigns: the three
galleries and one square cabinet that formed the
perimeter of the north-west quadrant, plus the grand
cross-axial gallery that commenced the first Duveen
extension. New wooden floors have been laid and
walls and ceilings rebuilt, but the *verde antica* marble
dados and door surrounds are original, having been
repaired and polished. The smooth plaster walls have
been painted in dark glowing colours to enhance
the historic pictures from the permanent Collection
that hang there.

Completely new is the double-height
stairhall/atrium, a variant both on the Tate's rotunda
and the hall of the Clore, but with the additional
advantage that it can serve also as an exhibition area.
The walls are rendered with a textured stucco that
complements the stone of the floor and the door
frames, and the atrium, covered by a glazed pitched
roof, has been installed with a movable gantry, which,
although smaller, is not unlike the one retained from
the old power station in Tate Modern. The atrium forms
the dramatic connection to the lower storey, which
is given over first of all to the Linbury Galleries, a suite
of six rooms intended for temporary exhibitions,
fashioned from the original lower floor galleries but
much enhanced. In size and shape they complement
those above, but the vaults are shallower. Most of
the illumination is artificial, banks of fluorescent lamps
being combined with incandescent spotlights,

Centenary wing:
Linbury Galleries.
*Exposed: The
Victorian Nude*
exhibition, 2002.

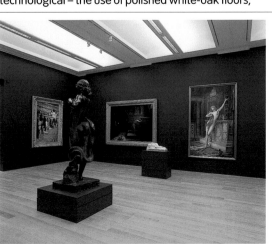

Tate Britain

Centenary wing: atrium stairhall. View in 2001 with Tony Cragg's *Britain Seen from the North*, 1981.

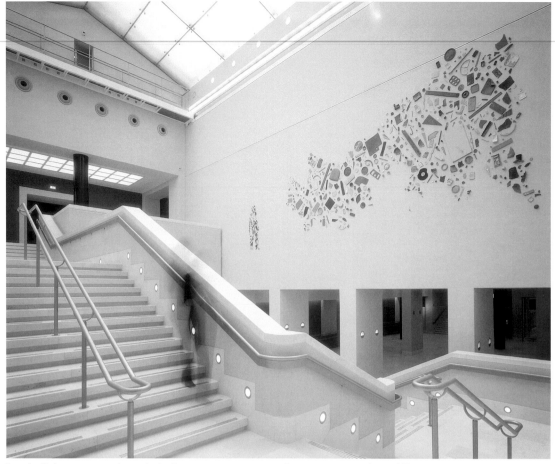

but daylight can enter through the basement windows, which, depending on the display, can be closed off with panels or left open to admit light.

The new entrance, reached via a ramp or steps, and located directly under the original Turner gallery, feeds into this lower level. The warren of rooms, which over time had been carved out for various departments of a sort unforeseen when the Tate opened, has been eliminated and a full circuit of the western basement is now possible. Besides providing more exhibition space, a major goal of the Centenary Development was to rationalise circulation, which had become increasingly confused and obstructed.

Miller's experience with exhibition design has given him an awareness of the impact of the architectural frame on art. Works in different media and from different periods find a sympathetic setting in these magnanimous yet unostentatious galleries. Not only the building that made the original footprint on the site of the former prison (remnants of which were unearthed when excavation for the Centenary wing was in progress), but the later additions and extensions, have been gathered together in a stately integration characteristic of the traditional art museum, without sacrificing the appealing if quirky singularity of the first Tate at Millbank. Whatever the variations in stylistic details – which convey an engaging discourse on the building's history – the Tate once more presents a coherent image true to the vision of its benefactors and directors.

Centenary wing: view in 2003 towards the atrium stairhall from Room 7 (formerly Gallery VII).

Tate Britain

Tate Liverpool

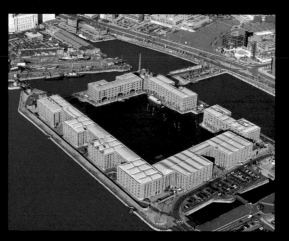

Above: Liverpool, Albert Dock (1841–8), Jesse Hartley. Aerial view c.1990.

Right: Albert Dock, looking east with Tate Liverpool (1984–98) in the centre, James Stirling and Michael Wilford.

There can be few public art galleries that have as unconventional a situation as the northern branch of the Tate, the first phase of which opened in 1988. Whereas most museums dominate their surroundings, Tate Liverpool is modestly located within a vast riverside complex occupied by shops, restaurants, offices, flats, television studios, and the Merseyside Maritime Museum. Very deliberately these various components are visually subordinate to the whole – the magnificent Albert Dock (1841–5).

Designed by an engineer in a century that resolutely separated art from science and architecture from engineering, in its day Albert Dock had been considered the very antithesis of such grandiose public structures as museums. But the proposed resurrection of the disused warehouses in 1981 coincided with a new trend in museum formation – the utilisation of industrial buildings for the exhibition of art. Now the aesthetic power of Albert Dock is recognised and wielded to confer status on the institutions and enterprises sheltered reticently within its handsome walls.

The first museum to anticipate such a mix of commercial and cultural uses was doubtless Louis Kahn's Yale Centre for British Art in down-town New Haven, Connecticut (1969–74). But that was a purpose-built structure and only the street level was rented out to the retail trade, whereas Tate Liverpool thrives in a pre-existent industrial ensemble renovated to serve many competing

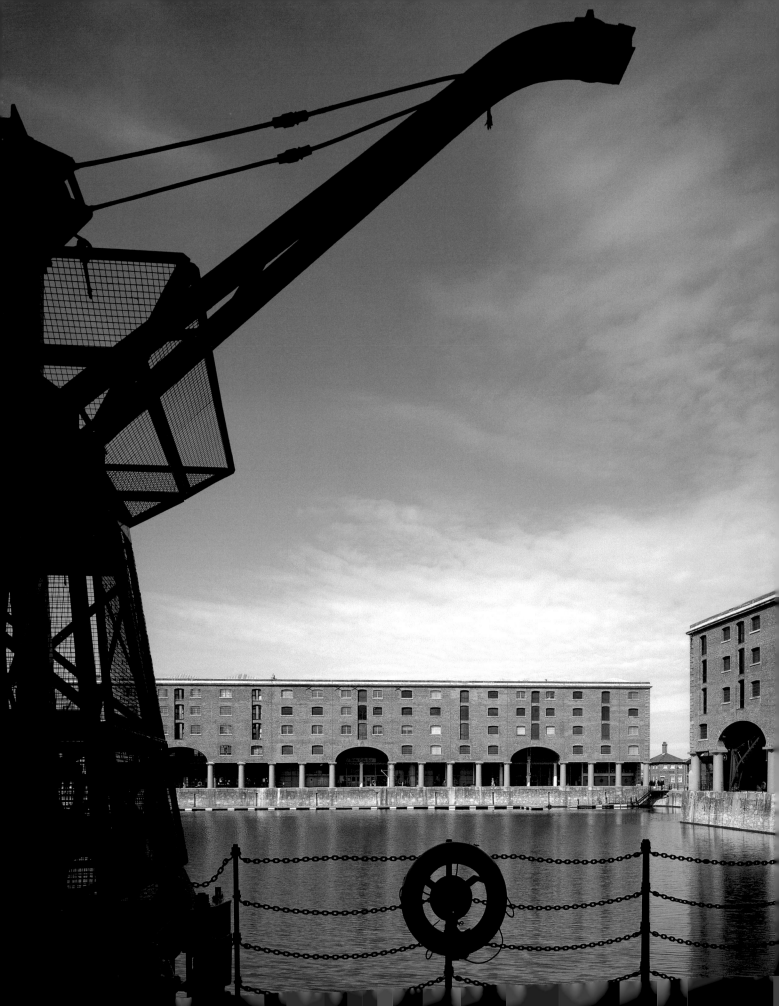

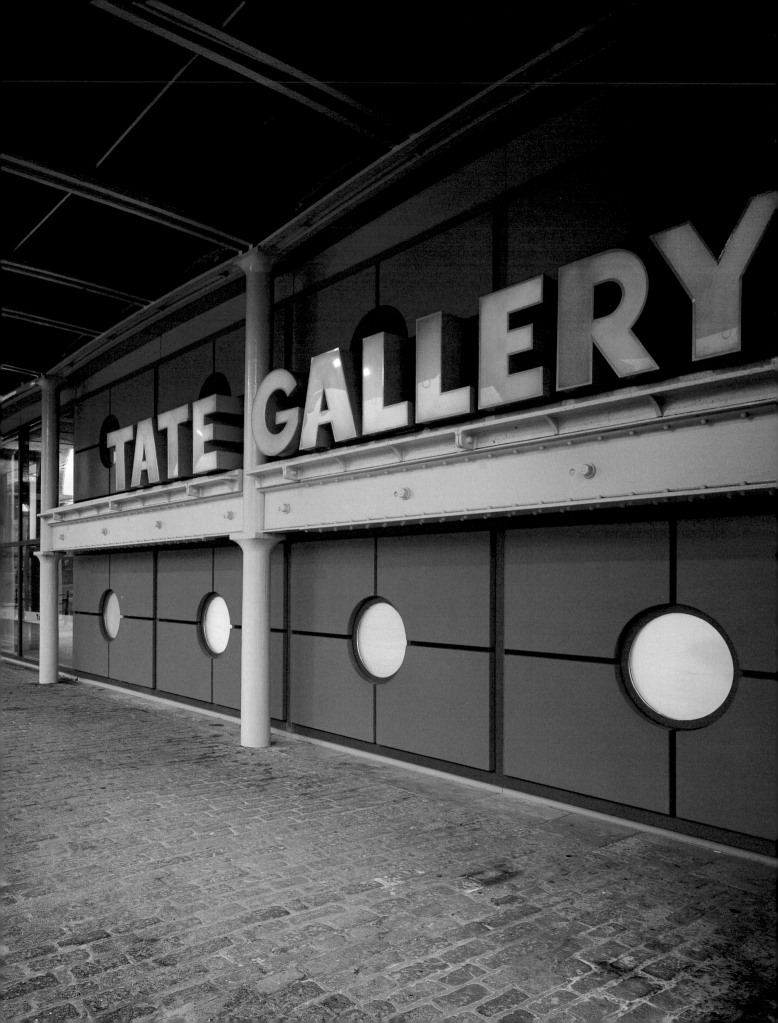

attractions. Although the Tate's identity is emphatically manifest within, its exterior presence can be indicated only at ground level, through the signage and bold signature colours of orange and nautical blue distributed along its recessed façade.

The starting point for Tate Liverpool was the trustees' vision of a northern outpost for the gallery's overflowing holdings. This vision had been developing in the late Seventies in a Board chaired by the historian – and Yorkshireman – Lord Bullock, but it was given shape by the new Director, Alan Bowness. Tate in the North, as the fledgling institution was initially called – several cities, among them Manchester and Leeds, were under consideration – was also propelled by the feeling that the capital should not hoard its treasures. This opinion was especially pertinent in the case of modern art for, aside from the Scottish National Gallery of Modern Art in Edinburgh, there were no comprehensive collections outside London. Although the Tate was not as ambitious as the Guggenheim a decade later, with its international succession of 'satellites', it was aware of its obligations to make works in its possession available to regional audiences, an experiment that had been pursued during and after the war when the Tate was closed. In 1945, for example, it had dispatched loans to Norwich, Sheffield and Bristol, a policy that continued and was extended to other cities.

Bowness's aspiration would correspond with a different goal on the part of national and local governments to remedy the dire economic and social problems of the once-flourishing port of Liverpool. In 1981 the Merseyside Development Corporation (MDC) was established and as part of its efforts at improvement, envisaged the restoration of the large acreage of vacant warehouses, which included the Albert Dock. Later that year, following the Toxteth riots, Michael Heseltine, then Secretary of State for the Environment, was named Minister for Merseyside and armed with funds for redevelopment. Recognition that these objectives were compatible and indeed mutually reinforcing led to an invitation to the Tate to participate in Liverpool's renaissance.

Right: Tate Liverpool, gallery with exposed service ducts. Left: Detail of the sign at the north end of the Gallery. Note the exposed metal columns and beams, and shallow brick vaults resting on metal beams.

Tate Liverpool

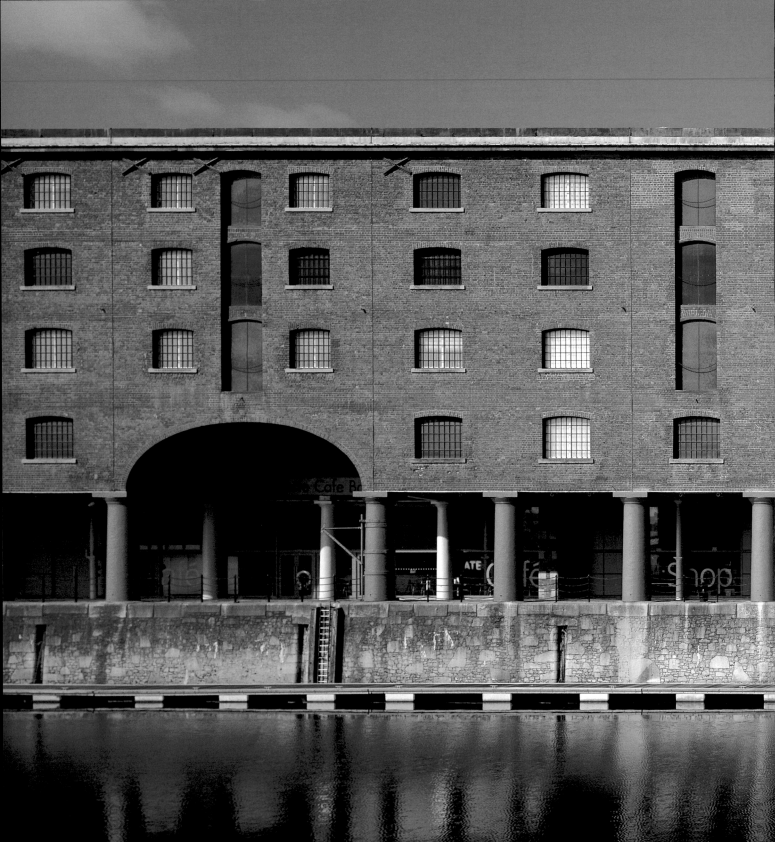

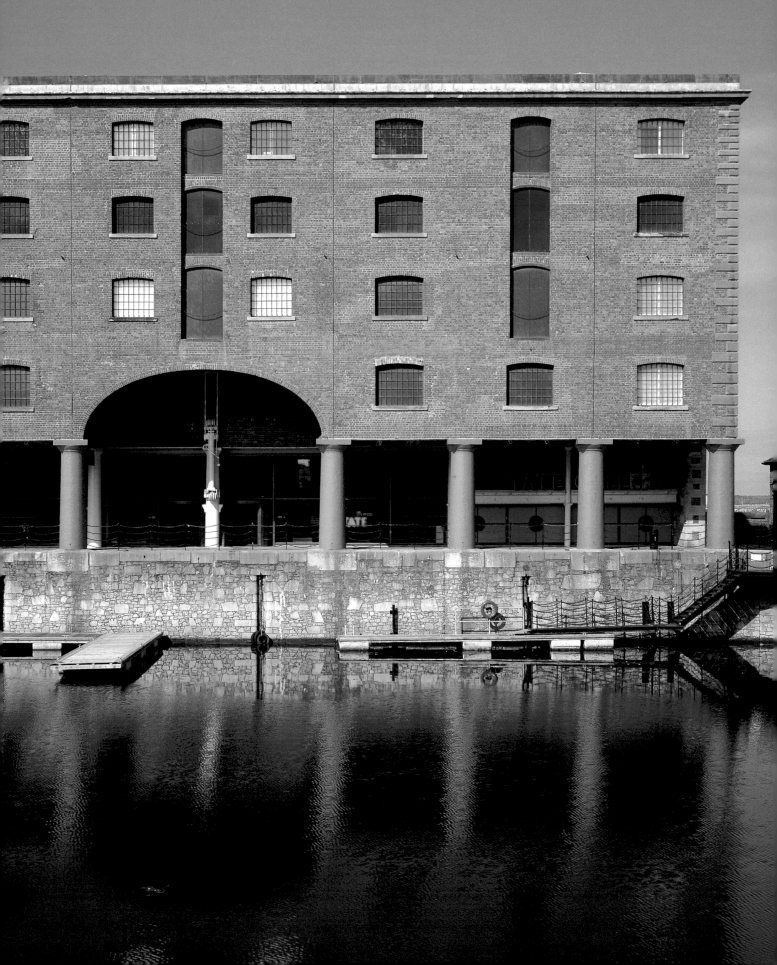

It had been determined early on that Tate Liverpool's particular sphere would be modern art. Traditional British works were already well represented in the Walker Art Gallery (1874–7), and since 1957 Liverpool had been established as the location of the biennial John Moores exhibitions of contemporary art. Tate Liverpool's mission would be to display twentieth-century works from the foreign and British holdings at Millbank, supplemented by occasional loans, and to host a series of temporary exhibitions focusing on recent work by artists of various nationalities. No less important was its commitment to contributing to urban regeneration, and a special effort was made to involve the regional population by sponsoring innovative educational outreach programmes and recruiting local people as gallery staff.

The Tate had to obtain more than £2 million to supplement grants from the MDC and the government, but nevertheless the director and trustees were able to announce in the *Biennial Report* for 1984–6 that the first phase was being developed by James Stirling, Michael Wilford and Associates. It was, of course, extremely fitting that Tate in the North should land in Liverpool, Henry Tate's native city and the place where James Stirling had grown up and pursued his vocation at Liverpool University's School of Architecture, one of the finest in Britain. He had vivid memories of the derelict but appealing warehouses along the river.

Right: Liverpool, Albert Dock (1941–8), Jesse Hartley. View before restoration. Previous spread: Tate Liverpool, view of eastern façade from the basin, c.1998.

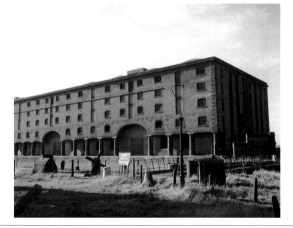

Stirling was still engaged with the Clore at the time he undertook the Liverpool project. The latter seemed tailor-made for his interests and some of the disagreements about curatorial and architectural means and ends that had arisen at the Clore were happily absent. Stirling was a staunch admirer of nineteenth-century English vernacular buildings and Albert Dock was an outstanding example in this category, precisely the blend of classical and industrial that Stirling himself was pursuing at this time.

Jesse Hartley (1780–1860) had been responsible for constructing a series of docks in Liverpool that had made the port second only to London. Gradually, however, sea trade declined, especially after the Second World War, and in 1972 the docks were closed entirely, awaiting rebirth. The most magnificent candidate for this renewal was Albert Dock (originally opened in 1845), an ensemble that surrounded a basin – described by Stirling as 'that perfect plaza of water' – and offered 1 1/4 million square feet of space. Hartley's knowing design of the brick and iron warehouses, comprising five storeys of varying heights, plus basement and mezzanine, ennobles but does not disguise their utilitarian function. He gave a classical rhythm to the seemingly repetitive elevations which, marching along the quays, achieve sublimity by their simplicity and sheer scale. Hartley had before him the example of London's St Katharine Dock (1827–9) by Philip Hardwick and Thomas Telford, where similar cast-iron columns support the brick superstructure

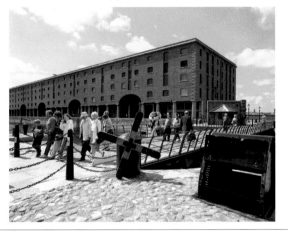

Liverpool: Albert Dock, north-western block after restoration.

and which also surrounds a pool for unloading cargo directly into the warehouses. But at Albert Dock the floors are tile and brick rather than timber, a gain in fireproofing, and the elevations along the basin are composed with a subtlety rarely encountered in such practical or unassuming building types.

The main structure consists of shallow brick vaults resting on iron beams supported on iron columns. The beams run lengthwise, parallel to the front and rear façades, with multiple thin iron tie-rods threaded at right angles between them. When Albert Dock was built, iron construction combined with masonry was an exciting new development. The Industrial Revolution made possible the smelting and production of iron in sizeable amounts, providing an important structural material that could replace stone and brick in architecture. Cast iron, strong in compression, was customarily used for the vertical supports, wrought iron, strong in tension, for the horizontal beams. Ornamental details were also fashioned out of iron. Though the material encouraged experiments that would eventually transform the appearance of buildings, at first the iron elements themselves were given forms familiar from classical and medieval times. At Albert Dock, the columns assume the shapes of the ancient orders. The Greek Doric – without a base and of very heavy proportions – inspired the outer range of columns that bear the brick wall. Inside are found the slenderer Tuscan Doric columns, without the base that normally belongs to this order; their simple 'capitals' metamorphose into flanges to carry the beams.

It is not only the columns that testify to Hartley's knowledge of the classical tradition. The front façade, which gives on to the basin, reads as a succession of visual and functional units arranged with the subtlety of a Renaissance or Beaux-Arts monument, the ground storey composed in counterpoint to the upper floors. Hartley is at pains also to reveal the connections between exterior elevation and interior structure. The segmental arches of the windows correspond in profile to the brick vaults within.

The units themselves vary in depth. Taking as a 'bay' the slice of interior space framed by columns, each eight-bay unit, subdivided longitudinally by a brick

James Stirling and
Michael Wilford:
Tate Liverpool,
1998. Perspective
view of entrance
on main level
(above) and
axonometric
view of loggia
and entrance hall
(below).

Entrance hall.
Note double-
height cast iron
Tuscan Doric
columns and
metal beams.

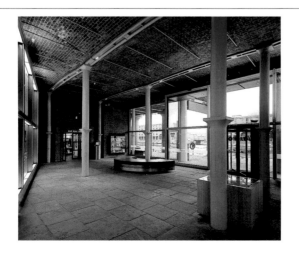

View of quayside
loggia with
revolving doors.
Note stone
pavement and
two parallel rows
of baseless Tuscan
(left) and Greek
(right) Doric
columns.

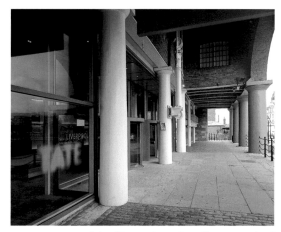

spine wall, is twice the depth of its five-bay sibling, and is separated from it by an interior cross wall perpendicular to the outer façades. The 5:8 ratio is one beloved by architects from ancient times to Le Corbusier and is often used as the numerical expression of the Golden Section. The difference in depth is not revealed on the front because the walls form a smooth, continuous plane around the inner quay. The alternation in plan and massing is apparent only from the rear – and from the air. The projecting and recessed volumes disclose the actual three-dimensional composition, the indentations in the rear allowing more light to enter the interior. The roofs also tell the tale. The gently pitched tents run crosswise over the deep units, lengthwise – perpendicular to the façades – over the shallow ones.

Warehouses are in some respects well suited for renovation on behalf of arts activities, as a generation of curators, dealers and artists discovered in the 1960s when many former industrial buildings were converted into galleries and studios. Used for the storage of goods, the loft-type spaces with few partitions answer the need for flexibility, and the general absence of top-lighting is unproblematic, since so many works made since the early twentieth century are at home in an artificially illuminated environment. Nevertheless, in other respects, particularly in terms of environmental standards for art, there are disadvantages. At the Albert Dock goods were in transit, often protectively packed, and could withstand erratic temperatures, especially those caused by the icy sea winds that refrigerated the lofts within. On sunny days a blinding light reflects off the Mersey and the water basin onto the façades and can penetrate the interior through the numerous windows cut into the walls. Insulation and the control of side-light were therefore a necessary part of the conversion brief.

Stirling readily accepted the challenge. After all, how many warehouses possessed such monumental power, and how many architects such sympathetic appreciation of their design? Accordingly, Stirling concentrated on retaining the Dock's structural, spatial and formal integrity. The architects succinctly outlined the guiding principles: 'Only make alterations where

necessary … mainly of two categories – those required in making a sequence of galleries … and an entrance hall that is a public meeting space … [and those required] to achieve the environmental standards necessary for exhibiting art … on the International gallery circuit.' While replacement of some parts of the building was inevitable – original iron elements were redone in steel and cast aluminium, new bricks were exchanged for old – the external appearance of the captivating industrial complex substantially remains the same.

The Tate had selected for its venue the northern corner of the western range of Albert Dock, with façades along the river as well as the inner, dockside quay. This favourable location makes the gallery quasi-independent as a destination and situates it conveniently across from the Maritime Museum, reinforcing a cultural/education enclave on the northern tier. The pattern established by Hartley whereby deep eight-bay units alternate with shallow five-bay wings has been cleverly exploited for the Tate's needs – the smaller wing is given over to ancillary activities.

Because of financial constraints, the project had to be phased. When the first campaign was completed in 1988, the top storey – the fourth floor – was undeveloped. The original mezzanine was removed over all but the two northernmost bays to create the tallest spaces in the building, where works too large for the other floors could be accommodated. A small

Tate Liverpool:
Phase I,
1988, plans.
**Opposite: 4th
floor Riverside,**
with Richard
Deacon exhibition,
1998.

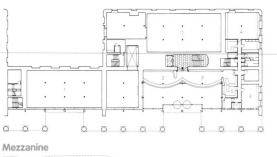

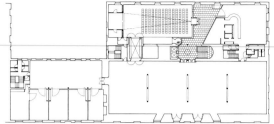

Mezzanine

Unrealised designs for fourth floor

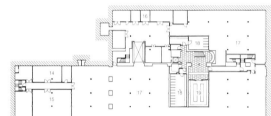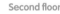

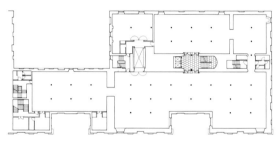

Ground floor

Second floor

Basement

First floor

café and bookshop were ingeniously tucked onto a balcony fronted by a double-bowed parapet that overlooked the lobby, which rose the full height through the mezzanine, reminiscent of Le Corbusier's ideal dwelling with its master bedroom on the second level looking onto the double-height living room. Although the building type is completely different, this reference is not without foundation, for Le Corbusier's practice tantalised Stirling, who simultaneously admired and severely criticised his work.

In the first phase, two galleries occupied the ground storey. The riverside gallery remains, but the one on the quayside has been exchanged for a much larger

café and bookshop. When it was a gallery, the eastern wall of necessity was opaque. On the exterior it was clad with the blue powder-coated panels one still finds on the western end of the building; the other walls are glazed. In the original warehouses this membrane, which separated the loading loggia from the storage areas behind, also was a partition rather than a bearing wall. All along the quay it is the iron columns and beams that support the outer brick walls above. Stirling has emphasised the dockside enclosure's nature as a screen by sliding it behind the iron structure that marches in back of the loggia, a three-bay segment articulated by two superposed columns

Gallery on
Level 2.

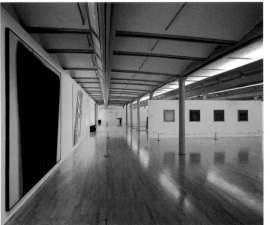

Tate Liverpool

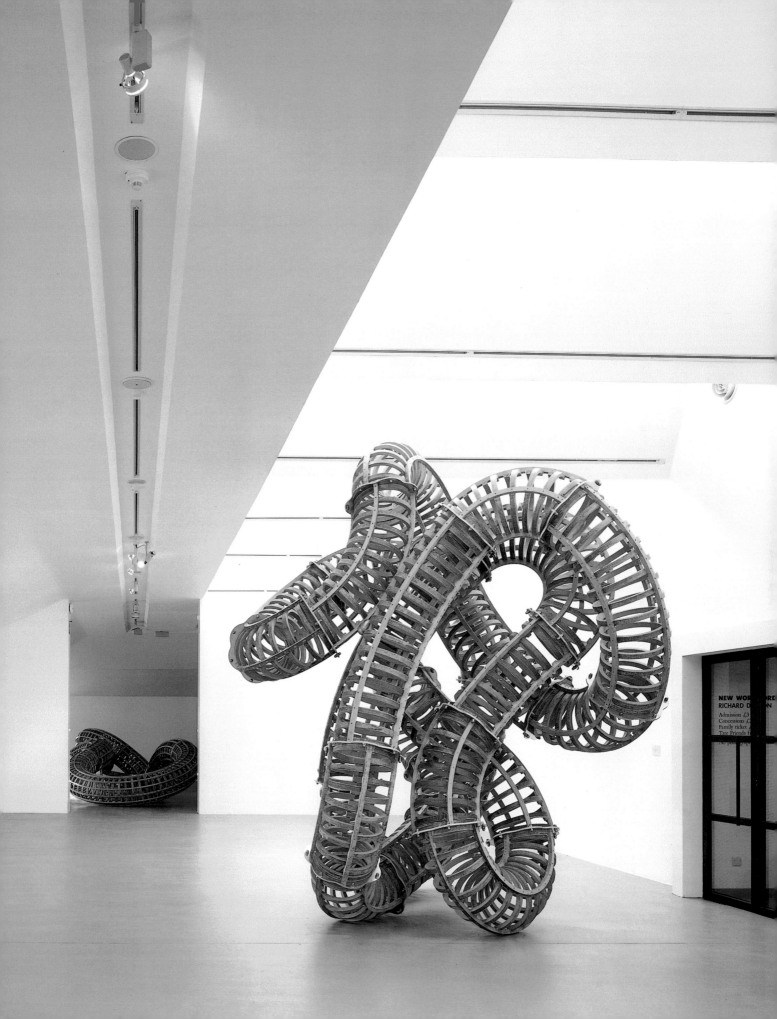

Phase II: riverside
gallery on Level 4.
Note saw-tooth
skylights.

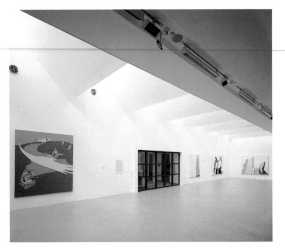

that give the measure of the storey-and-a-half space
within, which also has two slender columns atop one
another. A thick iron beam, its surface alive with nuts,
bolts and flanges, rests on the 'capital' of the lower
columns. The beam now serves a rhetorical rather
than a structural function, and carries the illuminated
orange letters that constitute the Tate's vibrant sign.

Over the next decade the building was altered,
amplified and eventually the full height was occupied,
although according to a new brief. After Stirling's
untimely death in 1992, work was carried out by
Michael Wilford and Partners, and the gallery
reopened to an eager public in 1998 with a completed
top floor and a grand new café-restaurant.

Some clarification is in order when explaining the
vertical organisation of the warehouses. They are often
described as seven-storey buildings, but it seems
less misleading to insist that they have five storeys with
a basement and a new partial mezzanine above
ground level (since Stirling removed most elements of
the mezzanine to create an entrance and galleries one
and a half storeys in height). The architects have thus
been able to exploit the different heights of each floor
to maximum advantage, providing diversity within the
constraints of a pre-existing envelope.

Most of the deeper, north wing is reserved for the
galleries, except at basement and third-storey levels,
which are too low for exhibition purposes. The heights
of the galleries on the first and second storeys were
pre-determined by the existing warehouse sections.
They are low, especially compared with those at
Millbank, the ample height of which had caused such
consternation in the 1960s and 1970s to those who
believed them much too lofty for modern displays.
Now at least one very high room is a desideratum,
and is provided at Liverpool by the remaining ground-
floor gallery on the riverside. A service zone rises
from basement to top storey and runs the entire length
of the wing immediately to the west of the spine wall,
with the result that the riverside galleries are one
bay shallower than those on dockside, another gain
for heterogeneity over the uniformity that was so often
sacrosanct in museum planning.

The many provisions necessary to the modern
exhibition gallery are carried by ducts running parallel
to the iron beams of the original building and
suspended below the lateral tie-rods. There are further
service spaces behind the white walls that line the
inner surfaces, shutting out most of the side-light and
providing areas for hanging. Temporary partitions
can easily be added for individual exhibitions; currently
most of these non-bearing walls line up with the
column grid and often two planes enclose a row of
columns to provide hanging space on both sides.
The elegant wood floors distinguish the gallery spaces
from the service zone, floored in a slate that
complements the straightforward metal detailing of
the stair, the treads of which are similarly of slate.
The neutrality of the white-painted columns and walls
and the natural materials leaves the art on display to
make the major statement.

When the top floor was completed in 1998, further
curatorial options became available. With its greater
height and polished concrete flooring the fourth floor
is ideal for contemporary art, and thus far has been
dedicated to temporary exhibitions. For the first time
at Tate Liverpool, top-lighting was available. The inner
area of the riverside gallery is covered with a new saw-
tooth roof fitted out with vertical scoops that admit
light over the tallest part of the room. The dockside
gallery retains the four sloping iron and cork roofs
running perpendicular to the outer walls, though
'skylights' have been introduced on their northern side.

Phase II: section
of riverside gallery
on Level 4, looking
east.

Thus flexibility is achieved not by the older pattern of undifferentiated universal spaces that need re-configuring after every exhibition, but by providing a series of different types of rooms that can be selected by the curators according to the requirements of changing displays.

The southern section beyond the galleries, which has its own stair and lift, is devoted to offices, meeting rooms, and activities that connect the gallery with its audience in the community. On the recently completed top floor in this wing are a seminar room, conference chamber and 'hospitality suite' that can be kept open after the museum closes. The tent-like roofs seen in the fourth-floor riverside gallery make a striking ceiling here too, but they run parallel to the main façade.

The ground-level southern bays house the café-restaurant, with a balcony-bar at mezzanine level. The decor blends the 'Victorian Tech' of the superposed iron columns and gentle curving iron beams with early modern references to ocean liners (the metal panels enamelled in blue) and a touch of High-Tech (the silvery metal furniture and detailing), creating a maritime/industrial atmosphere. The restaurant can remain open after the galleries are shut and is a popular destination for those visiting the docks in the evening.

From the café one can go directly into the shop, which also gives on to the entrance lobby, reached more directly from the dockside quay through two brightly painted revolving doors, favoured by Stirling

Phase II: quayside gallery on Level 4, 1998. Note 'tent' roofs with skylights.

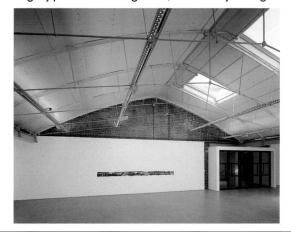

for his museum entrances. In its reconfigured form the lobby now presents a soaring, dramatic space which provides artful stone benches and an information desk. The tough original materials of the stone floor, shallow brick vaults and iron frame contrast with the smooth surfaces and brightly coloured details of the intervention. The lobby leads to the circulation zone, immediately beyond which lies the tallest gallery. To the right is the low-ceilinged reading/friends' room.

In accordance with the Merseyside Development Corporation's overall scheme, prepared by the Arrowcroft Group, the exterior changes were minimal. A careful observer can see that in the gallery area, many of the windows and all of the goods bays are covered by black metal shutters, but otherwise Hartley's elevations above the ground storey are intact, as they are in every other part of Albert Dock. It is at quay level, under the loggia behind the outer row of Doric columns (now painted pink rather than Hartley's dignified black), that the different enterprises stake their claim to recognition. Tate Liverpool is identified by the beautifully proportioned screen wall and its unique palette. A crisp metal grid alternately glazed and filled in with opaque marine-blue squares, a pair of orange revolving doors, and blocky orange plexiglass lettering, illuminated after dusk, attract the eye. Behind the sign are eight orange-rimmed portholes set into the blue wall, subdivided into two levels, that clads the two end bays where the mezzanine was kept intact. The nautical reference here survives only as the chastened remnant of a dismantled section of an ocean liner jutting from the northern face of the building.

Since its founding, Tate Liverpool has met the high expectations of its founders and supporters. Its successful provision within an existing warehouse of exciting and sympathetic spaces for the display of twentieth-century art may have prompted, or at least ratified, the decision to select another former industrial building when sites for Tate Modern were being investigated. The relatively small gallery in its renovated Merseyside quarters anticipated the huge ensemble on the south bank of the Thames, different though the circumstances and the solutions.

Tate St Ives

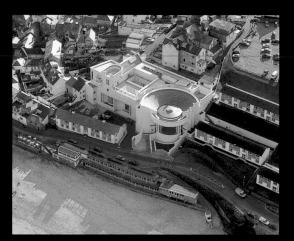

Above: St Ives,
Cornwall, Tate
St Ives (1991–3),
Eldred Evans and
David Shalev.
Aerial view c.1998.

Right: Tate
St Ives, view from
Porthmeor Beach.

Tate St Ives, created in sympathy with its natural and man-made setting in west Cornwall, is as stunning topographically as architecturally. Built into a sharply sloping promontory overlooking Porthmeor Beach, the museum is gleaming white, the marble chips in the rendered surfaces sparkling, when the sun shines, like the waves on the sea below. In foul weather as in fair, through the colour and texture of the walls, the proportions of the windows, the grey slate of the roofs, and the composition of small, articulated parts, the building conforms with the surrounding architecture. The route through the intricate layout of the town is circuitous, the gallery alternately concealing and revealing itself as the visitor seeks it out. Suddenly anticipation is rewarded by the full sight of the building on its diminutive acropolis, manifesting a singularly powerful presence that attracts both local residents and tourists to its precincts. The rotunda form – a favoured motif in museum architecture from its earliest beginnings – dominates the ensemble and communicates its special purpose.

The architects, Eldred Evans and David Shalev, brought unusually appropriate qualifications to the job. Evans's father, Merlyn Evans, was a painter familiar with St Ives, and the architects themselves have occupied a studio there for over twenty-five years. Their Cornish credentials were proven with the award-winning County Courthouse in nearby Truro (completed in 1988). The design for Tate St Ives

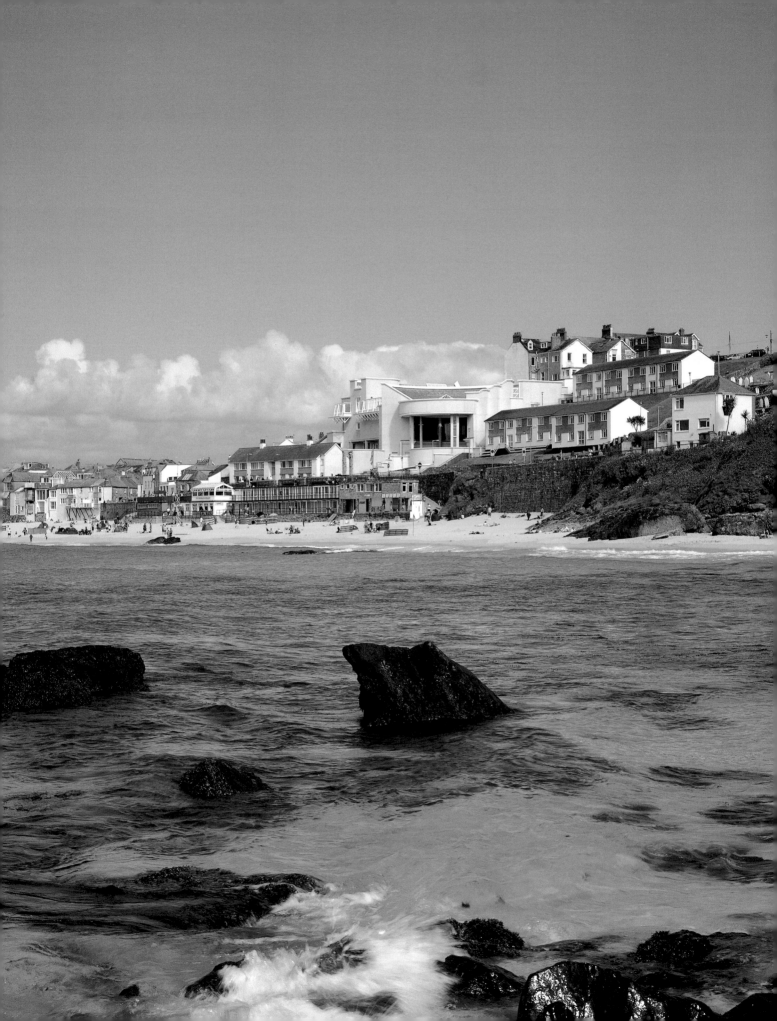

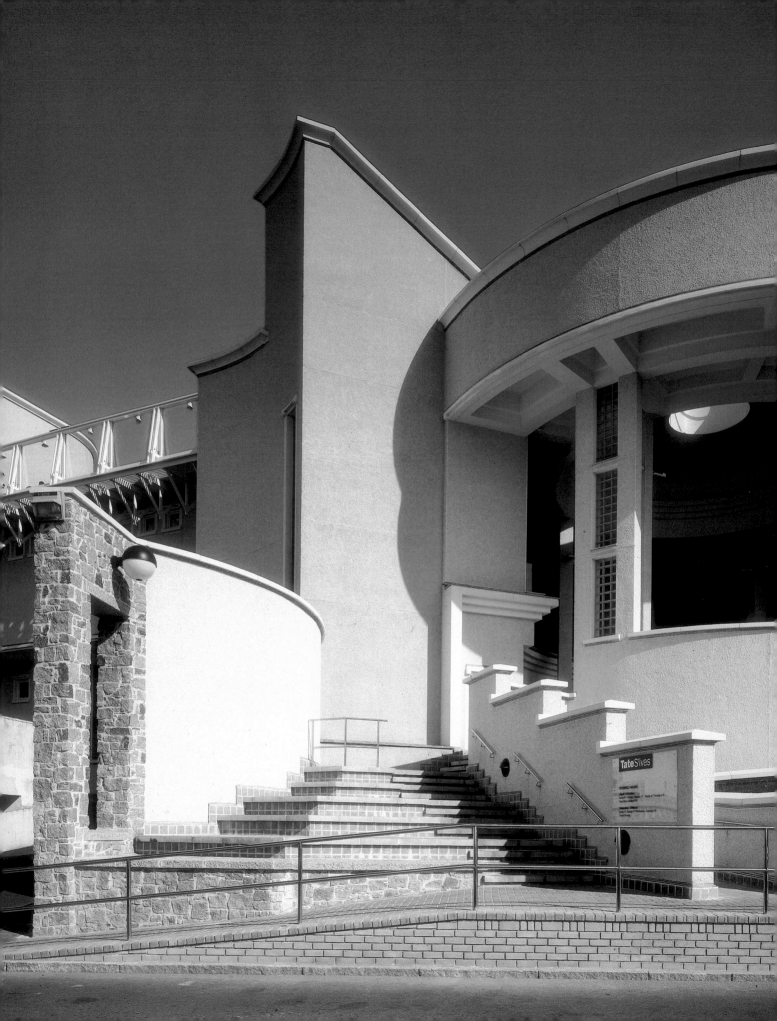

demonstrates their sensitivity to the works on display in the museum, the artists who made them, the people in the community who would be the primary audience, and the character of the hilly, water-girt peninsula occupied by the town.

Evans and Shalev grasped the unusual opportunity offered by the situation to place the visitor in close communion with the land- and townscape that inspired many of the works in the collection, which includes both abstract and representational images.

But that is only the beginning; for it was the team's canny, if subliminal, understanding of the history of this particular building type on the one hand, and their participation in a particular moment of architectural thought and practice on the other, that allowed them to make such a significant contribution to the genre. Evans and Shalev have been true to their modernist roots, avoiding the pastiche of much Post-Modernism without ignoring certain traditions of museum design, past and present, that have served the institution well. They have attained a rare balance between contemporary image and historical allusion, while creating a jewel of a monument that is an attraction in its own right, as galleries today must be, overpowering neither the context nor the works of art to be exhibited.

Right: View from roof level of Tate St Ives. Left: Tate St Ives, entrance with Loggia. Note use of local stone and pebble-dash stucco.

Tate St Ives is reached from the street that borders the beach. From the base of the building, made of the irregular, varicoloured rough-cut stones set in mortar that may be seen throughout the town, one ascends via stairs or ramp into the circular Loggia or open porch. Unlike the conventional rotunda, the Loggia is not concealed within the building but forms an inside–outside space connecting with the street as well as the museum, where visitors may pause to savour the vista over sand and sea. It is also reminiscent of the columned porticos that typically welcome visitors to the traditional museum. The ground-level, open part of the Loggia is fashioned like an amphitheatre, and can be used for community activities and for changing displays of sculpture and artist-designed banners. Daylight descends through the oculus, historically an integral part of the rotunda form, here covered with a glazed cone.

One can linger in the Loggia, or turn left into a rectangular foyer that rotates the axis towards a longitudinal enfilade, which begins with the entry hall and leads to the Mall. Although available for selective

Right: Mall with window by Patrick Heron. Opposite: View of Tate St Ives from Porthmeor Beach.

Gasworks into Gallery

Tate St Ives

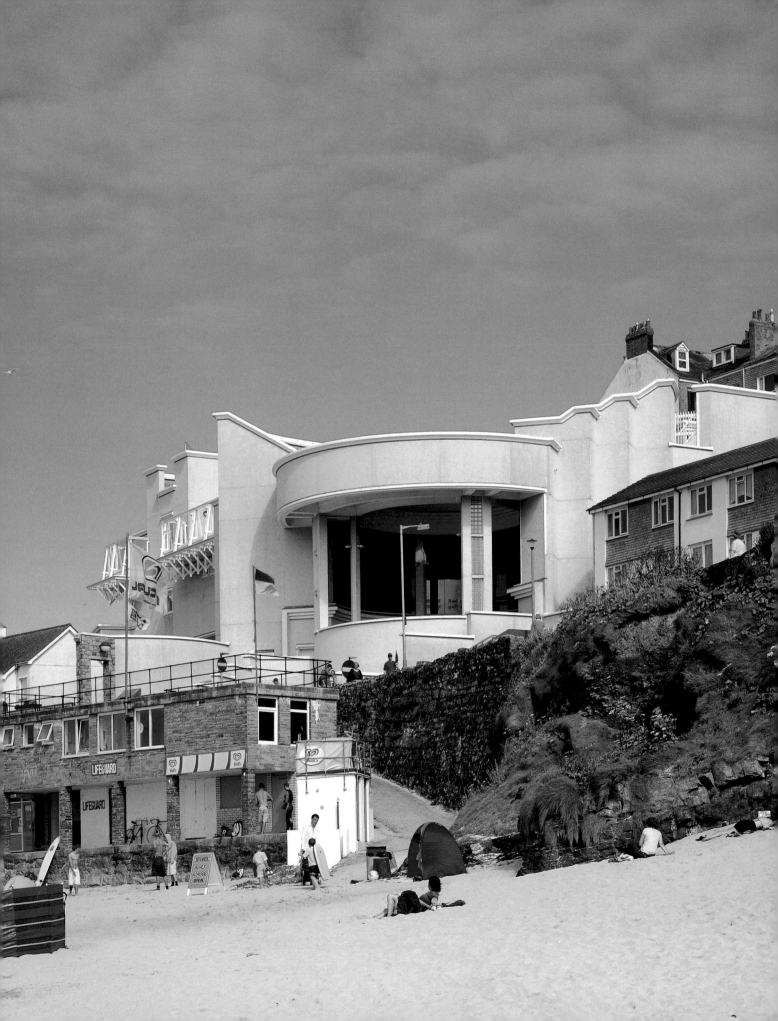

Gallery 2, facing
the Loggia:
lower level.
*Barbara
Hepworth
Centenary*
exhibition, 2003.

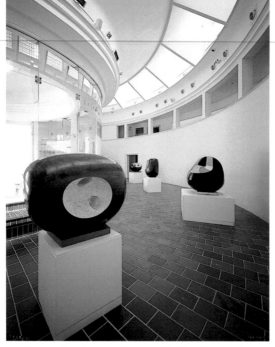

exhibits and social activities, the Mall is often kept dramatically empty, and in summer, when the number of visitors can overwhelm the interior, it provides an anteroom for crowd control. The Mall's most striking feature is the 4.6 by 4.2 m window in the north wall – the only one in the room, because the south side of the ground floor is built into the cliff. The translucent polychromatic 'Window for the Tate Gallery, St Ives', was designed at the invitation of the architects by the painter Patrick Heron, a long-time resident of west Cornwall. Concerned that the leaded lines of standard stained glass would compromise the imagery, Heron enlisted the services of Studio Derix in Germany to laminate coloured, handcrafted panes onto clear float glass for an uninterrupted surface that is more faithful to the 'irregular frontiers', as he called them, of his gouache preparatory sketches. To translate his small drawings into the monumental window, Heron also worked closely with architect Julian Feary.

The lyrical shapes of Heron's window, in varied shades of blue, purple, red and yellow, glow in the stark white room, heightening the expectations of the visitor, who can look into the round vestibule beyond, its plan echoing in miniature the plan of the Loggia. The entrance, with its porthole window, extends through to the mezzanine, and can be reached via the grand stair, that staple of museum design. This second floor accommodates the bookshop, an education room and the first level of the circular sculpture gallery.

The main, third floor extends southward to occupy the full width of the site. It offers a sequence of five differently proportioned and shaped galleries, a strategy that allows the exhibition of works of varied size and media, while avoiding the disadvantages of those amorphous spaces that became the hallmark of museums from the 1940s through to the 1970s because of their vaunted flexibility. More recent curatorial wisdom suggests that flexibility is best achieved through rooms of diverse character rather than through undefined areas that leave viewers disoriented and works of art in limbo. Such a tactic is especially appropriate when, as here, the permanent collection is known to the architects, who can mould the rooms around its requirements. Another important sphere of differentiation pertains to the methods of admitting and controlling natural light. Each of the galleries has a distinct but straightforward system of illumination. Clerestories, skylights and apertures of diverse dimensions receive daylight from various directions and in various degrees of brightness – although it was originally intended that the Gallery should have louvre blinds, which were omitted to keep the project within budget.

Gallery 1 on the north side, intended for the art produced in St Ives between 1900 and *c*.1940, consisting mostly of paintings, reliefs and drawings domestic in scale, is relatively low in height. At the top of the walls runs a series of small square windows, visible on the exterior under the projecting brackets that carry the windscreen of the terrace. These windows can be blocked when daylight must be excluded to protect the art or provide a darker ambience. The first gallery leads to the balcony of the double-tiered circular space (Gallery 2), ideal for small pictures and the ceramic pieces associated with the school of Bernard Leach, who in the 1920s established

Vestibule clad in
glass brick.

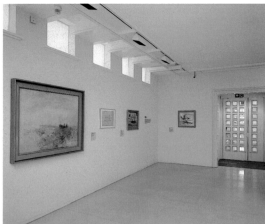

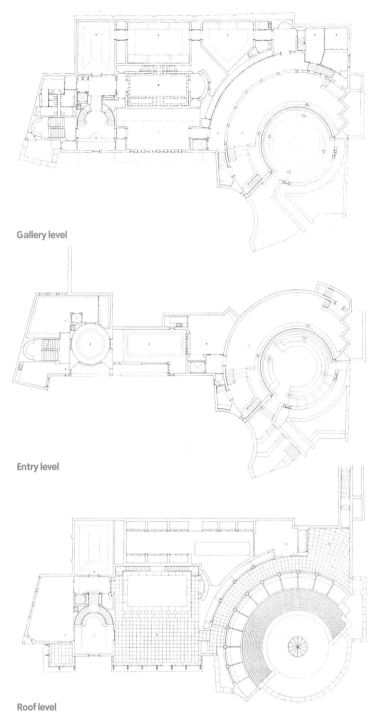

Gallery level

Entry level

Roof level

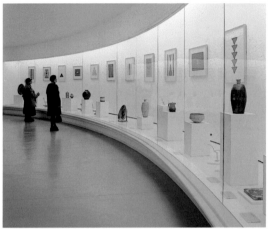

Top: Gallery 1.
Middle: Gallery 2,
upper level,
with pottery by
Bernard Leach
and his school.
Bottom: Gallery 3.

a pottery workshop in St Ives. Indirect natural light is admitted through rectangular openings that give onto the terrace below.

The balcony leads to the pentagonal Gallery 3, suitable for intimate study displays. It is aligned with the remaining rooms through doorways placed off-centre, a device that offers more options for arranging exhibits, since the walls to either side are alternately wider and narrower rather than equal in width. The passage from one gallery to another is negotiated through ingenious transition spaces, floored in slate (in contrast to the softer surfaces underfoot in the gallery spaces). These conceal services and storage cupboards and emphasise the fact that in this small museum one should nevertheless take the time to perceive the deliberately planned distinctions between the rooms. The central portion of Gallery 4 is fitted with a lowered ceiling, so that light coming in through the clerestory is concentrated on the perimeter, permitting varied light levels within the same space. Gallery 5, its main axis at right angles to its neighbour, has a pitched roof fitted with a sloping skylight. Its height encompasses two storeys. Rising uninterruptedly into the fourth level, its verticality is ideal for the large works so characteristic of late twentieth-century production. It frequently is dedicated to temporary, one-person exhibitions, some of them the result of a programme supported by the Tate that invites artists from elsewhere to occupy for a time a studio in west Cornwall, and to show the work they produce, which habitually has been influenced by their sojourn.

After completing the gallery circuit, one discovers

Transition space between galleries. Note slate floor.

one bow curves

two bow cleaves

three sail powers

four sail steadies

five rudder steers

six stern stitches

clinker-built copper-fastened sailing dinghy

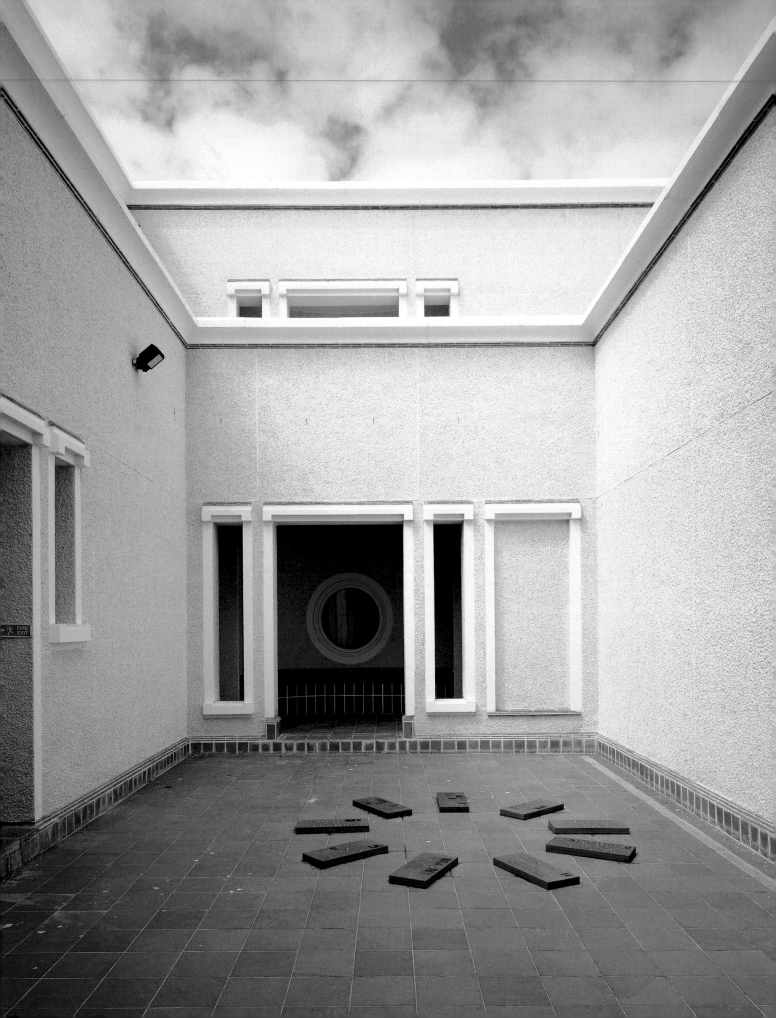

Terrace on roof
level: view
towards
Porthmeor Beach.
Left: courtyard
with Ian Hamilton
Finlay exhibition.

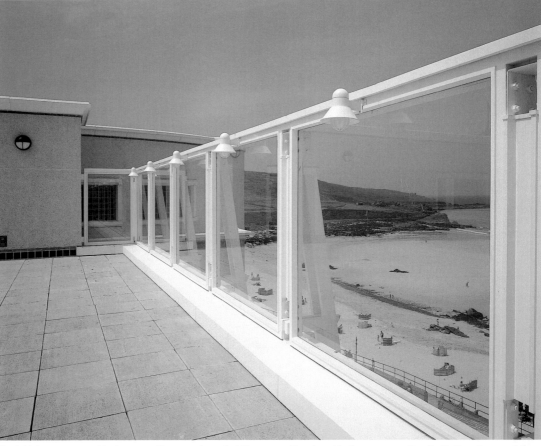

the hidden courtyard it circumscribes, enclosed at the sides but open to the sky, from which a dose of bracing sea air may be enjoyed; it can also be used as a sculpture or plant garden. The courtyard is overlooked by the large paved terrace at the top level, which encourages a clamber around the roof of the Loggia. From this lofty perch the panorama extends south and eastward, giving glimpses of the town, Porthminster Beach and the harbour. Here also is that indispensable accessory, the restaurant.

As the space that most dramatically links the natural surroundings with the art, the lower terrace of Gallery 2 lures the visitor to it again and again. It soars through three storeys, the circular heart of the buildng. One may choose to visit it immediately from the mezzanine, descend via its balcony from the main gallery level before proceeding to Gallery 3, save it for a climactic finale, or perhaps perform all three actions. Three-quarters of the inner circumference – the fourth quadrant belongs to the exterior Loggia – is faced with glass uninterrupted by mullions. This technical tour de force allows the gaze to turn smoothly toward the sea or down into the Loggia. Daylight pours in through large clerestory windows set between the supporting concrete ribs above the balcony. Sculpture, a specialty of such St Ives artists as Barbara Hepworth, Naum Gabo and Denis Mitchell, appropriately finds its home here; paintings can also be mounted on the curving wall. The monochromatic tones – dark grey slate on the floor, brilliant white on the walls – provide a backdrop, sensually pleasing in its own right, that accommodates a variety of personal expressions.

Terrace on roof
level outside the
restaurant.

Tate St Ives

The genesis of the gallery did not directly involve the Tate in London. The first initiatives stemmed from the community, which had long wanted a gallery dedicated to the art of west Cornwall, a region that had drawn into its orbit many artists of international stature, a number of them foreign-born. But economic motives also weighed heavily in an area so dependent on the tourist industry for its well-being; indeed, a grant from the European Community Development Fund, recognising the deprivation of the region, was a decisive factor in the realisation of the scheme. A local action group mounted a campaign, supported by the Cornwall County Council (CCC), which eventually led to the choice of a site above Porthmeor Beach that had been occupied by a derelict gasworks. A feasibility study made in 1988 led to negotiations with the Tate for a co-operative venture.

The Tate Gallery had major holdings of the work of twentieth-century St Ives artists, whom they had exhibited in 1985. Also, the Tate already had a presence in the Cornish art colony: since 1980 it had operated the Barbara Hepworth Museum and Garden, willed to the public by the artist, who died in 1975. Hepworth, who first moved to Cornwall with her family and a number of other London artists on the eve of the Second World War, in the 1960s created Trewyn Studio out of the former Palais de Danse. She gradually acquired other small buildings that worked with the landscape and her sculptures to form an engaging all-encompassing environment, which ultimately could be perceived as a work of indoor–outdoor architecture. The large yard and garden inspired her to expand her activities to embrace nature as well as art. Working with her friend Priaulx Rainer, she manipulated the natural and man-made setting. The large-scale bronze and stone sculptures that Hepworth created are integrated with trees and plants to create the effect of a maze-like building open to the sky and framing inviting views of the surroundings. It was an 'installation' *avant-la-lettre*. The popularity of the studio and sculpture garden encouraged the Tate to take on the fledgling museum to be sited nearby.

To find an architect it was decided to hold a modest one-stage competition, which five architectural firms

Origins

Tate St Ives

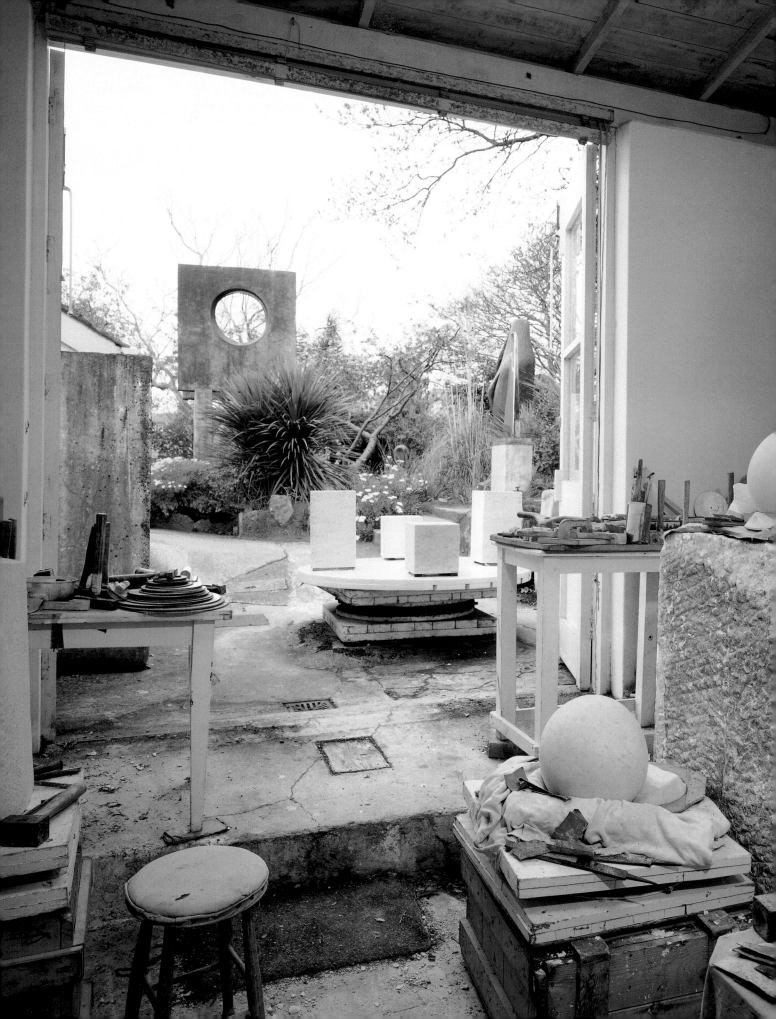

were invited to enter – Evans and Shalev, Stanton Williams, Michael Hopkins (who later withdrew), Feary and Heron (the authors of the feasibility study) and John Miller & Partners (who were already active on the Tate's behalf at Millbank). The brief concentrated on the general programme and the complex problems arising from the need to realise it on a difficult site within a tight budget; specifics relating to museum issues of conservation and display were not yet on the table. The majority of jury members (who included Richard Carew-Pole representing the CCC, architectural critic Colin Amery, a delegate from the office of Richard Rogers, who had acted as consultant, and former and current Tate directors Alan Bowness and Nicholas Serota, respectively), voted for the project by Evans and Shalev. When the construction documents were signed in 1991, the Tate agreed to assume the burdens of management. The museum building itself remains the property of the CCC, which raised the bulk of the more than £2 million original costs.

During the course of construction, those specific requirements necessary for the responsible preservation and exhibition of works of art, the bulk of which were to come from the Tate's Collection, were incorporated into the winning scheme through talks between the architects and Tate staff members. Although a few practical issues await resolution at a later phase, when expansion of the facility is envisaged, the success of the building – as a museum, as a contribution to the architecture of west Cornwall, and as a favourite destination for residents and tourists alike – is not in doubt. In its issue of 30 July 1999, *Building* magazine asked 'is this the best gallery in Britain?', implying a positive answer. A poll conducted shortly after the opening in 1993 by the *Independent* revealed that, of the fifty most notable British buildings of the twentieth century, Tate St Ives ranked no.4.

Uncompromising in its modernity – the asymmetry of the plan and sections, the avoidance of decoration, the technical sophistication manifest in the reinforced concrete frame and bent structural glass window of the Loggia, the smoothly flowing visual links between interior and exterior, the freedom of movement for the spectator – Tate St Ives not only fulfills its particular function but eloquently expresses it, through such references to the archetypal museum as the rotunda, the court, the enfilade, the top-lighting achieved via clerestories, skylights and an oculus. At the same time, some features of the classical museum are conspicuously and tellingly absent. The organisation of galleries around an interior court, with a sequence deliberately structured for the visitor, is far less formal and offers many more choices regarding circulation than in the past.

As already noted, instead of being entirely protected from the exterior world and focused inward, the visitor is encouraged to look outside, not only for occasional diversion but for the more important goal of analysing the relationship between the artist's vision and the artist's environment. Moreover, instead of the somewhat intimidating grand vaulted gallery, the modestly sized exhibition rooms, with their flat or pitched ceilings, derive from artists' studios as these developed from the late nineteenth century onward. Their unpretentiousness plays off against the spectacular, multilevel Gallery 2 to create a winning hybrid of the intimate and the monumental, the casual and the formal. If the circular shape of the Loggia recalls a museum rotunda, it refers equally to the cylindrical containers of the gasworks formerly located here. The recollection of this industrial forebear is preserved to remind us of the technological revolution that coincided with the birth of the museum.

To underscore the special qualities of this Tate outpost, it may be instructive to compare it – without implying any direct influence – with a slightly earlier project that balances the dual claims of modernity and tradition in a way that possibly suggested to Evans and Shalev tactics to both emulate and avoid: the Neue Staatsgalerie at Stuttgart, a commission won in competition by James Stirling in 1977, completed in 1984, and acclaimed worldwide. Admittedly Stuttgart's grand extension to a nineteenth-century museum is at the opposite end of the scale-spectrum, and is in a thoroughly urban setting. Nevertheless, it reintroduced some features that would be influential

Stuttgart: Neue Staatsgalerie (1977–84), James Stirling and Michael Wilford. View of rotunda.

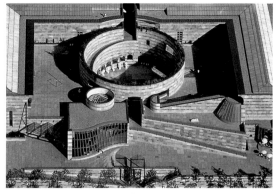

for subsequent museum designs everywhere, especially the sequence of contained, top-lit galleries arranged enfilade within the U-shaped plan, and the rotunda, here completely open to the sky, which integrates the Staatsgalerie with the city around it via ramps and terraces that negotiate the passage from the lower town at the front of the museum to the upper town at its rear. Stirling played off the new against the old, but in terms of juxtaposition rather than reconciliation. Brightly coloured metal detailing and large, undulating glass surfaces deliberately clash with the stone cladding that both conceals the concrete structure and gestures to the older masonry buildings in the neighbourhood. Evans and Shalev also confronted a steeply sloping site, and similarly have employed materials that are frankly contemporary – reinforced concrete, concrete block, glass brick, bent structural glass, exquisitely refined metal bolts to hold the glass sections together – but they are used in harmonious tandem with those employed for centuries in the vernacular buildings of St Ives – local stone, wood, slate and rough-cast render. The latter is given glamour by its marble aggregate and is used on some interior surfaces as well, a worthy substitute for the masonry walls of the iconic Neo-Classical museum. Ironically, budgetary considerations required that the slate be imported from Brazil; it resembles the Cornish product, but the individual pieces had to be cut to a smaller measure.

In both museums, the rotunda is incomplete, in keeping, perhaps, with the uncertainty of our present age compared with the positivism of the Enlightenment. In Stirling's museum, the rotunda lacks a dome; in Evans and Shalev's, the round volumes fitting inside each other are eaten into at the upper levels. Each building supplies a smaller sibling: at Stuttgart, the cylinder of the information booth rising through the irregularly shaped entrance pavilion to provide a finished counterpoint to the larger drum beyond; at St Ives, the vestibule leading to the galleries, its circular plan invisible from outside. Stirling confines nature to the plants that have overgrown the rim of his hypaethral rotunda, hinting at the museum's ultimate decay, or at least at the equivocal nature of its undertaking, as does the eroded façade with its deconstructed stone blocks. At St Ives, in contrast, where the rotunda is open at the base rather than the summit, nature is an integral part of the design. This is unusual in such a building type, which usually has a metropolitan context; one of the very few examples comparable in this regard is the Louisiana Museum in Humlebaek, designed in 1957 (and ongoing) by Jørgen Bo and Vilhelm Wohlert, and located on Denmark's coast fourteen miles from Copenhagen.

Museums of such importance are rarely found in locations like St Ives, not just because of the wild marine scenery, but also because, although this is a real town where people of many interests and occupations reside, it is a holiday resort as well. The architects and the promoters have been able to retain a ludic ambience without neglecting the serious aspirations of a museum.

Evans and Shalev have achieved the difficult balance of creating a public building important and visible enough to warrant a pilgrimage to St Ives for its own sake, but respectful none the less of the mission of exhibiting the works in a way that maximises their intended effect. Responsive to the natural setting, they have honoured it, as well as its impact on the art, in their design. In a period when the distinction between nature and culture has been increasingly emphasised, Tate St Ives intimates that this dichotomy may be exaggerated, along with those other putatively irreconcilable themes of modernity versus tradition, technology versus art.

Tate St Ives

Above: London, Tate Modern (1997–2000), Herzog & de Meuron. View from St Paul's Cathedral, 2003.

Right: Tate Modern, view from north-west. Lightbox on chimney by Michael Craig-Martin, 2001.

From the exterior, Tate Modern presents a study in contrasts. Vast scale is countered by fine detail, soaring verticals by syncopated horizontals, darkness by light. Sombre palisades of brown and buff brick, accented with red, are pierced by transparent bands, perpendicular at the sides, oblong to either side of the lofty chimney. Crowning the heavy structure is a two-storey box sheathed in matte glass. Behind its translucent skin letters spell out 'Tate Modern' and identify the gallery's temporary exhibitions. Subtly shimmering or reflective by day, depending on sky conditions, by night the 'light beam', as it is called by the architects, glows luminously above the opaque brick mass. The ultimate contrast – Giles Gilbert Scott's towering, tactile masterwork and Herzog & de Meuron's distilled and optically scintillating renewal – has been harmoniously brought together, though each maintains its integrity and visual identity, to form a spectacular new addition to London's South Bank.

Within, the effect is more paradoxical. One confronts a space that may be perceived simultaneously as outdoors and indoors, industrial and museological. The colossal turbine hall, its name commemorating its original purpose, is as much an avenue or a galleria as a vestibule: 115 feet (35m) in height and 75 feet (23m) in width, its full 500 foot (155m) length is covered with a skylight. The hall determines the main axis of the building, which runs

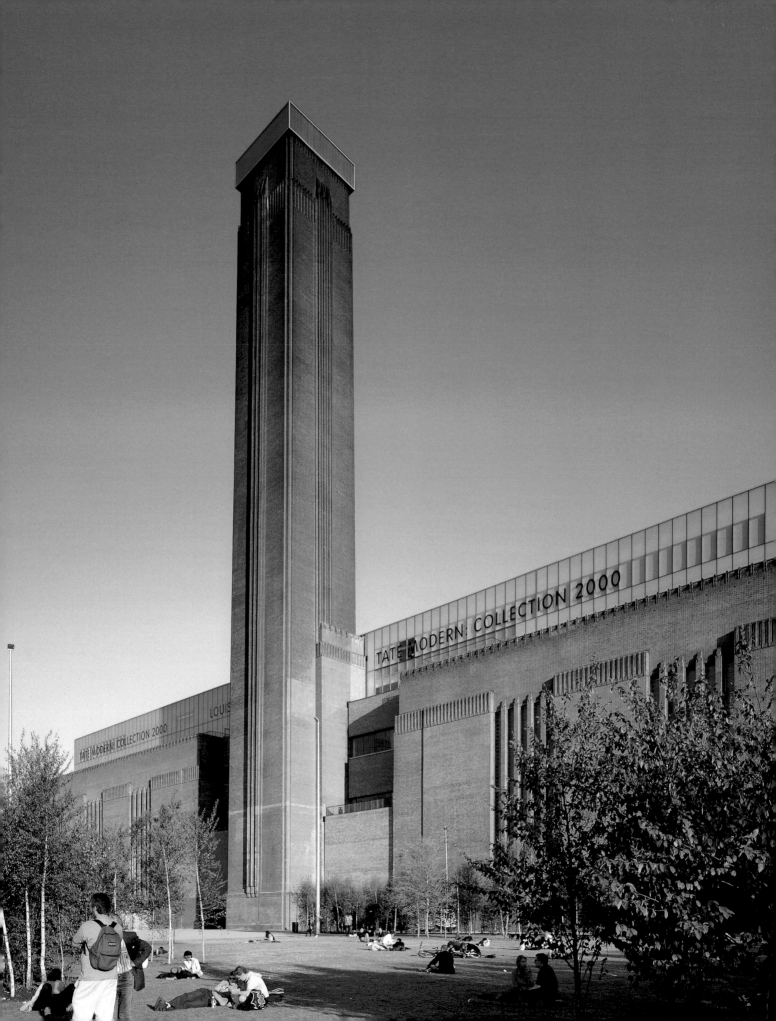

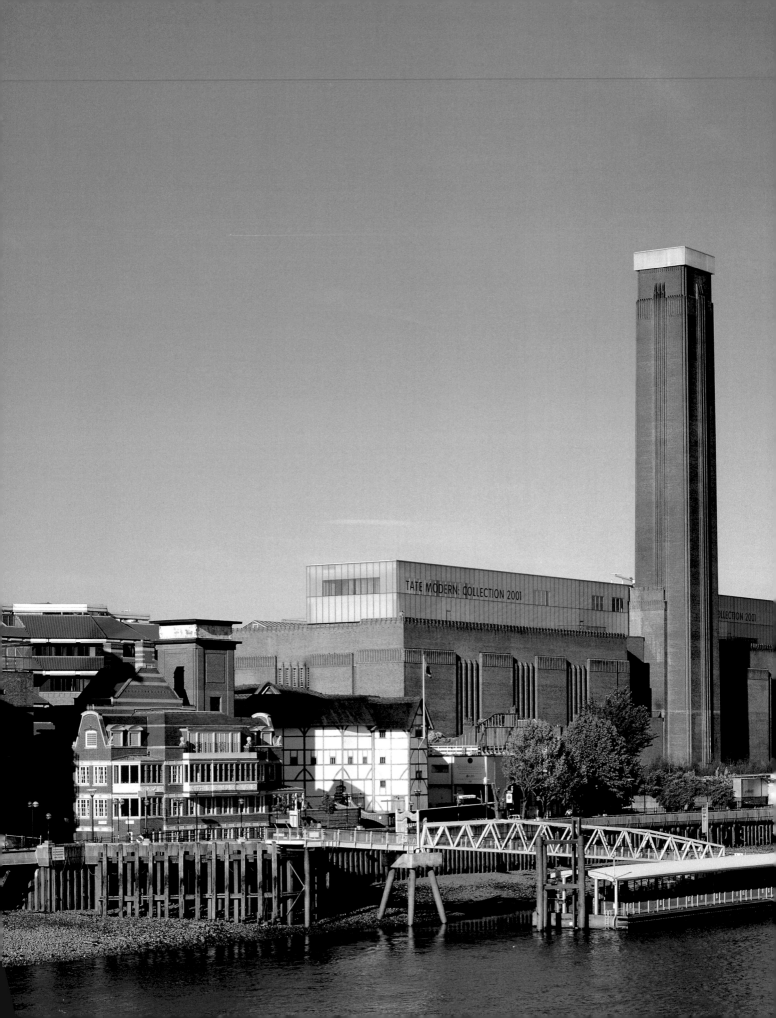

parallel to the river, but unlike the symmetrical cross-axial circulation patterns of conventional museums, here the longitudinal, east–west orientation thoroughly dominates. The forays one makes north of the turbine hall, along little lanes and alleys carved into the former boiler house where the museum proper lies, are but movement in a minor key.

The turbine hall has its own internal façades, dominated by the grid of the steel frame, infilled with opaque and transparent planes. Now painted dark grey, its necessary rivets and flanges create an elegant but functional decorative pattern on the surface. The fact that the skeleton is in front of the skin, rather than behind or flush with it, is reminiscent of Mies van der Rohe's revelatory treatment of steel frame buildings after his arrival in America, and suggests that the architects, although very much following their own agenda, were not indifferent to the Miesian aesthetic. Moreover, they also embrace Mies's credo, 'beinahe Nichts' ('almost nothing') in the perfection of the detailing, in sharp contrast to the coarse quasi-Miesian elements of the Llewelyn-Davies extension at Millbank.

On the southern elevation of the turbine hall, a band of light threads like a classical string course through the skeleton, behind which is the grey partition wall, formed from the original fittings of the power station, that shields the existing London Electricity switch-station (the space of which will

eventually be incorporated into Tate Modern). Contrasting with the repetitive modular character of the southern façade is the varied nature of the northern one, articulated to show the different functions it shelters.

The first and second levels have continuous glass walls, revealing spaces dedicated on the ground level to the main shop, cloakroom, education centre, study room and studios, and at the second level to the large café, auditorium, one of the smaller shops and the northern entrance from the riverside. This runs at right angles to, and one floor above, the main entrance and gives on to a balcony, formed from the original ground floor of the turbine hall, the rest of that surface having

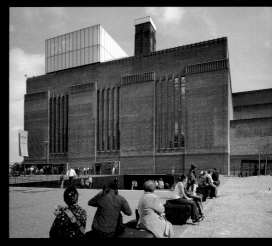

Tate Modern:

Right: Tate
Modern, loading
bays, viewed
from the east.
Opposite: Turbine
hall, looking
east down the
entrance ramp.

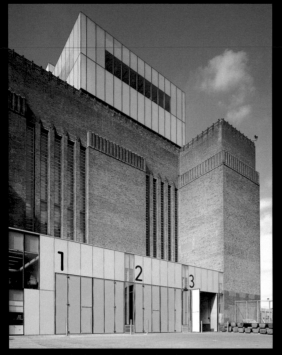

To the north, the galleries are bisected into eastern and western halves by the circulation core, which also supplies visual connection with the turbine hall. On Level 4, a clear glass strip along this core draws visitors to survey the scene below. On the third and fifth storeys 'bay windows' project, beyond the steel frame of the hall. It seems more descriptive to term them 'light boxes', for behind their sandblasted glass cladding, fluorescent fixtures make them glow. The interior counterparts of the light beam at the top of the building, they also gesture to the luminous stringcourse opposite. The light boxes shield areas where visitors may step out of the flow, functioning rather like roadside lay-bys and offering a similar service of temporary repose. At intervals clear glass interrupts the translucent planes to allow views onto the turbine hall, comparable to the original function of the rotunda balcony at Tate Britain, from where it was once possible to observe fellow visitors below. Those just entering into the turbine hall entrance of Tate Modern may also participate in the exchange of glances, as the radiance of the light boxes draws the newcomer's eye upward.

The light beam housing the two top levels (6 and 7) is not visible from the turbine hall. It contains the restaurant, Members' room, and entertainment rooms, with spectacular views in all directions. Thus the two lowest and the two uppermost storeys serve collateral functions, the three floors between comprising the gallery spaces.

disappeared when the lower level was opened up to enhance the height of the hall and to eliminate the basement.

The remaining three storeys visible from the turbine hall are dedicated to the galleries, mostly shielded from view by walls – except for the galleries to the extreme east and west on the top floor, which have a window looking directly down into the hall.

Tate Modern

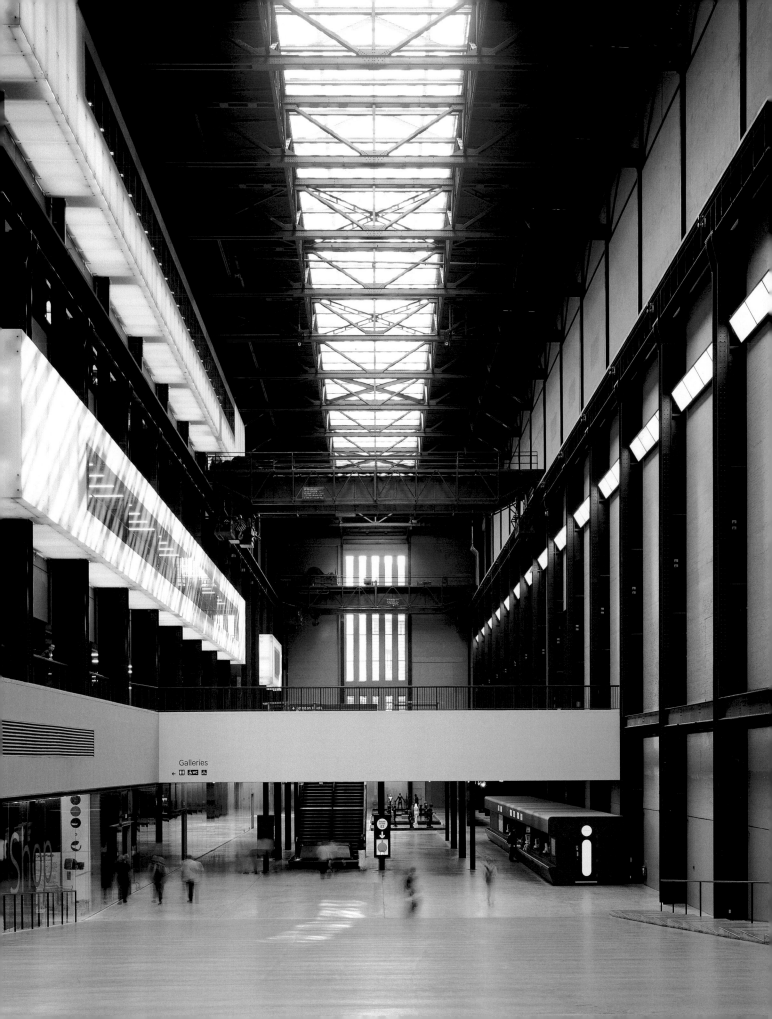

Reading point

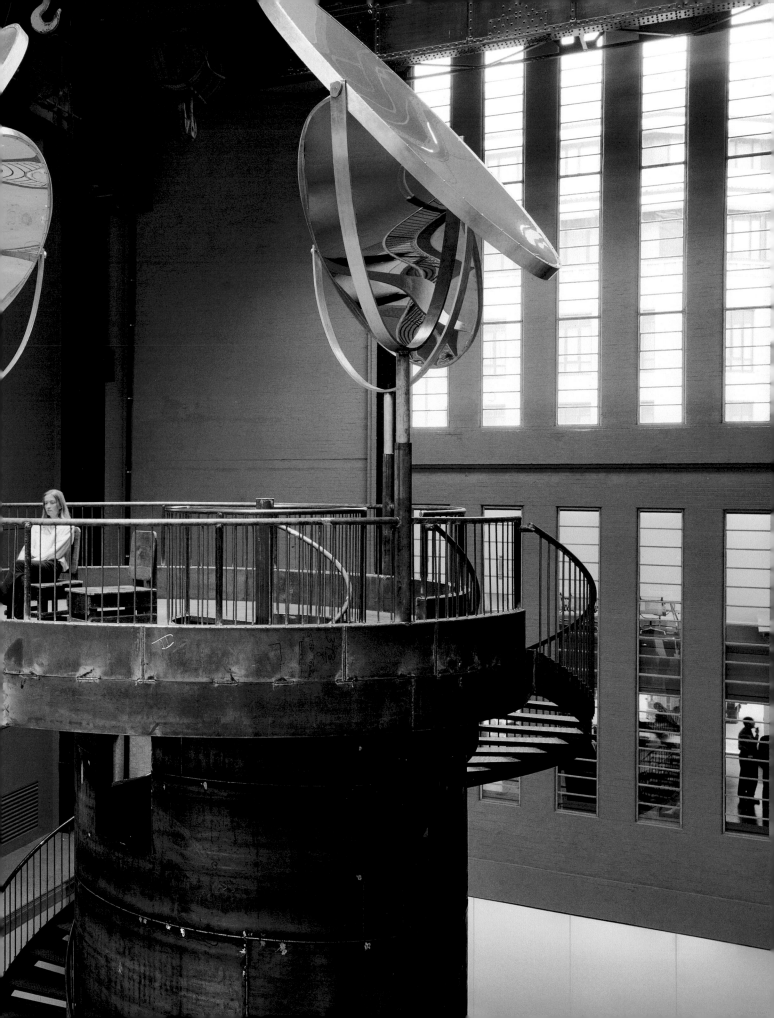

The controversial decision to reuse an existing building dating from the 1950s, rather than erect a new extravaganza that, like other Millennial projects, would ratify Britain's status as an architectural mecca, was vindicated by the instant and overwhelming approbation accorded Tate Modern by the architectural establishment and by the general public.

We have seen that the resolution, announced in late 1992, to separate Tate Britain and Tate Modern was the public admission of the decision not to proceed with Stirling's New Museums plan for Millbank and the start of the search for locations in London for a fourth Tate. One important factor here was the belief that there would never be sufficient space at the Millbank site to accommodate the needs of the rapidly growing modern collections. Another was perhaps the indication that new money might become available through the creation of a national lottery, which had been pledged by the Conservatives in their 1992 election manifesto.

At first it was assumed that a completely new structure would be commissioned for this purpose, and sites in Docklands, Vauxhall and behind King's Cross and Euston stations were among those considered but found unsatisfactory. Eventually the manifold possibilities offered by Bankside Power Station in Southwark, which had been shut down in 1981 and was threatened with demolition, were recognised. In 1994 the Tate acquired the land and most of the building, with the exception of an area on the south side that remains in the leasehold possession of London Electricity (but offers possibilities of further development once decommissioned), and thereupon launched an international competition for its transformation.

Bankside Power Station, conceived in 1946 but not fully completed until 1960, was erected more than a century after Hartley's 14-acre Albert Dock in Liverpool. But it is comparable in its commanding scale – Bankside's site measures 8.48 acres and the building itself occupies 174,000 square feet (16,100 m^2), including the 33,000 square feet (3,065 m^2) still in use as the substation. The engineers who were

commissioned to design it enlisted Sir Giles Gilbert Scott to give an acceptable appearance to the utilitarian building scheduled to arise opposite St Paul's Cathedral. Scott had atttained early prominence in 1903 when he won the competition for Liverpool's Anglican Cathedral (not completed until after his death). While Scott was best known for religious and collegiate commissions, in 1930 he had been called in by the London Power Company to do a cosmetic job on the coal-fired Battersea Power Station. Its imposing presence on the Thames across from Chelsea and Westminster, just upriver from the Tate at Millbank, had worried residents and museum officials who saw it as a visual threat. Thereupon Scott was asked to take the hulk that was already in the process of construction and reshape it with classicising references appropriate to its important location. He turned it into a work that would eventually be chosen, in a survey of 1939, as the second most admired building in Britain.

In 1947 Scott had been invited to perform his magic again. This time he was consulted at the outset, to counter the expected indignation over the creation of an oil-powered electricity facility in such a sensitive location. After sketching a few schemes, Scott arrived at the solution seen today. The staged construction lasted twelve years; by the time it was complete, the historical resonances, the monumentality and the complex detail of the brick walls were anathema to the modernists, then dominant in Britain, who had accepted international Functionalism and then Brutalism. For his modern style Scott had looked to the more conservative manifestations of interwar architecture in Germany and especially the Netherlands, where several architects and movements had eschewed nineteenth-century historicism without wholeheartedly embracing machine-age minimalist aesthetics.

Scott was not alone; buildings inspired by the Dutch Amsterdam School and by Willem Dudok, who in 1935 had received the Gold Medal of the Royal Institute of British Architects (Scott was then its president), are not strangers to London – witness the Royal Masonic Hospital (Burnet, Tait and Lorne, 1930–4) and the Greenwich Town Hall (Culpin and Bowers, 1939). But the admiration for such Dutch manifestations dates mostly from before World War II, whereas Scott extended Dudok's mannerisms into a period that no longer welcomed them.

Dudok, powerfully influenced by Frank Lloyd Wright, had synthesised traditional brick motifs with the abstract geometries employed by more radical groups like De Stijl. In particular he sought the visual excitement generated by the stark opposition of vertical and horizontal forms and by surface effects created by bricks subtly varied in hue and employed to create a modest Art Deco ornament integral with the wall.

The less rigid, more eclectic attitude that prevails today permits a fresh enjoyment of the virtues of Bankside, and a new generation of modernists like Jacques Herzog and Pierre de Meuron can discern and appreciate its merits without seeking to emulate them. Herzog celebrated Bankside as a 'hybrid of tradition [and] Art Deco; our strategy was to accept the physical power of the massive mountain-like building and to even enhance it rather than breaking it or trying to diminish it'.

The Tate's decision to convert an older building may initially have puzzled many, but there was already confirmation from Liverpool that a renovated industrial structure could positively serve the purposes of a modern art gallery, and the wisdom of performing such an operation on a cosmopolitan scale would eventually be acknowledged. The huge power station provides a volume and quality of space that is the envy of museums elsewhere, and the period of its construction symbolically resonates with its role as a showplace for twentieth- and twenty-first-century art. Moreover, the feat of saving a worthy structure, and of stimulating the prospects of a borough suffering some of the greatest deprivation in the country, has gained widespread approval. The number of visitors – some 5.3 million during the first year of operation – is unprecedented and has exceeded even the most extravagant projections.

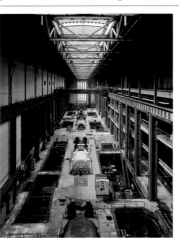

Right: Bankside Power Station (1948–63), Giles Gilbert Scott. The turbine hall before renovation. Previous spread: Turbine hall, Louise Bourgeois, *I Do, I Undo, I Redo* 2000, the first installation in The Unilever Series for the opening of Tate Modern in 2000.

An open international contest for the design of Tate Modern was announced in 1994, and 148 entries were received in the first round (the firms are listed in *Tate Gallery of Modern Art: Selecting an Architect*, repr. from *Blueprint* magazine, 1995; the thirteen short-listed designs are illustrated also). A significant number of the entrants were museum specialists, or in the process of becoming so, and many had at least one exhibition gallery to their credit.

The daunting number of entries attests to the powerful attraction art museums exercise on architects. Admittedly, some of the submissions were merely perfunctory; not all of the architects professing interest were eager to deal with a building so overpowering in size and character that it might dwarf their own efforts. From the initial group, thirteen practices were invited to provide more detailed particulars about how they would solve both the general museological demands and the rather unique ones that pertained to this project, such as ameliorating the urban agglomeration that surrounds the site and rationally connecting it to the new Tate Modern. The Tate wished to discover not a finished design but an architectual firm with a valid concept that could be developed in close contact with all of the players, including representatives of the community.

The jurors included Sir Simon Hornby, former chairman of W.H. Smith and of the Design Council (chair), Richard Burdett (director of the Architecture Foundation), Hans Hollein (architect renowned for his museum designs), Sir Philip Powell (architect), Michael Craig-Martin (artist and Tate trustee), and Janet De Botton (trustee and informed collector of contemporary art).

Six of the entrants on the shortlist were invited to proceed to the final phase. Dropped after the second round were the British firms Grimshaw & Partners, the scarcely-known Future Systems (Jan Kaplicky and Amanda Levete), Sir Michael Hopkins and Partners (in 2001 engaged to work on an extension to the Royal Academy), Rick Mather Architects (whose American principal has practised in London since 1964 and whose subsequent museum work includes interventions at the Wallace Collection and the

Axonometric
cut-away
view showing
northern façade
of turbine hall.

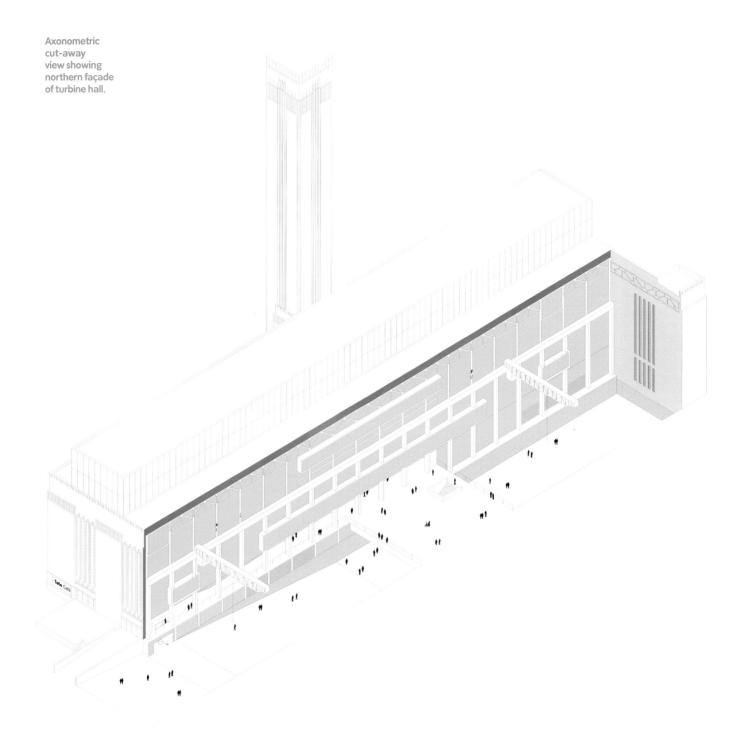

View from the
north-west.

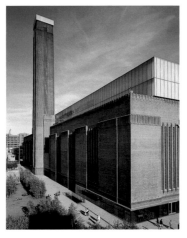

Herzog & de
Meuron's final
plans for Tate
Modern. Note
subterranean
cloverleaf, to
become available
as galleries when
Tate Modern
takes over the
sub-station.

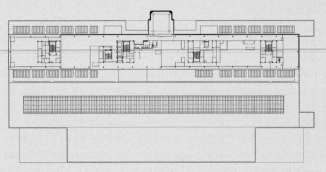

Level 7

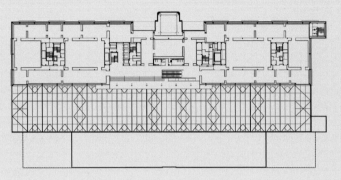

Level 5

Level 2, with mezzanine and auditorium

Ground (entry) level

Dulwich Picture Gallery) and Alsop & Störmer (responsible for the addition to the late nineteenth-century Museum für Kunst und Gewerbe (Arts and Crafts) in Hamburg, who in 2000 would win the Stirling Prize for their Library and Media Centre in Peckham, London). The Japanese architect Arato Isozaki (whose portfolio included the Los Angeles Museum of Contemporary Art (1986) and the conversion of a loft building in Soho for the Guggenheim Museum (1992) as well as several highly regarded museums in Japan), and the team Claudio Silvestrin/Rolfe Judd (a Milanese architect who designed the Contemporary Art Museum in Turin, and a London-based architect, respectively) also disappeared from contention.

In the very intense final round, only one British firm survived – David Chipperfield Architects, who are remodelling Leipzig's Arts and Crafts Museum and built the River and Rowing Museum at Henley-on-Thames (1989–97). Some of the others were acknowledged specialists.

Rafael Moneo has since 1980 become known for several highly valued museum designs: the National Museum of Roman Art in Merida, Spain (1980–6), the Thyssen-Bornemisza Collection in Madrid's restored Villahermosa Palace (1989–92), the Museums of Architecture and Modern Art in Stockholm (1991–8), the Davis Museum at Wellesley College in Massachusetts (1991–3), and the Audrey Jones Beck pavilion of the Museum of Fine Arts in Houston (1998–2000).

Renzo Piano, who with Richard Rogers had stunned Paris with the Centre Pompidou (1972–7) and later founded Renzo Piano Building Workshop, has designed two widely admired buildings in Houston for the DeMenil Collection (the main gallery, 1981–7, plus the Cy Twombly pavilion, 1995), the new Metropolis Science Museum in Amsterdam (1990–7) and is working on the long-term transformation of the Fiat Lingotto factories in Turin into an arts centre.

Tadao Ando is another museum maestro – the Suntory Museum in Osaka (1994), the Naoshima Contemporary Arts Museum in Kagawa (1992–5) and the Pulitzer Foundation for the Arts, St Louis, Missouri (1997–2001) are just three among his many relevant works.

The internationally staffed firm of OMA (Office for Metropolitan Architecture) headed by Dutchman Rem Koolhaas, is responsible for the Rotterdam Kunsthal (1990), and the new Guggenheim in Las Vegas (1999–2001); his Tate project was conceived in its later stages with Richard Gluckman – an American architect noted for his renovations of industrial buildings for art exhibitions, among them the Dia Center for the Arts in New York (1987) and the Andy Warhol Museum in Pittsburgh (1994).

The ultimate victors, Herzog & de Meuron, who at the time were not well-known to the British public, were gaining a reputation in the museum field. The Basel-based firm – founded by Jacques Herzog and Pierre de Meuron, later joined by partners Christine Binswanger and Harry Gugger – had designed the Goetz Pavilion in Munich, a private gallery, in 1992. After they won the Tate commission, they were shortlisted to add on to New York's MoMA (1997), renovated a 1916 mill building in Duisburg, Germany, to form the Küppersmühle Museum for the Grothe Collection, and are currently engaged on the De Young Museum in San Francisco, scheduled for completion in 2004, and the extension to the Walker Art Gallery in Minneapolis (2006). In 2001 Herzog and de Meuron were both Pritzker laureates, and indubitably the high visibility that earned them the award for what is often dubbed the 'Nobel prize for architecture' was due to their work for Tate Modern.

Of all the published entries, the Swiss firm's design interfered the least with the existing power station. Instead of considering it a restrictive nuisance to be overcome, they welcomed it as a challenge to the imagination, Herzog likening it to an inescapable feature of the landscape. The design trod very lightly on Bankside's territory as they established the necessary connections with the river, the surrounding buildings and the neighbouring terrain. It kept intact the tower outside and the essence of the turbine hall within, effected the minimum disruption of the vast brick surfaces, and retained the tall 'cathedral windows' mostly as Scott had designed them.

Herzog & de Meuron: competition entry. Section through Levels 3, 4 and 5, showing different gallery types.

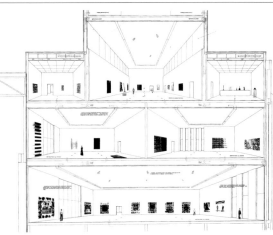

Tate Modern

Transformation

Tate Modern

After the announcement of the winner in January 1995, there ensued what must be one of the most closely considered and tenaciously controlled building projects of the period. Architecture is intrinsically the result of collaboration, but seldom have so many different persons from so many different areas of expertise and concern been so deeply involved with creating – and recreating – a building. Before making the final choice of architect, intensive workshops were held with the six firms still in contention. Staff included representatives of numerous departments of the tentacular Tate: exhibitions and displays, community development, education, regional and public services, and curatorial. Peter Wilson, then Director of Buildings and Gallery Services, together with Serota and a number of trustees, kept careful watch on the developing scheme. There were personnel from Schal, the construction management firm; Stanhope Properties, the Tate's project advisers; and the chief firm of engineers, Ove Arup & Partners. Others who would be drawn into the process included members of the community (encouraged by an imaginative series of creative events staged by the Tate), the Zurich team of landscape architects Kienast and Vogt, and eventually, and somewhat acrimoniously, the designers of the trouble-prone Millennium Bridge intended to carry pedestrians from the City to the Tate and vice versa, namely, Lord Foster, Anthony Caro, and the engineering firm Arup.

Tate Modern's schedule was postponed by

Right: Gallery on Level 5, Francis Bacon, *Triptych* 1972, and view into the turbine hall. Opposite: Gallery on Level 3.

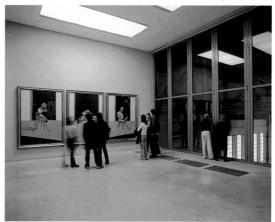

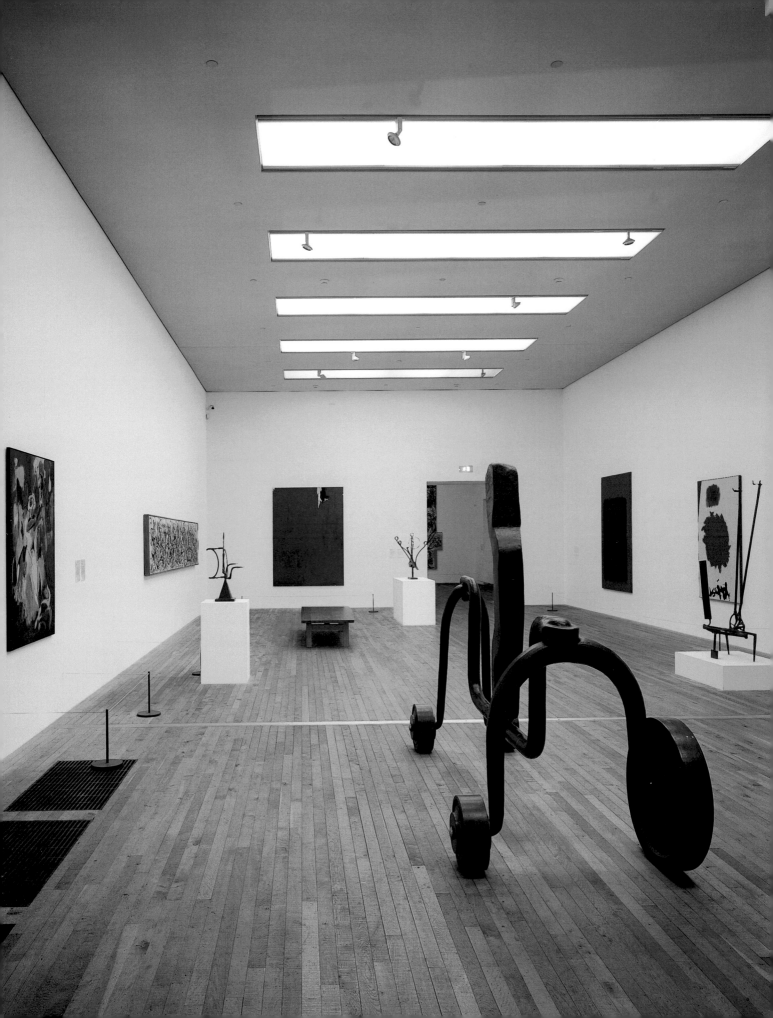

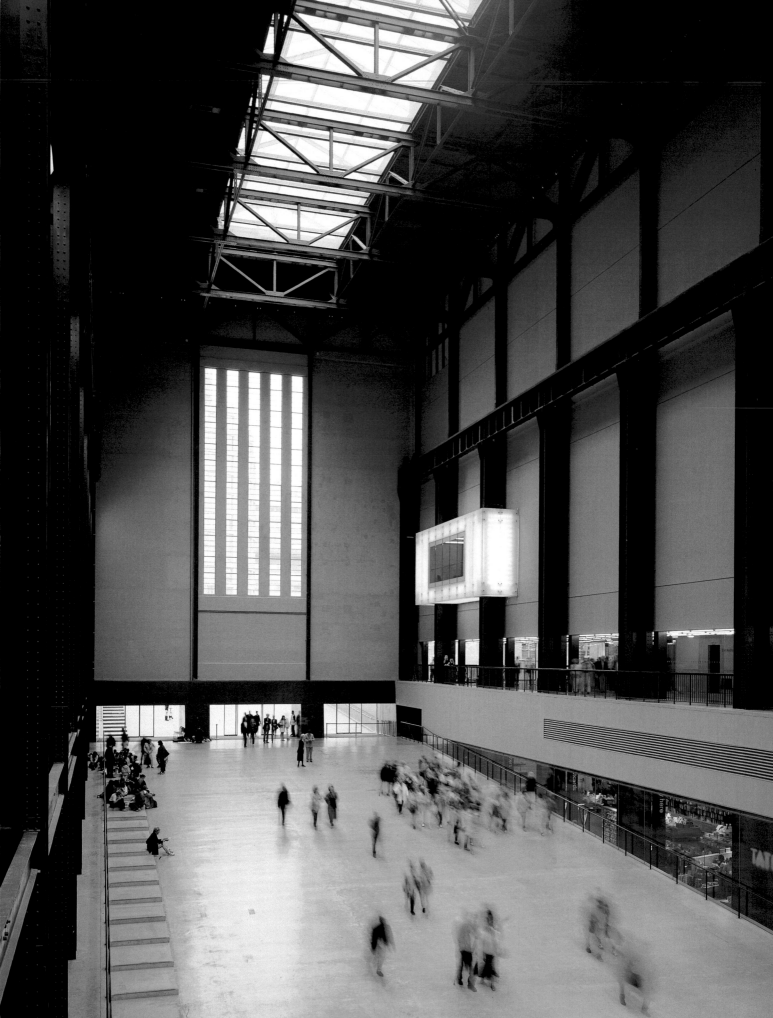

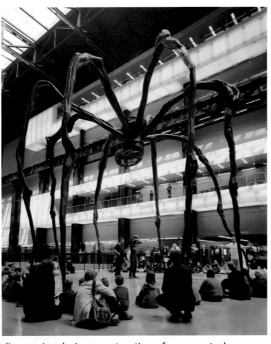

and new are here contrasted, there integrated, and constantly in dialogue, one of the abiding aims of the art museum. As for the building, commentators have noticed that sometimes it is difficult to tell where the original leaves off and the new begins, though the prevailing rule of preservationists that the viewer must at least subtly be made aware of the distinction has been largely observed. What has remained fundamentally intact for the present is the chimney, which bisects the composition into two almost but not quite symmetrical parts; when funds are available it is proposed to install a lift and an observation gallery.

Of course the ultimate test of any museum lies in the galleries. In some conversions these are left rough and raw as best accommodating the kind of art that was often produced in loft buildings by the generation who came to maturity in the 1960s, artists like Donald Judd, Richard Serra, Joseph Beuys and Mario Merz. When the Tate takes over the substation, this type of space will be available, especially underneath, where a cloverleaf of cavernous spaces awaits. The circular areas, formerly the location of three huge oil drums, captivated visiting artists who found them extremely promising for the display of vast works *in situ*.

For the rest, however, because the Tate's Collection spans the twentieth century and will continually extend into the twenty-first, such a one-sided solution was unsuitable. There are easel pictures in the Collection which, however unconventional the image they project, are nevertheless modest in size and definitively framed, and self-contained sculptures that likewise are best seen within a neutral and self-effacing room, the kind of 'white box' that from the advent of MoMA's first building in New York of 1938 has continued to present an alternative not only to the marble halls of the traditional museum but to the universal space so popular from the 1950s onward.

Tate Modern's galleries are entered to either side of a central circulation core, that comprises lifts, stairs and an escalator that in itself is a work of art, a futurist motion-machine that connects the entry floor with the three levels devoted to exhibition, thus serving uniquely the prime areas of the museum. Access to the second, sixth and seventh levels is by elevator or stair

discoveries during construction of unexpected problems, such as deteriorated conditions in the roof and in the concrete footings. Structural elements that had been listed for retention needed complete replacement; anticipated costs were rising. Such obstacles were met with effort and patience on the part of contractors, designers and clients. There were also the contretemps which typically arise among strong-willed people with desiderata that sometimes clash, among them Serota, whose vision drove the project, the curators, whose chief concern was the well-being and sympathetic display of the works of art in their care, and the architects, who had their own ideas about materials, colour, circulation patterns and design details. Such tensions can be very creative, and when resolved, result in a product that is all the more compelling because it embodies so many different priorities and sensibilities.

The building opened on time, on 11 May 2000, and its reception justified the Trustees' decision to remodel the power station rather than start from the ground up. Ultimately Tate Modern *is* a new building, and like the art inside, which spans more than a century, old

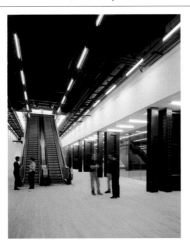

Tate Modern

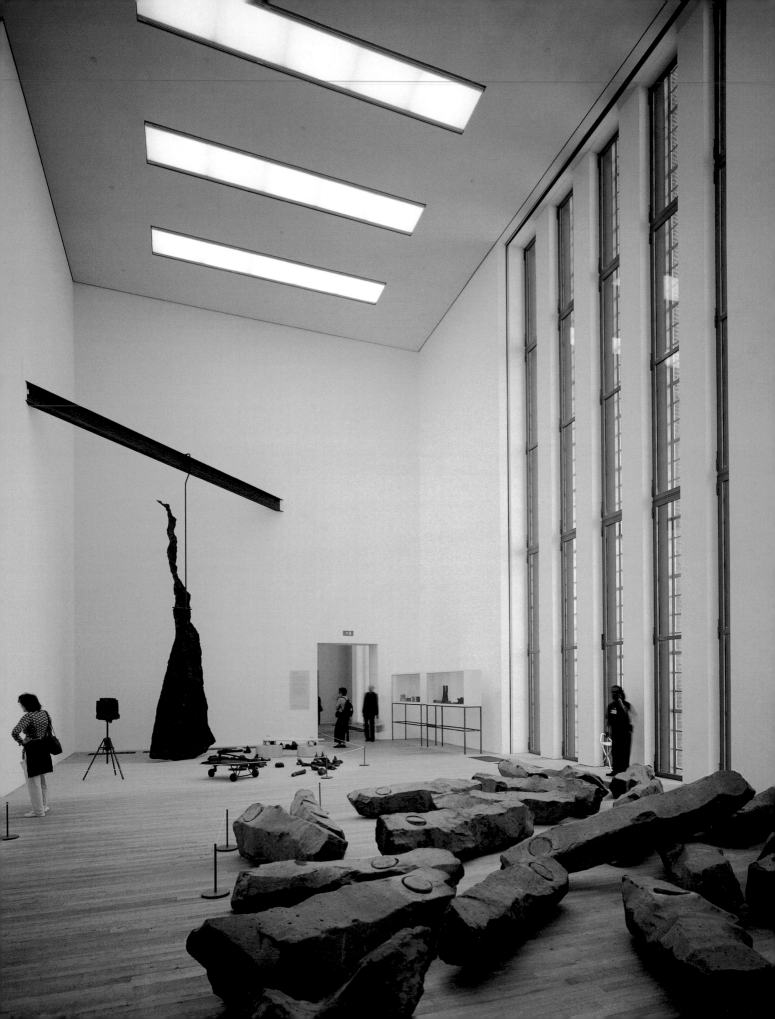

Right: Gallery on Level 3, looking into the turbine hall. Left: Double-height gallery on Level 3, with *The End of the Twentieth Century* 1983–5, by Joseph Beuys. Following spread: Gallery on Level 5 with sculpture by Donald Judd and Carl Andre. Note clerestory lighting.

as an indication of their subsidiary nature. The stairs run north–south, perpendicular to the axis of the turbine hall; the escalator is parallel to it. The materials of each circulation element are carefully chosen: the lifts and escalators are metallic; the stairs are encased in metal but have wooden treads and handrails, the latter stained and polished black. The handrail ingeniously incorporates lighting, yet another reference to the pervasive theme of light as a basic material incorporated into the fabric, one that functions both virtually and actually.

The galleries represent the most recent thinking about the best way for a museum, a permanent structure with its own priorities, to serve an art scene that is unpredictable and constantly in flux, in which new media rub shoulders with – or challenge – time-honoured practices of painting and sculpture. Thus the rooms, all rectangular, are of various proportions, some grand and lofty, others more confined and intimate. Ceiling heights range from 15 feet (4.6 m) on Level 5 to a majestic double-height gallery on Level 3 soaring to 43 feet (13.1 m). Floors on the third

and fourth level are of untreated oak, those on the fifth are of steel-fibre concrete. As for the palette, white is understandably predominant, but here and there rooms or walls are painted red, chartreuse, lavender and grey.

Both natural and artificial illumination is available in the side galleries. On the fifth level – the top of the original building – there is the possibility of zenithal lighting, admitted via glazed zones inserted into the roof. Particularly striking is the unobtrusiveness of the light sources. Ceilings in museums with top-lighting typically consist of a complicated and visible superstructure considered essential to tame the harmful effects of daylight. Herzog & de Meuron devised ways to avoid such complex and distracting mechanisms at Tate Modern. Light from above, whether from the sun or electricity, is subtly filtered through translucent glass set flush with the planes of wall and ceiling, and one is scarcely aware of whether the origin of the illumination is natural or artificial. Most of the galleries are enclosed, but in selected rooms Scott's cathedral windows, for the most part left unobscured, admit daylight from the side to transform the ambience of a given space. These vertical openings frame glimpses up, down and across the Thames. The architects have also introduced horizontal windows to either side of the chimney on the fourth and fifth floors, creating observation areas for relaxation.

Daylit exhibition rooms are no longer the sine qua non they used to be, since natural light has ceased to be a major factor in the making and viewing of much contemporary art. Indeed, for those employing cinematic and electronic media, it is undesirable. Tate Modern provides the potential for dimmed enclosures specifically prepared for films, videos and computer-generated presentations, an amenity still lacking in most museums, which must be content with makeshift quarters for such works. Since these media often have soundtracks that penetrate disturbingly in other display spaces, and typically require darkness to do justice to their flickering images, Tate Modern is well ahead in the race to accommodate in the most suitable manner possible the newest forms of visual art.

Temporary exhibition galleries on Level 4: 'Lagos', *Century City* exhibition, 2001.

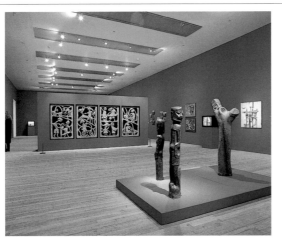

Tate Modern

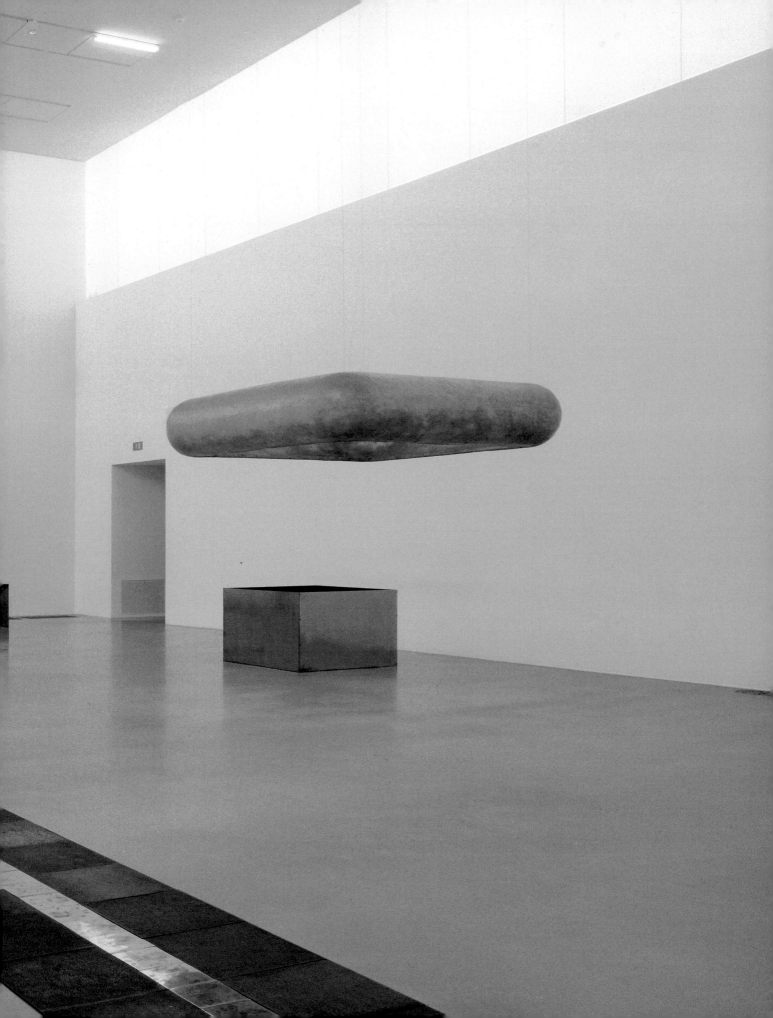

Housing modern art in the Machine Age

The Bankside venture has consistently been compared with another instantly applauded riverside icon of modern architecture: the Guggenheim Museum in Bilbao, by Los Angeles-based Frank O. Gehry & Associates, which opened in 1997. Both have the same general purpose – the display of the art of the twentieth and twenty-first centuries – and were credited with revitalising the local economic base, in Spain the entire port city, in London the borough of Southwark. In both cases the visitor has the unusual experience of descending from street level into the museum rather than climbing upward. Nevertheless, the two buildings are antithetical in idea and execution, not only because the Tate chose to save an existing building while the Guggenheim commissioned a new one, but because of the completely different vocabulary and conception of the image appropriate to the contemporary art museum. Gehry's building is flamboyantly Baroque in its bravura, which some complain overshadows the contents. Tate Modern, as reconfigured by Herzog & de Meuron, is classical in its reticence and rare in its deference to both the art and the powerful older building that forms the shell.

Comparisons with two other institutions – the Centre Pompidou in Paris (1971–7), recently restored and reconfigured, and Mass MoCA (Massachusetts Museum of Contemporary Art), which opened in North Adams in 1999 – probably are more relevant. In the case of the second, the link is the conversion of a large property comprising several mills and factories into a complex for art and performance. The Pompidou is important not only because its collection is seen as rivalling that of Tate Modern, but because, like Mass MoCA and Tate Modern itself, the Pompidou in its very fabric is complicit with the idea that the machine age irrevocably transformed the making and the reception of art. The Guggenheim Bilbao does not really participate in this aspect, despite the metallic sheen of its titanium 'oil can' surfaces, its location on the riverfront of a port, and the use of a computer-aided design programme devised to fashion the Mirage jet plane. In its high-art concept, which distinguishes it from its surroundings, the computer-generated design has more kinship with a traditional gallery such as the

Altes Museum, Berlin, or Tate Britain.

The identification of art and the machine inspired the first avant-garde, and gave rise to houses analogous to machines – Le Corbusier's 'machine à habiter' – and to the concept of the factory as ideal building type. The Centre Pompidou eventually brought that identification to full flower in its formal imagery, as did artists, in a different way, when they established studios in former industrial buildings, and showed their work in them.

An innovation that set the Pompidou apart from its peers was its capacity for continual alteration within its glass and metal frame. Piano has said that 'at the time, instead of a "building" we thought of it as a "machine", knowing it would be modified each time it became necessary' (*Connaissance des Arts*, 2000). To be sure, the universal space of many galleries erected from the 1950s onward achieved a similar flexibility, but never on such a scale. The Pompidou served a mixture of activities in exemplary ways, being home to a library, cinemas, performance and assembly spaces, the Forum for reception, exhibition areas for industrial and fashion design, and the requisite cafés, shops, ticket booths etc., but eventually was found wanting in one important regard – its specific function as an art gallery. In 1985 the then director, Dominique Bozo, invited Gae Aulenti to redesign the vexatiously amorphous areas devoted to the collections of modern and contemporary art. Her solution was to insert more room-like compartments on the gallery floors, and to suspend slabs from the ceiling to conceal the pipes and tubes, but the result never seemed more than provisional.

After twenty-five years of a spectacularly popular existence, the time did come, as envisaged by its founders and architects, Rogers and Piano, to make major alterations. The carcass with its pipes and exterior escalator has been renewed but essentially remains as conceived. The interior, however, has been revamped to reflect changes in the programme. The museum proper – Musée National d'Art Moderne – has not only been expanded, with the permanent collection occupying two floors (Levels 4 and 5), but has been reconfigured once again to make it more suitable for the purposive rather than random display of art. The renovation was carried out during 1997–9 by Jean-François Bodin in tandem with Piano, who proclaims himself extraordinarily pleased with the new arrangements. The 'new' Pompidou officially (re)opened a few months before Tate Modern, in January 2000.

Like Tate Modern, the museum is organised around an 'interior street', running the length of the building, which gives access to rooms of various sizes. There are wooden floors and white walls, but overhead, instead of encountering the flat, laconically understated ceilings of Herzog & de Meuron, one's eye is drawn to the bevy of metal beams and ducts, in keeping with the visual emphasis on structure and services that obtains on the exterior. There is no overhead natural illumination in the galleries and only a small percentage of daylight enters through the outer glass walls. The galleries and cabinets of the old-fashioned museum have reappeared, but without the decoration and elaborate detailing that obtained before the modernist revolution, and now they are organised to allow the viewers more freedom of circulation. The memory of the Enlightenment museum survives within the populist and iconoclastic body of the Pompidou.

Mass MoCA, conceived in 1986, with the first stage opening to the public in May 1999, does not resemble a machine but finds its home in a group of factories that once contained them. Situated on the 13-acre Marshall Street campus in North Adams, some of the utilitarian but often handsome structures have been demolished, but eight of the original buildings have been used thus far for the institution itself: they provide

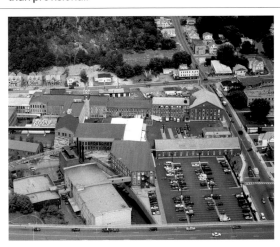

100,000 square feet (9,290 m²) of gallery space and 150,000 square feet (13,940 m²) of public space. The architects of the renovation, Bruner/Cott (Simeon Bruner, Henry Moss, Lee Cott and Dan Raih) of Boston, were asked by the founders to make 'the juxtaposition of old buildings and new art as direct and unmediated as possible' (*Mass MoCA: From Mill to Museum*, 2000). Thus in concept Mass MoCA is very different from Tate Modern – the galleries are often eccentrically configured, there are no enfilades, symmetrical circulation patterns or repetitive fenestration, finishes are deliberately rough and much of the original timber frame and many of the patinated surfaces have been left as found. Metal doors rescued from the old plant retain the scars of use; old sinks from the original rest-rooms reappear in the new. Mass MoCA doesn't have a permanent collection and the art it displays, mostly on loan and made since the 1960s, sits, sprawls or hangs appealingly in ragged rooms of various sizes and shapes. Located in a blue-collar mill town that has suffered economic dislocation, Mass MoCA's emphasis on the industrial origins of its buildings is appropriate for its place and purpose.

Tate Modern occupied a more complex situation. The latest jewel in a thriving cosmopolis, its design required a certain degree of formality and grandeur. One of the challenges was to attain this without ignoring the obligation to be inviting rather than intimidating. The architects were motivated by the potential contradictions inherent in this condition: to conjoin the raw and the cooked, the popular and the elitist, the profane and the sacred, so that access to either or both might be available to all who make the pilgrimage to Bankside.

Tate Modern has retained far fewer traces of its container's industrial past than Mass MoCA. The turbine hall with its reconstituted metal frame and glass roof, and its surviving gantry crane, is the chief reminder that the visitor has entered a former power station, as opposed to the painstakingly detailed and entirely new galleries in the former boiler house, which resemble those of the most elegant purpose-built museum. Yet the antitheses between industry and art are not uncompromising. The galleries have metal heating grilles and rough timber floors, and Scott's exceedingly tall windows remain. The turbine hall is undoubtedly more grand than any Enlightenment museum foyer, yet one descends on a concrete pavement into the bowels of the power plant before rising toward illumination, both literally and figuratively. The metaphor of light pervades the structure and unites the old and new.

The choices made here are apposite for a venerable institution located in a world capital, possessing holdings that cover a protracted period of contested artmaking. Some of the works arose in ferment and revolt – not only against certain social problems, but also in reaction to the very institution of the museum. Others present a more positive view of the reception of culture in contemporary society. Tate Modern must provide a suitable and sympathetic place where different, even competing voices may be heard, and where extraordinarily diverse artistic manifestations may be seen and appreciated. To this end, the institution and the architects have crafted a milieu that is neutral enough to satisfy a miscellaneous collection, yet one that has at the same time sufficient visual appeal to attract a diverse audience, and delight as well as instruct them.

It is not just the activities, whether solemn, playful or educational, that take place within the building that are at issue. Tate Modern must make contact with its surroundings and this it does through such amenities as Café 2, which can be entered directly from the outside, and the landscaping which links the building with the river, the river walk and the Millennium Bridge. Moreover, commissioned graphic artworks extend the gallery's boundaries beyond its immediate frame.

The crowds from many countries and different educational and economic backgrounds that mingle in Tate Modern suggest that its architectural tactics support the vision of the museum as a democratic rather than privileged institution, one that does not intimidate but pleases the eye, engages the mind, stimulates the imagination and soothes the spirit. Tate Modern's architecture serves and enhances the evolving and complex roles that museums must assume in today's society.

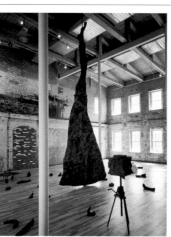

Tate Modern

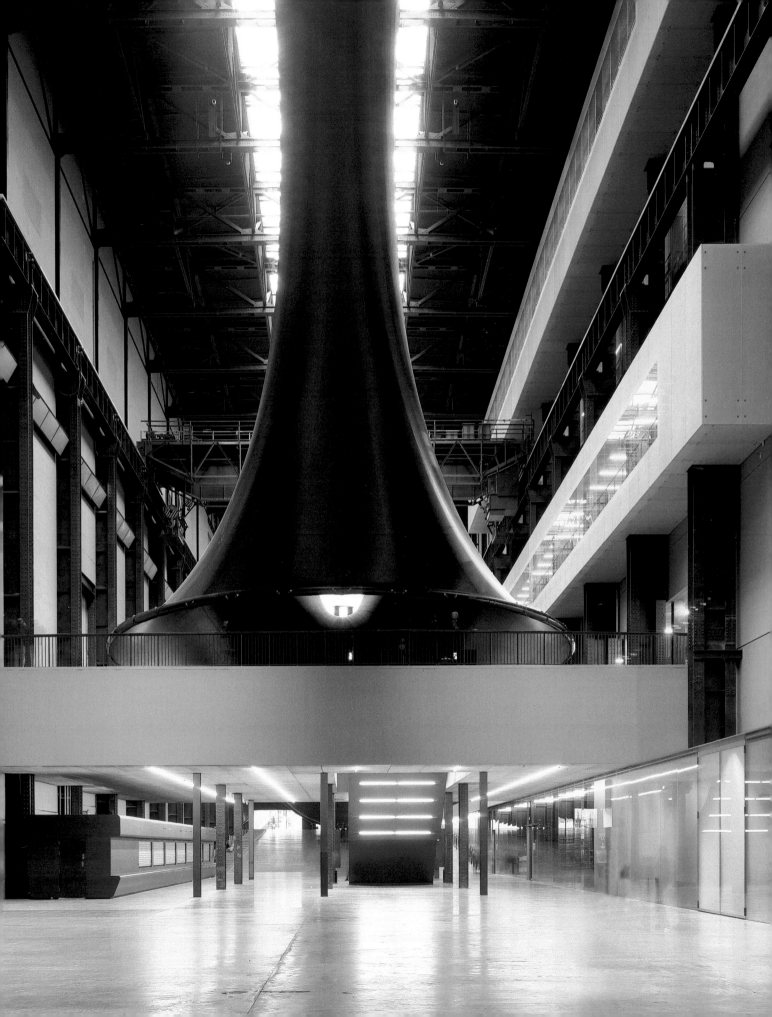

Conclusion: A space for art

For two centuries after its invention the art museum was most frequently encountered in an imposing edifice composed of lineaments that were so common to the genre that no identifying sign proclaiming 'museum', 'museo', 'musée' or 'galleria' was necessary. But in today's volatile and diverse museum world there can be no conclusion about a generalised architectural solution that would serve different establishments equally well on programmatic, structural and expressive grounds.

As museums have evolved into ever more individualistic foundations, heterogeneity has become the byword. After all, during the last few decades, both the institution and its visitors have developed additional, even contradictory expectations to those that originally prevailed. The art museum has become a theatre – performances, animated works, images on film, video or computer screens, often accompanied by sound tracks, require a fixed amount of time to experience and, like a play or opera, involve museum-goers in communal viewing. It has become a stage set – celebrities from various spheres haunt its precincts, followed by fascinated spectators. It has become a marketplace – consumption of food and merchandise are now an inevitable part of the pilgrimage. Nevertheless it remains a cathedral – communion with art continues to be the chief *raison d'être* for the visit, though now radically unexpected art forms and media must be accommodated to the liturgy along with such traditional artefacts as easel and mural paintings, works on paper, bronze and stone sculptures and the decorative arts.

This situation, thrilling with potential yet fraught with risk, imposes extraordinary demands on those charged with fashioning the receptacle for such diverse contents and so many competing expectations. Recently it appears that a number of establishments have gone the route of starting with a sensational building and emphasising its importance at the expense of conserving and displaying creative works so that they can be understood and appreciated in all their complexity and radiance. The concerned observer may rightly

question whether some museums are not in danger of losing sight of their original purpose and are being transformed into theme parks and leisure centres.

Nevertheless, for those who cherish the original function of the museum and insist on its primacy, it is heartening to realise that despite all the profound alterations in museological practice and the accompanying changes in the architecture, there are continuities and constants that survive – or have been revived – in many cases. Natural light may have been banished from the interior for decades –something the Tate never countenanced – but ultimately its indispensability for general ambience and for certain types of art has again been acknowledged. After years of proclaiming the universal space the ultimate solution for curatorial and visitor liberation from perceived tyranny, the idea of the plan as 'a society of rooms', to use Louis Kahn's eloquent formulation, has re-emerged. Cabinets, vaulted galleries and rotundas of varied proportions have returned to provide a firm and stable setting particularly welcome to works that arose in a world of rooms and were commissioned to adorn them.

Another revived practice that has been a part of the enterprise since its beginning is the use of competitions to select architects. In the mid-eighteenth century, museum programmes were favoured assignments at the French Academy for those students seeking the coveted Prix de Rome. During the nineteenth century, competitions were held for museums as diverse as the Glyptothek in Munich (1816), Thorvaldsen's Museum in Copenhagen (1839), the Rijksmuseum in Amsterdam (1885) and the Brooklyn Institute of Fine Arts in New York (1893). This expedient gained ever greater momentum during the twentieth century: in London alone during the last twenty years there have been a number of such high-profile contests, among them two for the extension to the National Gallery (the aborted one of 1982 and the successful effort for the Sainsbury wing, 1986) and the one for the Boiler House project of the Victoria and Albert Museum (1997). As we have seen, the Tate has also discovered

that the competition is an effective way to identify architects who can best fulfill a set of unique requirements.

Even the apparently novel manoeuvre of recycling buildings of other functions into galleries has a long and honourable history. In the past the rebirth may have occurred in a grand establishment such as a palace (the Louvre, 1793), a mansion (Montague House, the first home of the British Museum, 1753) or government offices (the Uffizi, 1743), and conversion of such elite structures has continued (the Picasso Museum in Paris's Hotel Sâle, 1985, and the Thyssen Bornemisza collection in Madrid's Villahermosa Palace, 1989–92). Railway stations, often grandiose and imposing in their own right, make natural candidates (Gae Aulenti's Musée d'Orsay in the Gare d'Orsay in Paris, 1980–6 and J.P. Kleihues's Museum für Zeitgenössische Kunst in the Hamburger Bahnhof in Berlin, 1990–6), as do hospitals (Museo National Reina Sofia in Madrid, 1991). If the vogue for using former factories and power stations is more recent, the idea nevertheless has a long pedigree.

The buildings occupied by the four Tate Galleries are not isolated phenomena, 'sports' in a world of familiar genres, aberrant interpretations of a sanctioned iconography. While each may be appropriately and necessarily distinctive in representing the individual character and context of the particular branch, the distinction is not won at the price of jettisoning the very attributes that have determined the development of museum buildings. Tate architecture has been and remains exemplary of the type while at the same time establishing its own unique voice.

Sidney Robert James Smith (1858–1913)
Sidney R.J. Smith
Trained in the office of A. Bedborough of Southampton and London, Smith began to practise in 1879 in partnership with his previous employer Henry Coe, architect to the Lambeth Board of Governors. The two libraries, in Lambeth and Balham, that he designed with Coe brought him into contact with Henry Tate, a generous benefactor of public libraries, with whom he forged a warm rapport. Henry Tate's subsequent public and private patronage – including the Tate monument in the West Norwood Cemetery – encouraged Smith to establish an independent firm. The numerous branch libraries he executed are eclectic in style, ranging from Neo-Georgian and Neo-Tudor to Queen Anne and Neo-Baroque. They include the small and charming Tate Library in South Lambeth (1888) and the large and imposing Tate Central Library in Brixton (1893). Smith's domestic commissions include work for Henry Tate's estate at Streatham (1887–9), as well as the house at 32 Green Street in Mayfair for Lord Ribblesdale (now the Brazilian Embassy), which demonstrates the same free handling of motifs and curious Ionic order seen at the Tate Gallery, Smith's most prominent commission.

William Henry Romaine-Walker (1854–1940)
W.H. Romaine-Walker
[Walker and Jenkins, from 1911]
Articled to the famed Gothic Revivalist G.E. Street (1824–1881 – architect of the Law Courts in London) from 1881 to 1896, Romaine-Walker was in partnership with A.W. Tanner, then from 1900 with Frances Besant. In 1911 he formed a partnership with Gilbert Jenkins, who had served as his chief assistant since 1901. Romaine-Walker designed an assortment of country and town houses for the newly rich merchants of the Edwardian era. Although he favoured the classical style, he was adaptable: a commission for Robert Hudson at 47 Park Lane (until recently Barclay's Bank), executed in 1899, was a hybrid of late Gothic detailing and Elizabethan composition; whereas for Robert Emmet he installed actual rococo panelling on the interior of his house at 66 Grosvenor Street. In 1905 he designed the house at 38 (today 128) Park Lane for

Henry Duveen, the dealer in furnishings, decorative art, and ultimately fine arts. The ground floor of the town house, comprising Portland stone Doric columns and piers carrying a simple entablature, is comparable in its severity and lack of ornament to the exterior of Tate Britain's Turner wing (1908–10), commissioned by Henry's partner and brother Joel Joseph (later Sir Joseph) Duveen. Joel's son, Joseph (later Lord Duveen), continued to employ Romaine-Walker, now in partnership with Jenkins, for the Foreign Galleries (1926).

John Russell Pope (1874–1937)
The American who in the 1930s restored the Roman Revival to favour in his native land practised an extremely chaste and restrained version of that style in tune with the modernist sensibility that affected even architects who continued to use historical allusion in their work. After Pope designed the Baltimore (Maryland) Art Museum (1925–33), he was entrusted with a number of similar commissions; a few, like that for The Metropolitan Museum of Art in New York City, did not come to fruition. As well as his contribution to Tate, he realised the gallery for the Frick Collection, New York City (1931–5), the Elgin Marbles Wing (1937–9) at the British Museum (also in collaboration with Romaine-Walker), and the National Gallery of Art in Washington, D.C. (1935–41), completed posthumously by the firm of Eggers and Higgins.

Richard Llewelyn-Davies (1912–1981)
Llewelyn-Davies, Weeks and Forrestier-Walker
Llewelyn-Davies, who became professor of architecture at London University in 1960, was educated at Trinity College, Cambridge, the Ecole des Beaux-Arts in Paris, and the Architectural Association in London. He began his career in the engineering department of London Midland and Scottish railways, investigating the rationalisation of railway station construction. Subsequently he directed the Nuffield Hospital and Laboratory Research team that explored the function and design of hospitals, where he met John Weeks, who would become his partner; in 1964 Forrestier-Walker joined the firm. Specialists in hospital construction and town planning,

the partnership's more prestigious commissions included the *Times* and Stock Exchange buildings. The Tate extension (1963–79) was – and remained – the sole arts building in Llewelyn-Davis, Weeks and Forrestier-Walker's portfolio. In 1963 Llewelyn-Davies was made life peer, the first architect to be so honoured.

James Stirling (1924–1992)
Michael Wilford (b.1938)
James Stirling, Michael Wilford and Associates, from 1971
James Stirling was educated at the Liverpool School of Architecture, later becoming professor at London's Architectural Association and Yale University's School of Architecture in New Haven, Connecticut. Recipient of the RIBA Queen's Gold Medal (1980), the USA's Pritzker Prize (1981) and the Japanese Praemium Imperiale 1990, the three most prestigious architecture awards, he was considered by many of his contemporaries to be the most gifted British architect of his generation. Michael Wilford, a graduate of the North London Polytechnic, came to work for Stirling in 1959, when the latter was in partnership with James Gowan (1956–63). From 1963 Stirling set up an independent practice, making Wilford partner in 1971. For Tate the firm designed and executed the Clore Gallery and Tate Liverpool, and created an unrealised masterplan (1985) for the Museums of New Art and Contemporary Sculpture. After two important though non-premiated competition entries in 1975 for German museums – the Wallraf-Richartz Museum in Cologne and the Museum for Northrhine Westphalia in Düsseldorf – the firm won the commission for the Neue Staatsgalerie in Stuttgart (1977–84), a major extension of the mid-nineteenth century museum of the state of Baden-Württemberg and a major urban intervention to reconnect fragmented areas of the city; it was hailed at the time as a revelatory work of museum architecture. James Stirling, Michael Wilford and Associates also built the Arthur M. Sackler Museum (extension of Harvard University's Fogg Art Museum), Cambridge, 1979–84, and prepared an unsuccessful competition design for the Sainsbury Wing, National Gallery, London (1985). Since 1993 the firm has been known as Michael Wilford and Partners.

Eldred Evans (b.1938) and David Shalev (b.1934)
Evans and Shalev

Evans received the diploma with honours from the Architecture Association in London and subsequently won a fellowship at Yale University; Shalev graduated from the Technion School of Architecture in Israel. They formed their partnership in 1965 and both are active as teachers, Shalev currently holding a professorship at the University of Bath. They are particularly known for their institutional work, including government buildings (the award-winning County Court House, Truro, 1985–8), libraries (Jesus College Cambridge, 1993–5, Lady Margaret College Oxford, 1998) and museums (Extension to the Ashmolean Oxford, 1999, Bedes World Museum, Jarrow, Northumbria, 1995 and 1999, and Nature in Art Museum, Gloucester, 1996).

Jacques Herzog (b.1950) and Pierre de Meuron (b.1950)
Herzog & de Meuron

The youngest Pritzker laureates thus far, and the first to win jointly as partners of the eponymous firm, the Basel natives both received architectural degrees from the venerable ETH (Technical University) in Zurich. They established their practice in 1978: since then Harry Gugger and Christine Binswager have joined as partners. Their work is characterised by the geometric clarity of the concept and the inventiveness and refinement of the materials used, the wide variety of which endows each commission with its own unique character. They have collaborated with a number of artists, and before winning the competition for Tate Modern had created a house for an art collector in Therwil, Switzerland (1985) and the exquisite building for the private Goetz Collection of Contemporary Art in Munich (1991–2), the galleries of which prefigure those of Tate Modern in their reticence and subtle lighting. Herzog & de Meuron were among the three semi-finalists for the extension to the Museum of Modern Art in New York (1997) and currently are engaged on museum designs for San Francisco and Minneapolis.

John Miller (b.1930) and Su Rogers (b.1939)
John Miller & Partners

The partnership of Colquhoun and Miller was established in 1961. When Alan Colquhoun retired in 1990, Miller, who received his architectural diploma from the AA, founded John Miller & Partners with Richard Brearley and Su Rogers, formerly a partner with Richard Rogers, whose museum expertise was forged when she worked on the Pompidou Centre. The firm's experience of designing exhibitions and upgrading facilities for art is extensive and very impressive; the commissions are notable for demonstrating concern that works of art dominate the space rather than the architect's whims. Colquhoun and Miller did the acclaimed restoration and addition at London's Whitechapel Art Gallery (1985) and since then Miller and his partners have executed upgradings and extensions to the Serpentine Gallery, the twentieth-century rooms at the National Portrait Gallery and the Henry Moore gallery at the Royal College of Art, and are currently completing the extension to the National Gallery in Edinburgh.

Jesse Hartley (1780–1860)

The Yorkshireman (born in Pontefract), who began his career as a stonemason, subsequently became the Bridgemaster of West Riding. This led to his appointment in 1824 as engineer for the Corporation of Liverpool, the port of which he transformed over a 36-year period. In addition to Albert Dock (1841–8) Hartley designed Brunswick Dock and half-tide basin (1832), Wapping Dock with its warehouse and hydraulic tower (1846–58), Stanley Dock's warehouses, Salisbury Dock's Victoria Tower, plus river and dock walls, gates and watchman's huts. Using brick, granite and iron, he created works of strength, solidity and a commanding scale that brought unparalleled mercantile prosperity to his adopted city.

Sir Giles Gilbert Scott (1880–1960)

Scott's grandfather, Sir George Gilbert Scott (1811–1878), was a prolific Victorian architect who revered the Gothic style, as can be seen in the Albert Memorial (1863–75) and St. Pancras Station (1868–74), but when clients objected he could turn out a classical Italianate scheme as in the case of the Foreign Office (1866–73). His father, George Gilbert Jr. (1839–1897), and younger brother, Adrian Gilbert (1892–1963), also were architects of the Neo-Gothic persuasion. Giles Gilbert, known especially for collegiate and ecclesiastical commissions, himself was perhaps proudest of the magnificent Liverpool Anglican Cathedral (1903–60). However, for many of his contemporaries Scott's two most memorable buildings, which rival the cathedral in scale and majesty, are power stations: Battersea (1930–4, with the engineers Halliday and Agate) and Bankside (1947–55).

1889
Henry Tate offers his pictures to the nation.

1892
Millbank Prison demolished; part of the site eventually to be used for the Tate Gallery.

1897
Tate Gallery on Millbank, designed by Sidney J.R. Smith, is opened by HRH the Prince of Wales (the future Edward VII). It consists of seven galleries plus a rotunda used for sculpture. Funded by Sir Henry Tate and called the Gallery of Modern British Art, it is placed under the control of the Trustees of the National Gallery.

1897–1906
Charles Holroyd Keeper.

1899
Extension (part of Smith's original plan) opens, adding eight galleries plus a large sculpture hall, a studio and a restoration room. Funded by Henry Tate.

1906–11
D.S. McColl Keeper.

1910
Turner wing, designed by W.H. Romaine-Walker, opened; with five galleries on the main floor and five at basement level. Funded by Joel Joseph Duveen, who dies before completion; his son, Joseph Duveen, enables the project to be completed. It houses painting and drawings by Turner transferred from National Gallery.

1911–16
Charles Aitken Keeper.

1914–21
Closure of Gallery to the public.

1915
Curzon Committee recommends rationalising the national collections with regard to British art. It proposes that the Tate Gallery be the home for Historic British Art and Modern Foreign Art.

1917
Tate Gallery is granted a separate Board of Trustees; it is made responsible for work by British artists born before 1790 as well as for nineteenth- and twentieth-century British, and modern foreign, art.

1917–30
Charles Aitken (formerly Keeper) Director.

1926
Sargent gallery, the gift of Lord Duveen, also designed by Romaine-Walker, is opened by HM George V and Queen Mary; it consists of four rooms – one for the work of John Singer Sargent, the others for Modern Foreign Art.

1928
The River Thames floods the lower floors.

1930–8
James Bolivar Manson Director.

1937
Duveen sculpture gallery, designed by John Russell Pope, is opened by King George VI and Queen Elizabeth. The old sculpture hall is demolished and the rotunda remodelled to make it compatible with the new wing. The new sculpture hall consists of two vaulted rooms each *c.*100 feet (30.5m) in length divided by an octagon. Funded by Lord Duveen of Millbank.

1938–64
John Rothenstein Director.

1939
With the declaration of war, the pictures are removed for safety; the Tate is closed to the public.

1940–1
Bomb damage from air raids.

1946
Gallery receives first purchase grant from government.

1949
Tate Gallery reopens.

1949–71
Tate Gallery is venue for temporary exhibitions of the Arts Council.

1955
Tate Gallery and National Gallery are officially separated; Tate becomes independent.

1963
Government agrees to the extension of the Tate Gallery; the architect chosen is Richard Llewelyn-Davies.

1964
Robbins Report recommends that galleries and museums should no longer be under the jurisdiction of the Treasury but placed under the new Minister for Arts and Education, giving them a voice in the cabinet. Large purchase grant awarded for five years with a special grant to buy foreign works from period 1900–50.

1964–79
Norman Reid Director.

1969
Exhibition of Llewelyn-Davies's scheme for extension proposing the demolition of part of the façade; public outcry forces change in design to retain original building and place extension in north quadrant. Government agrees to grant permission to expand on the adjoining site of the former Queen Alexandra Military Hospital.

1979
James Stirling, Michael Wilford and Associates appointed as architects for the extension plan on the QAMH site. The [fifth] extension, designed by Llewelyn-Davies, is opened by HM the Queen. It consists of 22,144 square feet (2,058 m²) of flexible gallery space plus a lower gallery and service spaces. Funded by the Treasury with a substantial gift from the Gulbenkian Foundation.

1980–8
Alan Bowness Director.

1980
It is announced that Vivien Duffield and The Clore Foundation will fund the long-discussed wing to house the Turner Bequest; it will be known as the Clore Gallery and will extend east from the original gallery on to the QAMH site. James Stirling, Michael Wilford & Associates are appointed architects.

1980
Barbara Hepworth's Trewyn Studio in St Ives, bequeathed to the nation in 1976, is to be operated by the Tate Gallery; it thus becomes the first outpost of the Tate beyond London.

1983–6
Brief and design for New Museums plan, to consist of a Museum of Modern Sculpture, the Museum of New Art, a Study Centre; Stirling's design remains unexecuted.

1987
Clore Gallery, designed by James Stirling and Michael Wilford, is opened by HM the Queen. It consists of a lecture theatre, the Duffield Room, reception and schools areas on the ground floor, seven picture galleries with two rooms for works on paper and memorabilia on the main level, two prints and drawings galleries and open reserve on Level 3. Funded by the Clore Foundation with a contribution from the Treasury.

1988
Phase I of Tate Liverpool, inserted into a portion of the Albert Dock re-designed by Stirling and Wilford, is opened by HRH the Prince of Wales. It consists of six galleries on the first three levels plus a café and bookshop. Funded by Merseyside Development Corporation, the Treasury and the private sector.

1988– present
Nicholas Serota Director.

1992
Tate announces plans to redefine the mission of Tate Millbank as the national gallery of British Art, and to create a separate gallery for Modern Art.

1993
Tate Gallery St Ives, designed by Evans and Shalev, is opened by HRH the Prince of Wales. It consists of five galleries of diverse dimensions and configurations, plus a shop, a restaurant, and studio space. Funded by the European Community, and public and private donations.

1994
Tate announces that the Bankside Power Station has been chosen as the site for the new gallery for modern art. It underwrites an international competition to find an architect. In September thirteen architects from 148 entrants are short-listed; in November six finalists are chosen to develop plans in consultation with the jury.

1995
Herzog & de Meuron win the commission for Tate Modern.

1998
Re-opening of Tate Gallery Liverpool after a £6.9 million redevelopment, which included two additional galleries on the top floor, a conference centre, and an expanded restaurant.

1998–2001
Lars Nittve Director of Tate Modern.

1998– present
Stephen Deuchar Director of Tate Britain.

2000
Tate Modern, designed by Herzog & de Meuron, is opened by HM the Queen. It consists of three floors of galleries, including one for temporary exhibitions, the turbine hall, also used for exhibitions, plus shops, restaurants, and an auditorium. Funded by the national Lottery through the Millennium Commission and the Arts Council, foundations, corporations and private individuals.

2001
Centenary wing of Tate Britain, designed by John Miller & Partners, is opened by HRH the Prince of Wales. In addition to a new entrance on Atterbury Street and the restoration of the Duveen Galleries, it provides ten new galleries on first and ground level, an atrium, shop and lecture room. Funded by the Heritage Lottery Fund, Sir Edwin Manton, and foundations, corporations and private individuals.

2003–present
Vincente Todoli Director of Tate Modern.

Tate Britain (including Clore Gallery)
Opened 1897; extended 1899, 1910, 1926, 1937, 1964 (offices), 1977, 1987 (Clore Gallery), 1991, 2001 (Centenary Development)
Site Area 2.0 hectares
Total Internal Area 15,700 m^2
Galleries 9,050 m^2
QAMH Site Area 1.3 hectares

Tate Liverpool
Opened 1987; second phase opened 1988
Site Area 0.27 hectares
Total Internal Area 7,530 m^2
Galleries 3,430 m^2

Tate St Ives
Opened 1993
Site Area 0.14 hectares
Total Internal Area 1730 m^2
Galleries 468 m^2

Barbara Hepworth Studio and Garden
In Tate ownership from 1980
Site Area 0.06 hectares

Tate Store
Converted in phases from 1995 – 1998
Site Area 1.33 hectares
Total Internal Area 7,000 m^2

Tate Modern
Opened 2000
Site Area 3.9 hectares
Total Internal Area 37,600 m^2
Galleries 8,210 m^2
Turbine Hall 3,390 m^2

Peter Wilson
Director, Projects and Estates

Further reading

General

Barker, Emma, 'The Museum in the Community: The new Tates', in E. Barker, ed., *Contemporary Cultures of Display*, London and New Haven 1999

Girouard, Mark, *Big Jim: The Life and Work of James Stirling*, London 1999

Jenkins, David, *Clore Gallery: Tate Gallery Liverpool*, London 1992

Maxwell, Robert, Wilford, Michael, and Muirhead, Thomas, *James Stirling, Michael Wilford and Associates: Buildings and Projects 1975–1992*, Stuttgart 1994

Searing, Helen, 'The Brillo Box in the Warehouse: Museums of Contemporary Art and Industrial Conversions', in *The Andy Warhol Museum*, Pittsburgh 1994

Spalding, Frances, *The Tate: A History*, London 1998

Trainer, Jennifer (ed.), *MASS MoCA: From Mill to Museum*, North Adams, MA 2000

Waterfield, Giles (ed.), *Palaces of Art: Art Galleries in Britain, 1790–1990*, London 1991 (chapters on the original Tate Gallery by Robin Hamlyn and on the Clore Gallery by Colin Amery)

Tate Britain

Bedford, Stephen, *John Russell Pope: Architect of Empire*, New York 1998

Hamlyn, Robin, 'The Tate Gallery', in Waterfield, Giles (ed.) *Palaces of Art* (see above)

Hamlyn, Robin, *The Clore Gallery: An Illustrated Account*, second edn, London 1987

Lorente, J. Pedro, *Cathedrals of Modern Urbanity: Museums of Contemporary Art*, Aldershot 1998, chapter 3

Taylor, Brandon, *Art for the Nation*, Manchester 1999

Tate Liverpool

Biggs, Lewis, *Tate Gallery Liverpool: Souvenir Guide*, London 1999

Tate St Ives

Axten, Janet, *Gasworks to Gallery*, St. Ives 1995

Shalev, David, and Tooby, Michael (eds.), *Tate Gallery St Ives: The Building*, London 1995

Tate Modern

Davidson, Cynthia (ed.), *ANY* (*Architecture New York*), no.13, New York 1996, pp.14–62

'Herzog & de Meuron 1981–2000', in *El Croquis*, Madrid [nd]

Moore, Rowan and Ryan, Raymund, *Building Tate Modern: Herzog & de Meuron Transforming Giles Gilbert Scott*, London 2000

Sabbagh, Karl, *Power into Art*, London 2000

'Tate Modern, Bankside, London: Herzog & de Meuron', in *Architectural Review*, London August 2000

Numbers given refer to pages

Bob Berry 86
Chorley Handford 24
David Clarke/Tate Photography 93
© M. Denesce 23
Andrew Dunkley/Tate Photography 26, 40
© Guggenheim Bilbao/Foto Erika
 Barahoua Ede 121 (top)
Joanna Fernandes/Tate Photography 27,
 37, 41 (top), 43, 51, 52–3, 55, 57
 (bottom), 62, 63 (top), 65
Foto-Design, Waltraud Krase, Frankfurt 21
Mark Heathcote/Tate Photography 25, 41
 (bottom), 49, 60
Mark Heathcote and Joanna
 Fernandes/Tate Photography 54, 59
Herzog & de Meuron 110, 111
David Lambert and Rod Tidnam/Tate
 Photography 16, 67, 68, 69, 70–1, 74
 (bottom), 75 (top), 76 (bottom),
 78 (top), 79
© MPL 72, 73
Marcus Leith/Tate Photography 17, 31, 63,
 80, 107
Marcus Leith and Andrew Dunkley/Tate
 Photography 15, 81, 82, 84, 85, 86, 87
 (top and centre right), 88, 90, 91
 (bottom), 96, 97, 98–9, 100, 101, 103,
 104–5, 109 (bottom), 112, 114, 115, 116, 117,
 118–9
Marcus Leith and Mark Heathcote/Tate
 Photography 58, 87 (bottom right),
 91 (top),
Marcus Leith and Marcella Leith/Tate
 Photography 102
New American Art Museums (NY, 1982)
 18, 19
Phaidon Press Limited 56, 76 (top)
John Riddy, London/© Tate 2003 123
Roger Sinek 77
Staatsgalerie Stuttgart 94, 95
Tate Archive 28, 29, 30, 34, 35, 36, 39
 (bottom), 45, 46, 47, 48,
© Nicholas Whitman, Philadelphia
 Museum of Art, Mass MoCA 122
Michael Wilford & Partners Ltd 74 (top and
 centre), 78 (bottom)

Index